HIRSHHORN

Museum and Sculpture Garden ▪ 150 Works of Art

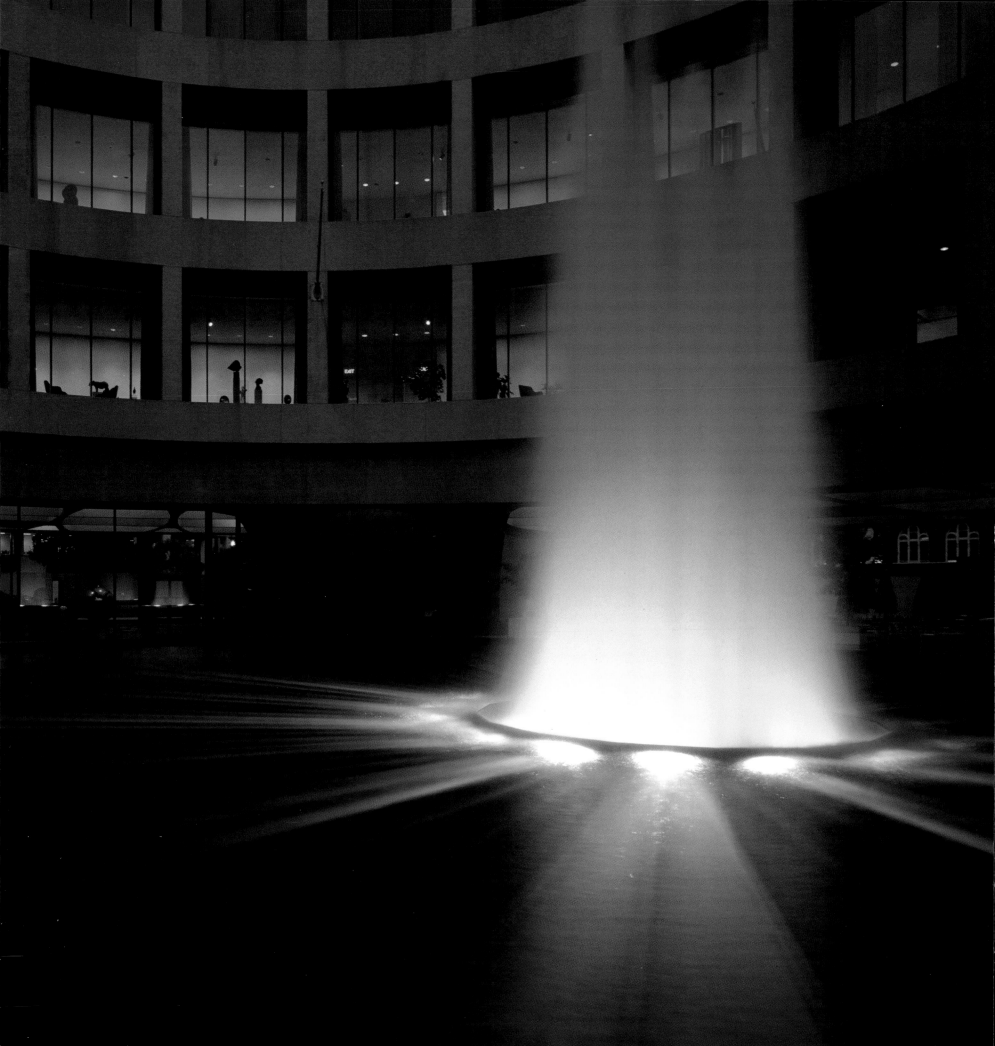

HIRSHHORN

Museum and Sculpture Garden

150 Works of Art

Hirshhorn Museum and Sculpture Garden, Smithsonian Institution

in association with Harry N. Abrams, Inc., Publishers

Published in 1996 by the Hirshhorn Museum and Sculpture Garden,
Smithsonian Institution, Washington, D.C., in association
with Harry N. Abrams, Incorporated, New York,
a Times Mirror Company. No part of this book may be
reproduced or transmitted in any form or by any means,
electronic or mechanical, including photocopying, recording,
or any information storage and retrieval system, without
the permission of the publishers

Editor: Jane McAllister, Hirshhorn Museum

Project Director: Margaret L. Kaplan, Abrams
Designer: Robert McKee, Abrams

Zabel 60.00 5/00

Library of Congress Cataloging-in-Publication Data
Hirshhorn Museum and Sculpture Garden.
 Hirshhorn Museum and Sculpture Garden: 150 works of art.
 p. cm.
 Includes index.
 ISBN 0–8109–3436–1 (Abrams: cloth)/ISBN 0-8109-2656-3 (Mus. pbk.)
 I. Art—Washington (D.C.)—Catalogs. 2. Hirshhorn Museum and
Sculpture Garden—Catalogs. I. Title.
N857.6.A57 1996
708.153—dc20 96–13054
 CIP

Printed and bound in Japan

Photographic Credits: All photographs are by Lee Stalsworth,
Hirshhorn Museum, except page 7 by David Douglas Duncan;
pages 22, 46, 56, 57, 82, 89, 101, 104, 115, 121, 139, and 157 by Ricardo
Blanc, Hirshhorn Museum; and pages 8 and 9, photographer unknown

Frontispiece: The museum's plaza at night

Contents

Acknowledgments

A publication about the museum's collection involves many departments and individuals, and it is my great pleasure to acknowledge those who were most directly involved. Foremost among the latter are members of the curatorial staff who authored the entries about specific works after participating in thoughtful discussions over many months regarding the selection of works and the format of the book. These writers are Valerie J. Fletcher, Curator of Sculpture; Frank Gettings, Curator of Prints and Drawings; Judith Zilczer, Curator of Paintings; Phyllis Rosenzweig, Associate Curator; Anne-Louise Marquis, Research Associate; and Amada Cruz, former Associate Curator. In addition, Neal Benezra, Director of Public Programs/Chief Curator, was an integral part of the process and contributed his knowledge and insights to the project. Although the responsibility for the final selection ultimately is mine, the original list of works was transformed over and over again as the result of discourse and debate among all of us.

Lee Stalsworth, Chief Photographer, and his staff, Ann Stetser, Photo Coordinator, and Ricardo Blanc, Photographer, performed admirably in providing the photography, which is the backbone of such a book. Librarian Anna Brooke, together with Jody Mussoff and Kent Boese, provided assistance with the essential research needs of the authors.

I am especially indebted to Jane McAllister, Publications Manager, who, after inheriting the project from her predecessor, Barbara Bradley, displayed almost superhuman patience and forbearance. Her good humor allowed us to proceed with civility. In addition, she oversaw the contributions of editors Kathleen Preciado, Marilynn Goldsmith, and Jane Sweeney, and conscientiously saw the project through to its completion. At Harry N. Abrams, Inc., Margaret L. Kaplan and her colleagues Lory Frankel and Bob McKee worked in close and effective cooperation with the Hirshhorn staff.

Former Deputy Director Stephen E. Weil was especially helpful during the formative stages, and Maureen Turman, Assistant to the Director, contributed numerous useful suggestions during the later phases. I am grateful to Museum Administrator Beverly Lang Pierce and her staff as well. My secretary, Kathy L. Jayne, together with Curatorial Secretary Tina Gómez, performed the unglamorous but critical task of typing and retyping the manuscripts with diligence and professionalism. To all of the above individuals go my heartfelt thanks.

My thanks would be incomplete without mention of the Jerome L. Greene Foundation, Inc., and Jerome and Dawn Greene, and the Jacob and Charlotte Lehrman Charitable Trust and Robert and Carrie Lehrman. Additional support was provided by the Sydney and Frances Lewis Foundation and Sydney and Frances Lewis. Their considerable generosity has made this publication possible.

J.T.D.

Introduction

The 150th anniversary of the establishment of the Smithsonian Institution is a milestone in the artistic, scientific, and cultural history of the United States. Even though the impetus and the initial munificence for its founding came from one who admired this country from abroad, by accepting James Smithson's unexpected and unprecedented bequest the federal government officially and publicly acknowledged that it had a significant role to play in the aforementioned areas of human achievement and endeavor.

The Hirshhorn Museum and Sculpture Garden—a small but

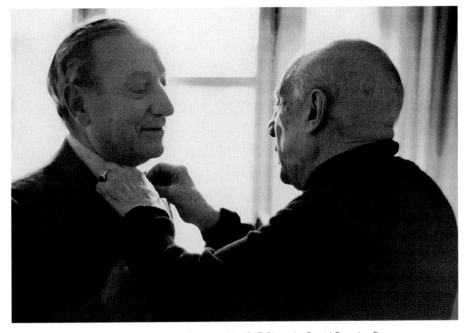

Joseph Hirshhorn and Pablo Picasso, July 1967. Photo by David Douglas Duncan

integral part of the Smithsonian, albeit one whose lifetime to date measures only a fraction of that of its "parent" organization—is proud to mark this special moment in the Smithsonian's history with a publication featuring 150 works from its collection.

The selection of artworks presented here is not intended to constitute a listing of the 150 "most important" works in the collection, although numerous such familiar masterpieces have been included and have been intermixed with an equal number of newcomers, that is, those works that have not "withstood the test of time" (one is never precisely certain how much time must elapse before the withstanding has proved successful). Nor is the publication meant to replicate the telephone directory–size volume that appeared in 1974 when the museum first opened its doors. That book, with its admirable aim of presenting a cross section of the museum's holdings, reproduced more than one thousand objects, fully 20 percent of the collection at that time. In his introduction to that publication Abram Lerner, the museum's founding director, noted the "fascinating if risky exercise of critical judgment" in selecting those

one thousand works that were meant to capture the essence of more than 130 years of art and at the same time "inform and delight" the reader.

With the Hirshhorn collection now nearly double the size it was in 1974, it would be a truly daunting task to try to capture the essence of the collection in 150 works. Rather, our goal at this juncture is simple and uncomplicated: to celebrate art. Indeed, at one point in the early preparation of this book, serious consideration was given to arranging the artists alphabetically to further emphasize their uniqueness without regard to the relationships that chronological organization implies. Yet we yielded—inevitably, it seems—to the primal curatorial imperative to present the objects historically and in general chronological order, acknowledging at the outset that we are not unveiling a complete history of art from Auguste Rodin to the present. We hope that this familiar structure will prove a useful approach for the reader while allowing the unique qualities of each work of art to become evident.

To begin this book with Rodin is to state the obvious: the Hirshhorn collection, despite an exemplary group of French sculptures and a smattering of American paintings from the nineteenth century, is, above all else, a collection of twentieth-century art. Rodin stands astride the turn of the century like a Colossus. Too modern for the traditionalists and too traditional for the modernists, he is the pivotal figure who defines the transition from the past to the future. Rodin was a particular favorite of Joseph H. Hirshhorn, who amassed more than twenty of his works, including several masterpieces, the foremost of which is the monumental *Burghers of Calais.*

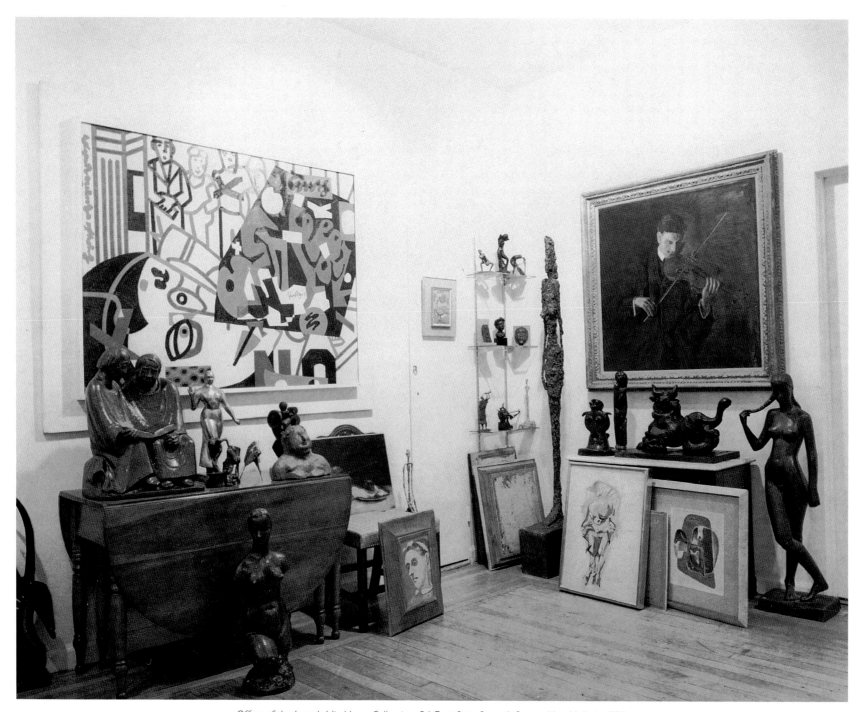

Office of the Joseph Hirshhorn Collection, 24 East Sixty-Seventh Street, New York, in 1958

If Rodin was a man who embodied two divergent directions in art, Hirshhorn was a man of forward vision with no looking back, whether in business or in the perennial search for new art to acquire. Born in Latvia in 1899, the twelfth of thirteen siblings, he immigrated to the United States with his parents eight years later. In many ways, his is the immigrant story of legend: poor boy leaves homeland; poor boy comes to America; poor boy works hard; poor boy gets rich. But there is an extraordinary addendum to the Hirshhorn story: poor boy donates outstanding art collection to his adopted country.

As a youth Hirshhorn had been fascinated by reproductions of nineteenth-century academic art that he clipped from calendars and pinned to his walls. His interest took a dramatic turn when, as a teenager, he became enthralled by two small engravings by the German Old Master Albrecht Dürer. Having made and saved a substantial sum of money from working as a novice broker in the curbside stock exchange, he purchased both original prints for $150. Thus, even at the outset, the youngster who would later come to be known for his voracious appetite for art began his life as a collector by acquiring two objects rather than a more cautious one. For Hirshhorn, those two original prints marked the beginning of his grand adventure in art and, although he was to sell numerous pieces over the years whenever his fortunes waned or his tastes changed, the two little works by Dürer remained with him until his death nearly sixty-five years later.

Salon art of the type he had clipped from calendars as a young boy had been the focus of his first collection. That assemblage was succeeded by a significant group of works from the French School, but those, too, subsequently gave way to make room, literally and figuratively, for his new and final passion: the art of our time. Even though he made occasional purchasing forays into the art of the distant past—alabaster heads from South Arabia, antiquities from Sardinia and Benin, and Pre-Columbian sculptures—more than 90 percent of what he acquired was created during his own lifetime.

The vagaries of the business world failed to deter or distract Hirshhorn from the activities that he found thrilling and rewarding above all: seeking and acquiring those objects of magic that we call art. The 1950s and early 1960s were particularly exciting years. While most of Europe struggled to regain its material and spiritual equilibrium in the aftermath of World War II, the United States basked in prosperity. Hirshhorn's fortune skyrocketed as his daring and bold investments in Canadian oil, gold, and uranium proved enormously successful. His collecting kept pace with his increasing wealth, and from the mid-1950s to the mid-1960s he was acquiring artworks at the breathtaking rate of two per day. In 1956 he hired Abram Lerner, an artist working in a New York gallery, to be his curator, registrar, and right-hand man in matters of art. It was a period of immense excitement and discovery as the artworks seemed to flow in from galleries here and abroad, filling every conceivable bit of office and storage space and forcing moves to more ample quarters.

As the collection became better known, requests for loans increased sharply, and entire exhibitions were eventually formed from Hirshhorn's vast holdings and shown throughout North America. In 1957 an exhibition of eighty-four American paintings and works on paper circulated to several museums in Canada, while another touring exhibition, organized by the American Federation of Arts and featuring American painters, traveled for two-and-one-half years to nearly twenty venues in the United States.

Perhaps more than the exhibitions of paintings noted above, it was the eye-opening show in 1959 of approximately 230 sculptures that focused serious attention on what Hirshhorn had accomplished as a collector. Hosted by the Detroit Institute of Arts, it marked the first exhibition devoted exclusively to sculpture from Hirshhorn's collection, and it made a deep impression on the public and critics alike. Because sculpture requires a considerable amount of space, significant private collections in the art form have not been readily developed. In this respect, Hirshhorn's collection

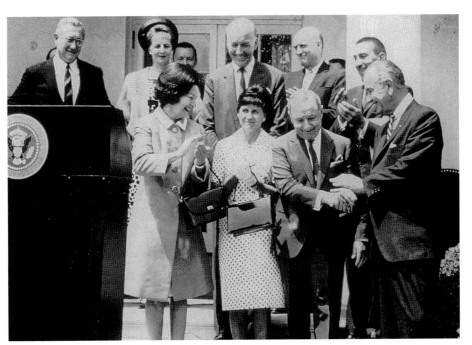

Olga and Joseph Hirshhorn flanked by Lady Bird and President Lyndon B. Johnson on May 17, 1966, the day the President presented to Congress Hirshhorn's plan to donate his collection to the nation

was unique. A smaller version of the Detroit show subsequently traveled to Milwaukee, Minneapolis, Kansas City, Houston, Los Angeles, San Francisco, Colorado Springs, and Toronto over thirteen months. During the two-year gap between the end of that touring exhibition and the opening of one devoted to his collection at New York's Guggenheim Museum in 1962, Hirshhorn added significantly—quantitatively and qualitatively—to his sculpture holdings. He purchased Rodin's *Burghers of Calais* during that interim. A Canadian reviewer of the Detroit exhibition had written enthusiastically about the stirring assemblage of modern sculptures but had also lamented the absence of the seminal figure Constantin Brancusi. Subsequently, during a seven-month period in 1961–62, three works by the Romanian sculptor, including the marble version of *Sleeping Muse* and the bronze *Torso of a Young Man*, entered the collection.

When the Guggenheim's exhibition opened in early October, the public was overwhelmed by an astonishing 444 sculptures in virtually all media. The event created a sensation and, before long, speculation increased regarding the final destination of the collection. The collector had earlier pondered that very question himself and had concluded *(a)* that a new museum with his name on it would have preference over a donation to an already existing institution, and *(b)* that his preferred site would be in Manhattan. Because no site in New York seemed to have the right combination of factors, however, a project there proved unfeasible. The municipal governments of Zurich, Beverly Hills, Toronto, Florence, Jerusalem, and London, among other cities, all expressed keen interest, and those possibilities were explored.

The Smithsonian Institution in the nation's capital was one of the last entities to enter the picture. In the late 1930s, that is, during the Great Depression, Congress had stated its resolve that there should be a museum on the south side of the National Mall devoted to the art and artists of our time. This action was taken in response to a concern that the recently established National Gallery of Art would, like its counterpart in London, be exclusively dedicated to the works of Old Masters and not to those of the living. Architectural drawings for a new museum were drafted by the renowned Eliel Saarinen, but with the onset of World War II, any hope of proceeding with the project had to be set aside.

The idea lay dormant for twenty years after the war's end, at which point S. Dillon Ripley, then Secretary of the Smithsonian Institution, revived the concept when it seemed apparent to him that Hirshhorn's collection could fulfill Congress's intention, now a quarter-century old, in one fell swoop. Thanks in large part to the personal involvement of President Lyndon B. Johnson and his wife, Lady Bird, the project moved forward with—for a government agency—surprising alacrity. An agreement was reached and the bill was signed into law on

November 7, 1966. Among the most important stipulations were the following: the museum would bear the donor's name and would be situated on the Mall; the operating costs of the museum would be borne by the federal government; there would be free admission to the public; any work could be deaccessioned, provided that funds derived from such action would be used to acquire other works of art; the museum would have a Board of Trustees with responsibility over the collection; and Mr. Hirshhorn had the right to select the museum's first director (he quite logically and understandably chose his trusted aide, Abram Lerner).

If the wooing of the collector and the official acceptance of the collection moved with relative ease, the eight long years leading to the opening of the museum must have been keenly nerve-wracking for all concerned. Political wrangling, bureaucratic delays, budgetary shortfalls, and architectural changes were bad enough, but in addition there was controversy about the unconventional plan for the building, the proposed location of the sculpture garden, and the donor himself. But ultimately the museum—designed by Gordon Bunshaft—and what is now a modestly scaled sculpture garden opened to the public on October 4, 1974. It was a singular moment of triumph for the poor boy from Latvia.

As the museum's first director, Lerner assembled a skilled and professional staff who would operate the museum on a day-to-day basis. Research on the collection, the education of docents and the public, the development of exhibition and publication programs, the formation of a reference library—all of these activities and more were his responsibility. Hirshhorn's benefactions to the collection continued even though he was persuaded by Ripley to designate a million-dollar contribution that he had intended for acquisitions to be used instead to complete the building when federal funding for it had been withdrawn in the midst of controversy. A modest federal appropriation enabled the museum to expand its holdings slowly, especially in the areas of contemporary American art and, to a lesser extent, of nineteenth-century French sculpture.

Hirshhorn continued to add to his personal collection. When he died in August 1981, his holdings were nearly as large as the collection he had given to the nation fifteen years earlier. Interestingly, the bequest included a number of bronze casts by Henri Matisse, Pablo Picasso, Henry Moore, Edgar Degas, and other artists that duplicated casts already in the museum's collection. The collector had been so enamored of some of his favorite sculptures that he had eagerly acquired another cast when the opportunity presented itself.

Lerner retired in 1984. After having been director of the Pasadena Art Museum and then the Des Moines Art Center, the undersigned was appoint-

ed the Hirshhorn Museum's second director. Conceiving of it as the nation's museum of modern and contemporary art, we have primarily focused collection-building on the post–World War II period, with particular emphasis on art created during the last quarter century. A museum's area of concentration and its goals for its exhibition programs are frequently interlinked. The Hirshhorn's significant holdings of Alberto Giacometti's sculpture and Francis Bacon's paintings, for example, were compelling factors in the development of retrospective exhibitions of their work organized by the museum in 1988 and 1989, respectively. Similarly, a rare early wax sculpture by Bruce Nauman became available and was acquired during the preliminary stages of co-organizing a retrospective exhibition of the artist's work that traveled from 1993 to 1995. Infrequently, artworks from an earlier period have been acquired when special needs of the collection could be addressed. Although Henry Moore, for example, one of Joseph Hirshhorn's favorite artists, is especially well represented in the collection, the museum lacked one of the sculptor's seminal stringed wood pieces until the purchase of *Stringed Figure No. 1*, 1937, from the artist's family.

The enlightened approach to deaccessioning that comprises a part of the original Smithsonian/Hirshhorn agreement has allowed the museum to prune the collection of works for reasons of their redundancy, condition, or quality. Funds realized from this practice, together with other resources contributed by a growing list of generous supporters, have permitted us to acquire works that fine-tune the collection on the one hand and forge ahead into new art realms on the other. For example, while the museum owned seven paintings by the Abstract Expressionist Clyfford Still, none was from the late 1940s, a particularly important moment in the artist's oeuvre. The flexibility to dispose of a painting by the artist from a period that was already well represented has resulted in the acquisition of another painting that provides the public with a more thorough understanding of the artist's achievement than it would otherwise have.

With the idea of a wider imperative for the Hirshhorn Museum's collections and public programs uppermost, we have endeavored over the years to increase our range to include internationally significant contemporary figures together with those emerging artists who show considerable promise. As never before, the past quarter century has been a time of unprecedented internationalism and cross-fertilization in the visual arts, phenomena the collection continues to reflect.

A passion for collecting and for the art of our time was the genesis of the Hirshhorn collection, and an abiding interest in contemporaneity is the promise we continue to strive to foster. Thus, intermixed with the most familiar objects from the museum's collection are works by younger and less-established artists of today. Such a mix constantly rejuvenated the museum's founder. It is my fervent hope that readers will be imbued with that same youthful spirit and intellectual curiosity. Therein lies the key to the celebration of art.

James T. Demetrion, Director

NOTE TO THE READER

The personal reflections of Olga Hirshhorn, Abram Lerner, and Stephen E. Weil were enormously helpful in the preparation of this introduction. The following sources were also consulted: Abram Lerner in his introduction to *The Hirshhorn Museum and Sculpture Garden* (New York: Abrams, 1974); Barry Hyams, *Hirshhorn, Medici from Brooklyn* (New York: Dutton, 1979); published Congressional hearings conducted by the House and Senate Committees on Public Works, Subcommittees on Buildings and Grounds, 89th Cong., 2d sess., held June 15 and June 30, 1966, respectively; and numerous articles, newspaper clippings, films, and other sources in the Joseph H. Hirshhorn Archives, Hirshhorn Museum and Sculpture Garden.

All the works illustrated belong to the permanent collection of the Hirshhorn Museum and Sculpture Garden. Entries are arranged in a general chronological order. Artists are identified by nationality or national school. Foreign-language titles have been translated into English in nearly all cases. When known, edition numbers for sculptures are provided; for example, "6/7" indicates the sixth from an edition of seven casts. In measurements, height precedes width and depth.

CONTRIBUTORS

The authors of the individual entries are indicated by the following abbreviations:
Amada Cruz (AC)
Valerie J. Fletcher (VJF)
Frank Gettings (FG)
Anne-Louise Marquis (ALM)
Phyllis Rosenzweig (PR)
Judith Zilczer (JZ)

Auguste Rodin

French, 1840–1917

The Burghers of Calais, 1884–89

Bronze, 8/12, cast c. 1953–59

$79^{3}/_{8} \times 80^{7}/_{8} \times 77^{1}/_{8}$ in. (201.7 × 205.4 × 195.8 cm)

Gift of Joseph H. Hirshhorn, 1966 (66.4340)

Abandoning stale classical traditions, Auguste Rodin developed an expressive style based on personal interpretations of his subjects. In 1884 the town council of Calais in Normandy commissioned him to create a monument commemorating the end of the terrible siege in 1346–47, when the conquering English had agreed to accept the town's surrender without punishing its people if six prominent citizens (burghers) would offer themselves as permanent hostages. Rodin's composition portrays them at the moment of departure from their homes and families. With necks encircled by ropes, and bodies covered only by rough robes, they walk barefoot to deliver the keys of the town.

After his preliminary maquette was accepted, Rodin made nude and clothed studies of the individual figures, then a second model in 1885 that was criticized as insufficiently patriotic. Rather than conveying a simplistic image of idealized heroes marching proudly to their doom, Rodin's burghers reveal complex emotions: courage mingled with apprehension, and stoic determination underlined by despair. Their intense states of mind are conveyed through exaggerations of anatomy—in the heavy gestures, tensed muscles, and pained facial expressions. Each man appears withdrawn into his own sorrowful thoughts.

The project was suspended in 1886 for financial reasons but was revived in 1893. Rodin proposed to arrange the life-size figures on ground level to allow direct confrontation with viewers—an innovative approach that was rejected by the council in favor of a tall stone pedestal. Subsequent casts, made with minimal bases, have been installed in London, Paris, Philadelphia, and other cities. VJF

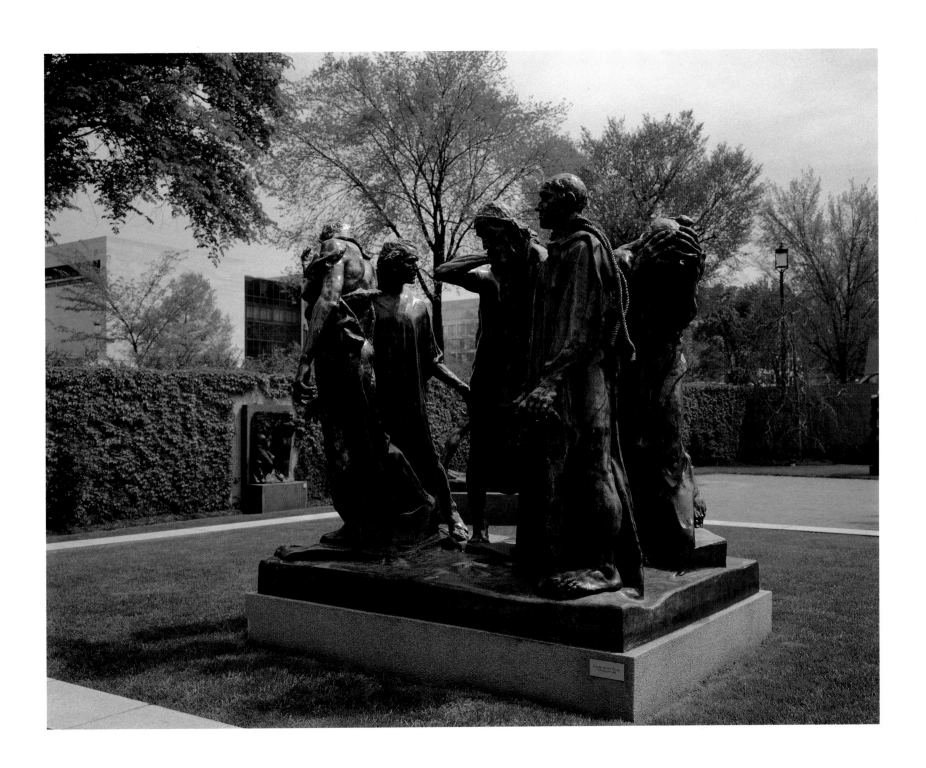

Mary Cassatt
American, 1844–1926

Young Girl Reading, c. 1894
Pastel on paper, 21⁷⁄₁₆ x 17⁷⁄₈ in. (54.5 x 45.5 cm)
Joseph H. Hirshhorn Bequest, 1981 (86.853)

Mary Cassatt composed paintings and pastels with a careful concern for design and organization. She lived most of her life in Paris, where she exhibited with the Impressionists, and while she was interested in visually exploring technique and theory, she was more concerned with recording real, contemporary experience. The Impressionists, especially Claude Monet, were preoccupied with the "atmosphere" that surrounded forms. They used brushstrokes of pure pigment and eliminated black from their palettes; they also rejected the traditional modeling techniques as a means to give the illusion of depth. In the resulting images, shapes often dissolve into vibrating patterns of colors. Cassatt, on the other hand, created strong forms and solid structures in her paintings by using light and color to fashion her subjects.

In *Young Girl Reading* the motif of a woman reading is transformed into a metaphor for mental activity. Cassatt's focus is on the reader's concentration. Omitting appealing details of body and dress, Cassatt instead built up the tones of the face and hands with diagonal strokes of chalk, which she applied thickly to give the impression of flesh. In contrast, she treated the garments and the background more broadly. By approaching her images concretely and sympathetically, Cassatt declared that women should be portrayed as individuals, not as formal decorative objects. Her paintings and pastels challenged the stereotypical presentations of women that commonly appeared in the art of the late nineteenth century. FG

Thomas Eakins
American, 1844–1916

Mrs. Thomas Eakins, c. 1899
Oil on canvas, 20⅛ x 16⅛ in. (51 x 40.8 cm)
Gift of Joseph H. Hirshhorn, 1966 (66.1522)

A native of Philadelphia, Thomas Eakins studied at the Pennsylvania Academy of the Fine Arts and attended anatomy lectures at Jefferson Medical College, early demonstrating his combined interests in art and methodical scientific observation. He attended the École des Beaux-Arts in Paris and traveled in Spain, where he studied the paintings of seventeenth-century Spanish masters such as Diego Velázquez and Jusepe de Ribera. After returning to Philadelphia, Eakins taught at the Pennsylvania Academy and became its director in 1882. Forced to resign in 1886 after a series of scandals about his personal life and for teaching anatomy based on nude models, Eakins thereafter devoted his career primarily to painting portraits. His later portraits were often considered unflattering, and many were rejected by his sitters.

Susan Macdowell (1851–1938) was a promising art student when she married Eakins in January 1884. Although she abandoned her own public career, she continued to paint and became a skilled photographer. The austere realism in Eakins's depiction of his wife, with its unrelenting attention to the lines of her face and graying hair, characterize the style of his late works.

After his death, the gritty realism he had advocated influenced a younger group of painters, including George Bellows and John Sloan, who believed in portraying the harshness of modern life instead of idealized, academic subjects. PR

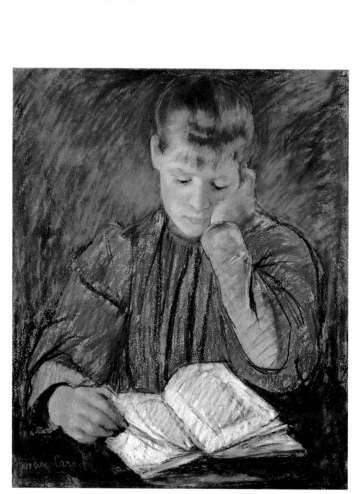

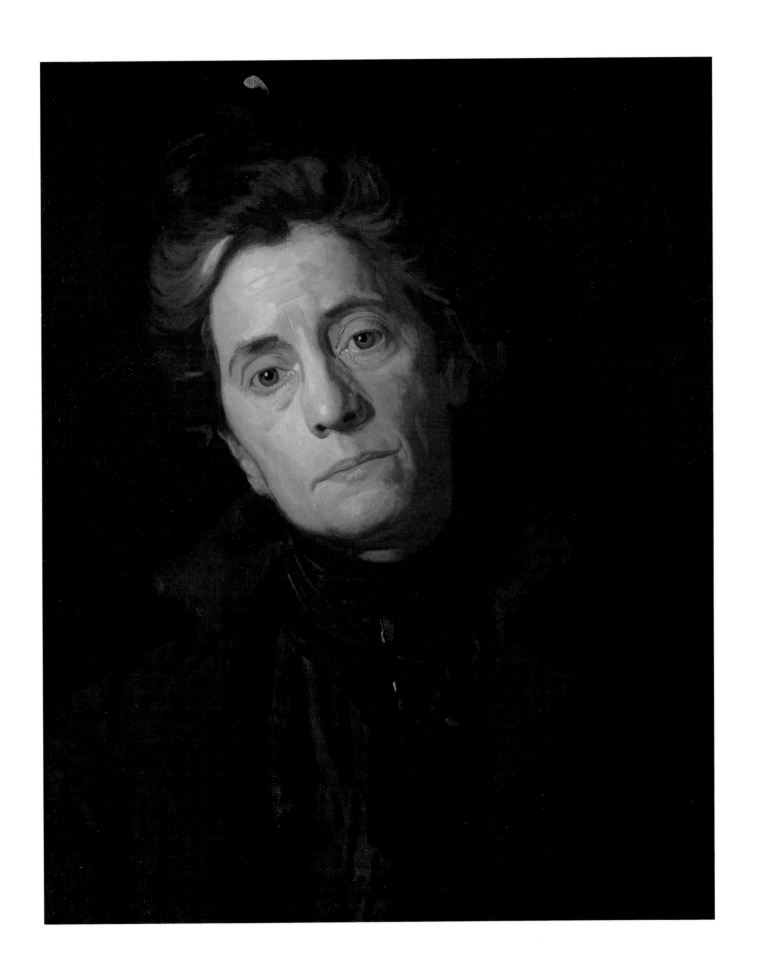

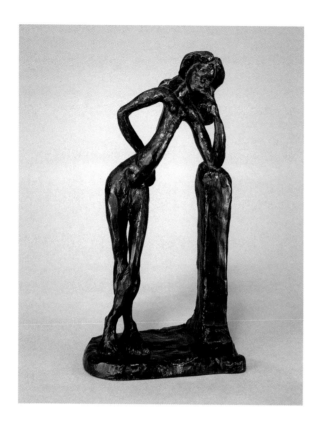

Henri Matisse

French, 1869–1954

Serpentine Figure, 1909

Bronze, 6/10, cast c. 1948
22⅛ × 11⅜ × 7½ in. (56 × 28.8 × 19.1 cm)
Gift of Joseph H. Hirshhorn, 1972 (72.197)

Best known for his brilliantly colored paintings, Henri Matisse worked in various media, including prints, paper collages, and stained glass. From 1899 to 1930 he modeled more than seventy sculptures in clay for casting into bronze. He sculpted primarily as a means of clarifying his ideas about form, particularly when he experienced difficulties in painting. Matisse once stated: "I took up sculpture … for the purpose of organization, to put order into my feelings, and to find a style to suit me. When I found it in sculpture, it helped me in painting."

Initially influenced by the works of Auguste Rodin, Matisse transformed that sculptor's emphasis on contorted poses and emotional drama into his own more formal and dispassionate style, particularly in his series of female nudes dating from 1906 to 1913. In *Serpentine Figure* he explored the rhythmic flow and interplay of forms and voids, a concern that preoccupied him in the contemporaneous paintings *Dance I* and *Dance II*. The sculpture's composition was based on a photograph of an academic model in a classical contrapposto stance. Matisse kept the pose, even her coquettish gesture of one finger on the lips, but he completely transformed the source from plump flesh into thin, nearly linear forms—a distortion of feminine anatomy that outraged critics when it was exhibited in 1912. The slender body became a three-dimensional arabesque, with the curving and angled forms of arms, torso, and legs harmoniously arranged in a rhythmic counterpoise of movements. VJF

Henri Matisse

French, 1869–1954

Back I–IV, 1909–31

Bronze, 0/10, cast c. 1959–60
Back I (1909): 74¾ × 46¼ × 8⅜ in. (189.9 × 117.5 × 21.2 cm)
Back II (1913): 75 × 47⅝ × 8½ in. (190.5 × 121. × 21.6 cm)
Back III (1916–17): 74⅜ × 45⅜ × 6 in. (188.9 × 115.2 × 15.2 cm)
Back IV (1930–31): 74⅜ × 45 × 6¼ in. (188.9 × 114.1 × 15.9 cm)
Gift of Joseph H. Hirshhorn, 1966 (66.3461–64)

Most of Henri Matisse's sculptures are modest in scale, but in 1909 he made his first life-size figure. By choosing relief, rather than in-the-round sculpture, he could explore in solid yet two-dimensional format the problems of style that challenged him in various paintings at that time. The initial version (known as *Back 0*) no longer exists; it was destroyed when Matisse remade it into *Back I*. Both versions presented an expressively modeled nude with muscular anatomy and contorted pose—features that he had absorbed from Auguste Rodin's art. Matisse's arduous efforts to create reductivist yet powerful nudes in large paintings in 1909–10 prompted him to return to the relief sculpture to help define his forms. Making a plaster cast of *Back I*, he completely remodeled the figure into simplified, stylized shapes. He subsequently used the same method—modifying a plaster cast of the preceding version—for *Back III* and *Back IV*. The successive revisions produced increasingly geometric and solid figures of massive proportions—comparable to developments in his painting and anticipating his later paper cutouts. Although the *Back* sculptures were not originally created as a series (they were not exhibited together during the artist's lifetime), they effectively chronicle the evolution of his style toward greater clarity and strength. VJF

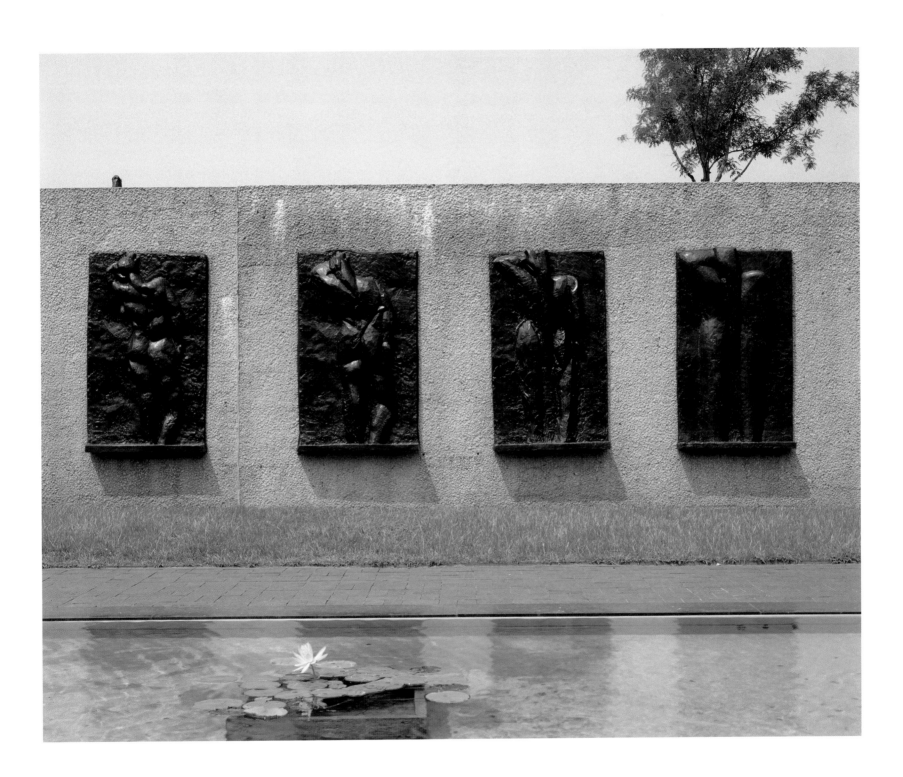

Paul Gauguin

French, 1848–1903

Cylinder with Hina and Two Attendants, 1891–93

Tamanu wood with gilt

14⁵/₈ x 5¹/₄ x 4¹/₄ in. (37.1 x 13.4 x 10.8 cm)

Museum purchase with funds provided by Smithsonian

Collections Acquisition Program, 1981 (81.1)

Although best known for his vivid paintings, Paul Gauguin created more than 150 sculptures. Rejecting traditional European methods of marble carving and bronze casting, he began to work in wood in 1880 and in ceramic by 1886. Believing that art should present an imaginative and evocative vision rather than describe observed reality, Gauguin daringly synthesized European images and ideas with elements from such diverse sources as Breton folk art, Japanese woodcuts, Buddhist sculpture, Pre-Columbian pottery, and Oceanic mythology. His style is distinguished by simplified forms with strong outlines unified by sinuously rhythmic designs.

During his first sojourn in Tahiti from June 1891 to June 1893, Gauguin worked with local materials and subjects. In tribute to Maori and Marquesan carvers, he used low-relief, curved shapes that undulate around a solid log in stylized patterns, and he valued visible carving marks. Although indigenous culture had been mostly eradicated by European colonists, Gauguin wanted to portray Polynesian religious beliefs, mingled with European analogies. This sculpture depicts Hina, the Tahitian moon goddess who had tried and failed to obtain immortality for humanity but in compensation had enabled the species to procreate. As a symbol of physicality and fertility, Hina appealed to Gauguin, who created an eclectic appearance: her face has Polynesian features while the body proportions and arm gesture descend from Buddhist sculpture, which Gauguin had studied in Paris (Hina's attendant figures may have been derived from photographs of reliefs at Borobudur in Java). Gauguin's primitivist approach influenced later artists to seek inspiration in non-European cultures. VJF

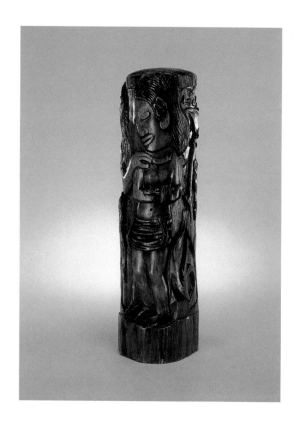
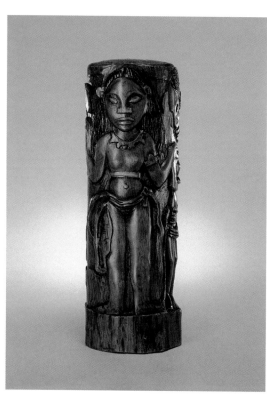
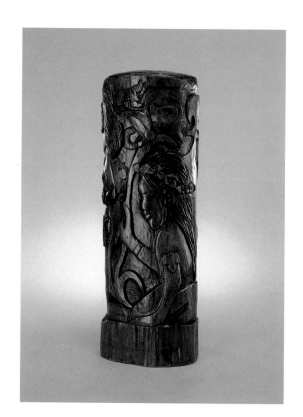

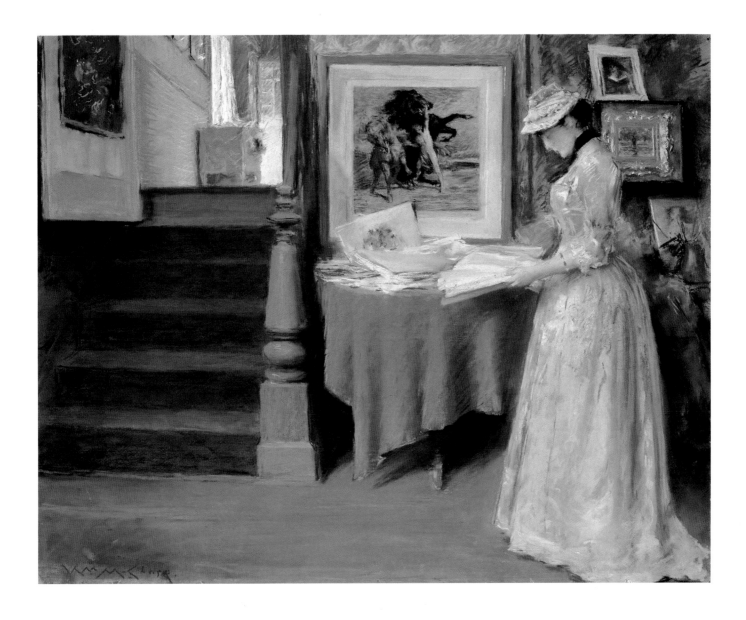

William Merritt Chase

American, 1849–1916

In the Studio, c. 1892–93

Pastel on paperboard, 22 × 28 in. (55.9 × 71.1 cm)

Gift of Joseph H. Hirshhorn, 1966 (66.878)

Comparable in size, complexity, and finish to his oil paintings, the pastel works by William Merritt Chase depict scenes of family and friends. Chase, whose painting style was akin to that of the Impressionists, liked the convenience of pastels. His handling of the medium, combined with his perceptive understanding of his subject, helped establish his reputation as a major artist.

Here, Chase has portrayed his wife, Alice, in his studio in Shinnecock, Long Island. The furnishings reveal his artistic interests. A blue Japanese fabric hanging on the open door at the top of the stairs reflects a fascination for the exotic, a preoccupation that he shared with many Europeans and Americans of the time. An engraving of Alexandre Regnault's painting *Automedon with the Horses of Achilles*, 1868, is seen on the wall behind the table. Chase's treatment of light contributes to the warmth of this pastel. Sunlight from a window illuminates the hall, while light from another source reflects off a gold frame at the right and subtly touches the figure's white dress. Chase adapted the devices of asymmetry and implied space that had found their way into some European art via Japanese prints. The artist's vantage point, for example, and the placement of the figure, balanced by the partially seen upstairs hall, show such influence. Chase's interior, while not as ambiguous as those in some Japanese prints, exhibits a manner of expanding space not common in American art. FG

Auguste Rodin

French, 1840–1917

Balzac, 1891–98

Bronze, 6/12, cast 1965–66
106 × 43 × 50³/₈ in. (269.2 × 109.2 × 127.9 cm)
Gift of Joseph H. Hirshhorn, 1966 (66.4344)

In 1891, when Auguste Rodin received the commission for a monument honoring Honoré de Balzac (1799–1850), he welcomed the opportunity to reevaluate the norms for portrait statues. Balzac had elevated the novel to new levels of perception and subtlety in his series *La Comédie humaine,* and Rodin therefore believed he deserved an innovative portrayal. After examining photographs of Balzac, the sculptor spent six years creating more than fifty studies—ranging from heads to standing figures—that evolved into Rodin's romanticized interpretation of the subject. Rather than the standard statue of an author garbed in his best suit and holding a book—all rendered in meticulous detail—Rodin favored a potbellied male nude. But because that would have offended the public, he dressed the figure in the Dominican monk's robe that Balzac habitually wore while writing. Rising without interruption, the robe dematerializes the body, forcing attention upward to the dramatic head. There Rodin concentrated expressive energy in the prominent facial features, disordered hair, and deeply hollowed eye sockets that remain in shadow even in brightest daylight—a visionary image of a writer transfigured by inspiration. This nontraditional portrait annoyed the commission's officials, who rejected the full-size plaster as an unfinished sketch. The severest critics likened it to a penguin, a snowman, and a sack of coal. Rodin therefore kept the plaster at his studio, where it was immortalized in evocative photographs by Edward Steichen, but no bronzes were cast until long after Rodin's death. VJF

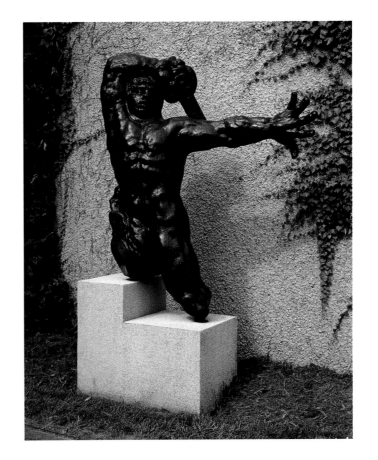

Émile-Antoine Bourdelle

French, 1861–1929

The Great Warrior of Montauban
1898–1900

Bronze, 3/10, cast 1956
73¹/₄ × 62 × 24¹/₈ in. (186 × 157.2 × 61.3 cm)
Gift of Joseph H. Hirshhorn, 1966 (66.593)

In 1893, Émile-Antoine Bourdelle began a fifteen-year stint as studio assistant to Auguste Rodin, whose expressive figure style at first influenced his own. In that same year, Bourdelle made studies for the proposed *Monument to the Defenders of Tarn-and-Garonne in the War of 1870* for his hometown of Montauban in southwestern France. After receiving the official commission four years later, he devised a multifigure composition in which a warrior strides dramatically to the right while reaching back to his left to support a female figure symbolizing France. This grouping paid homage to François Rude's famous relief *La Marseillaise* of 1830 for the Arc de Triomphe, Paris, which venerated the participants in the first French Revolution of 1789.

Following Rodin's practice of using fragments of large compositions to generate independent works, Bourdelle created *The Great Warrior of Montauban,* which gained renown as a more powerful work than the final monument. The figure has been pared down to the elements most essential to express the heroism and desperate urgency of the defenders in the Franco-Prussian War of 1870, when France was invaded and ignominiously defeated. With a generalized face to indicate his anonymity, the warrior tenses his muscular torso while stretching out a massive arm and huge splayed hand, as if to hold back the invaders. In this work, which anticipates his mature style from 1910 forward, Bourdelle integrated the expressive content with a rhythmic patterning of forms and made the image frontal and two-dimensional to emphasize the dramatic silhouette. VJF

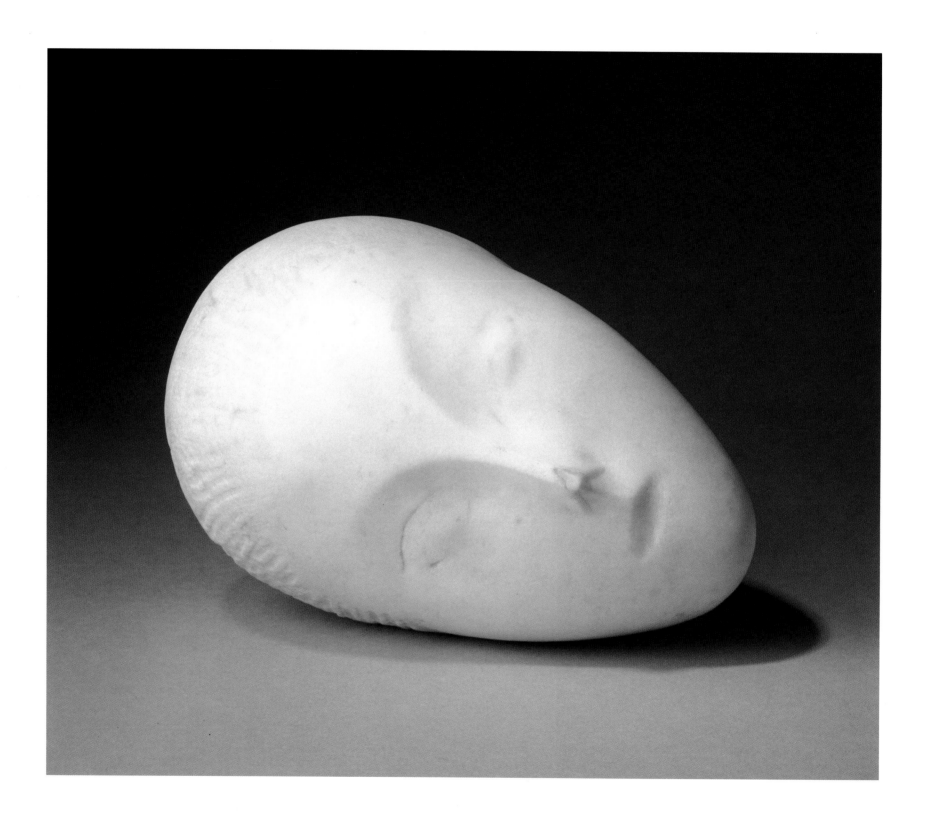

Constantin Brancusi

Romanian, 1876–1957

Sleeping Muse I, 1909–10

Marble, 6³/₄ × 10⁷/₈ × 8³/₈ in. (17.2 × 27.6 × 21.2 cm)

Gift of Joseph H. Hirshhorn, 1966 (66.610)

Fascinated throughout his career by the theme of a reclining sleeping head, Constantin Brancusi refined the motif of the sleeping muse for more than a decade. In preliminary compositions such as *Repose,* 1906, and *Sleep,* 1908, he emulated Auguste Rodin's marble carvings of dreaming or contemplative female heads. But Brancusi deliberately developed a coolly dispassionate style quite unlike that of Rodin's emotionally expressionist sculptures, with their contorted poses and distraught faces. Instead, Brancusi simplified a subject into its most elemental shape, synthesizing the original figurative reference with the then-new formalist discipline of abstraction.

In 1908–09, Brancusi sculpted two portraits of Baroness Renée Frachon, whose elongated oval face, thinly arched eyebrows, diminutive nose, and chignon hairstyle became the inspiration for the Hirshhorn's *Sleeping Muse I.* In this sculpture, Brancusi made the crucial transition from descriptive naturalism to abstract purity of form. The subtly delineated facial features do not interrupt either the contour or the surfaces of the head. Without overt reference to a body or subject, the image seems inner-directed, its pristine features and closed eyes conveying a classical sense of serene detachment and repose. The title implies the limitless realm of dreams and inspiration, while the white ovoid shape also evokes associations with an egg—a symbol for the potentialities of future life and growth. In subsequent versions, particularly two stone heads from 1917–18, Brancusi emphasized that analogy by further minimizing the descriptive details, a trend that culminated in the purely abstract ovoid *Beginning of the World,* 1920. VJF

Pablo Picasso

Spanish, 1881–1973

Head of Fernande Olivier, 1909

Bronze, 1/9, cast 1960, 16 × 9³/₈ × 10³/₈ in. (40.9 × 24 × 26.2 cm)

Gift of Joseph H. Hirshhorn, 1966 (66.4050)

Although the conceptual approach and geometric style of Cubism were originally formulated in painting, their development had much to do with the study of three-dimensional forms. Influenced by African carvings, Pablo Picasso in 1907–08 devised a simplifying, analytic mode that he and Georges Braque developed into Cubism. From spring through autumn in 1909, Picasso concentrated on a series of drawn and painted portraits with increasingly stylized and fragmented forms, culminating in *Head of Fernande Olivier,* which is now recognized as the first Cubist sculpture.

As he did in his paintings, Picasso broke solid surfaces into geometric forms and exaggerated the natural curves of cheeks, eyes, hair, and neck into a rhythmic pattern of faceted convex and concave volumes with an accentuated linear pattern. Although the head has a strong central mass, the sharp ridges and recessed furrows create contrasts of light and shadow over the surface.

Cubism rapidly exerted an extraordinary influence on artists from Paris to England, Italy, Russia, the United States, and other countries, and *Head of Fernande Olivier* had a considerable impact. In addition to Parisians such as Jacques Lipchitz and Raymond Duchamp-Villon, the Italian Futurist Umberto Boccioni knew the work by 1911, Oto Gutfreund studied a bronze in Prague in 1910–11, and many American artists saw a plaster in the New York Armory Show of 1913. VJF

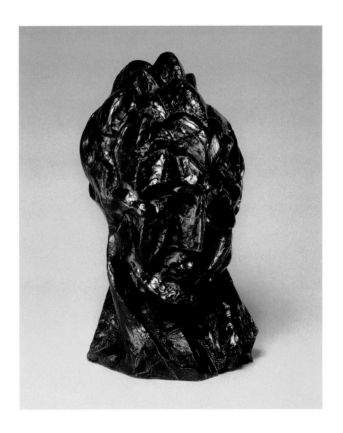

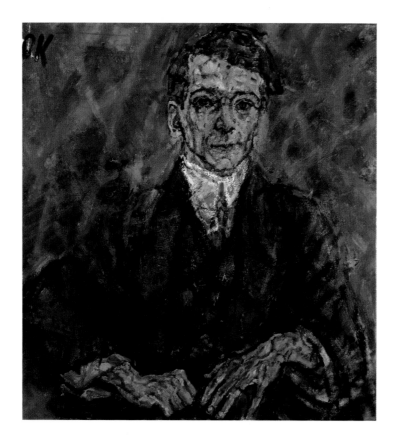

Oskar Kokoschka

Austrian, 1886–1980

Egon Wellesz, 1911

Oil on canvas, 29³/₄ × 27¹/₈ in. (75.5 × 68.9 cm)

Gift of the Joseph H. Hirshhorn Foundation, 1966 (66.2776)

In the years before World War I, Oskar Kokoschka attempted to capture the spiritual life of Vienna by portraying the leaders of the city's cultural elite. He explained, "The people lived in security yet they were all afraid. I felt this through their cultivated form of living, which was still derived from the Baroque; I painted them in their anxiety and pain." The likeness of the composer and musicologist Egon Wellesz (1885–1974) belongs to this early series. Kokoschka met Wellesz while both were teaching at a progressive Viennese school. Their mutual friends included the architect

Adolf Loos, Gustav Mahler's widow, Alma, and the art historians Hans and Erika Tietze, all of whom were subjects of Kokoschka's portraits. Wellesz, an authority on Byzantine music, was among the first pupils of the vanguard composer Arnold Schoenberg, who championed atonalism and the twelve-tone row. In his autobiography Kokoschka recalled that while sitting for his portrait, Wellesz discussed the underlying connection between Schoenberg's twelve-tone scale and Indian and Chinese music.

Kokoschka depicted Wellesz posed against a neutral background. Using subtle gradations of color to model the figure, he achieved a characteristically opaque palette. He created hues of opalescent gray by studying the effects of colors of the spectrum produced with a prism. Flecks of color and faceted planes suffuse the portrait with nervous energy. The distorted forms convey intense emotion and typify Kokoschka's expressive and symbolic approach. JZ

John Sloan

American, 1871–1951

Carmine Theater, 1912

Oil on canvas, 26¹/₈ × 32 in. (66.1 × 81.2 cm)

Gift of the Joseph H. Hirshhorn Foundation, 1966 (66.4616)

On January 25, 1912, the New York painter John Sloan recorded in his diary: "Out for a walk, down to Bleecker and Carmine Sts. where I think I have soaked in something to paint." Working quickly from memory, Sloan produced a small sketch, and within days he had completed the oil painting *Carmine Theater*. His deceptively casual rendition of a scene of urban street life typifies the style and subject matter of the so-called Ashcan School. Following the precepts of his mentor Robert Henri, Sloan chose to depict the everyday life of New York's masses, particularly the residents of the Lower East Side and Greenwich Village.

This scene represents a movie house located on Carmine Street in Greenwich Village, where Sloan had observed "wistful little customers hanging around a small movie show." Sloan's training as a newspaper illustrator in Philadelphia made him adept at memorizing, and later capturing on canvas, visual anecdotes gleaned from his urban surroundings. Although he worked in a rapid, almost sketchy style, his paintings were carefully structured. The composition of *Carmine Theater* is dominated by the cream-colored arches of the theater entrance that frame the small figures of neighborhood children and a nun who approaches from the shadows at the left. Details such as the fire escape on the brick building, the dressmaker's model on the sidewalk, and the dog rummaging through an overturned trash can evoke the visual richness of the city environment. JZ

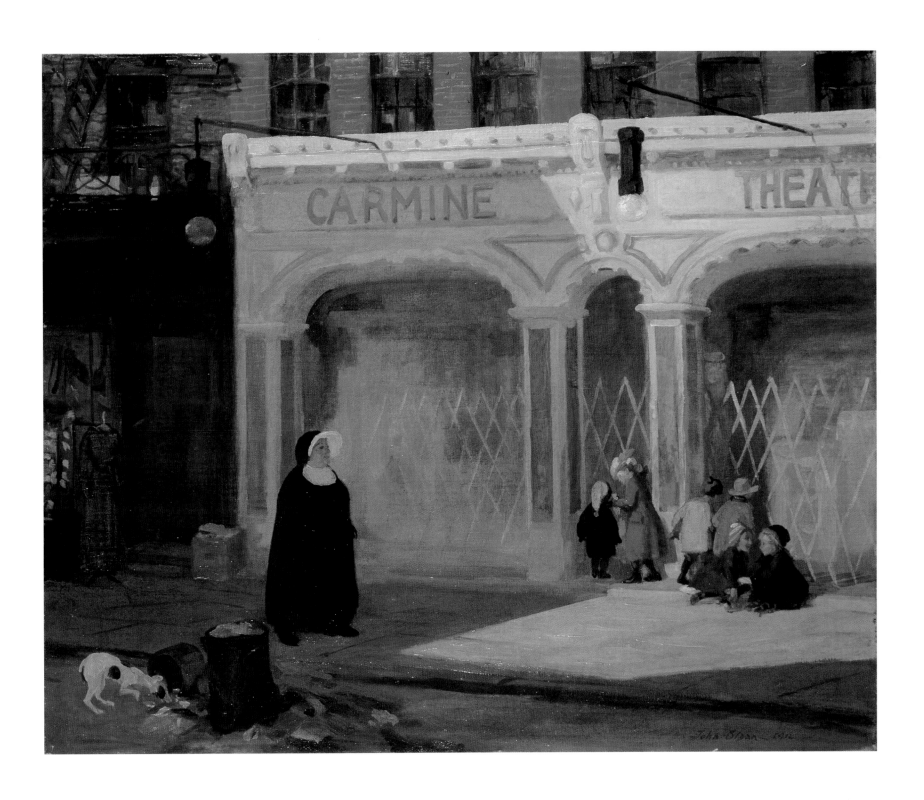

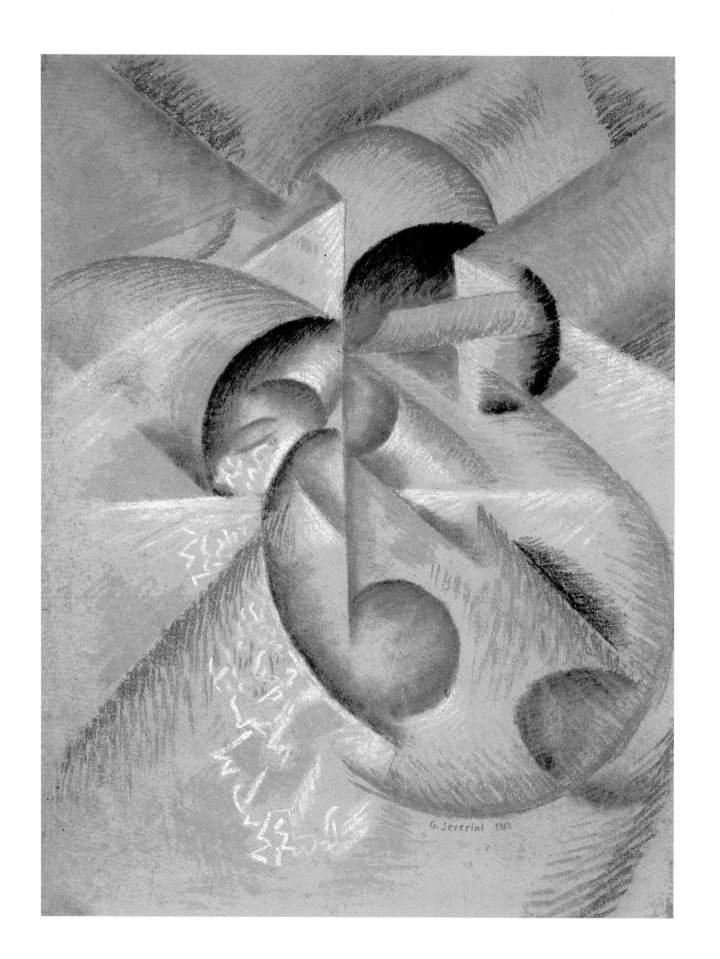

Gino Severini

Italian, 1883–1966

Dynamic Rhythm of a Head in a Bus, 1912

Pastel, charcoal, and pencil on paper
25 1/8 × 19 5/16 in. (63.8 × 49 cm)
Joseph H. Hirshhorn Bequest, 1981 (86.4208)

When he moved to Paris in 1906, Gino Severini became friends with members of the Parisian avant-garde, including Amedeo Modigliani, Juan Gris, and Pablo Picasso, but his strongest intellectual ties were in Turin and Milan. In 1910 he joined the Futurists, a group of Italian artists who planned to replace tradition with stylistic innovations in all avenues of artistic expression. Responding to this vanguard mandate, Severini created works that combined Futurist theories of dynamism with the multiple perspectives of Cubism. He developed an original painting style celebrating modern life with color and fluid geometric rhythms reflecting his optimism for the new century.

Dynamic Rhythm of a Head in a Bus, which presents in abstract forms the head of a passenger in a bus in various positions at once, evokes the experience of movement and the passage of time. This changing reality, or "dynamic rhythm," of life was the essence of Futurist art. The counterbalance of variously directed cylindrical and flat shapes creates a compelling vitality, the horizontal and vertical lines in the center contrasting with diagonal lines that imply speed and force. A transparent plane intruding from the left converges with other central elements, including the curved forms that imply a counterclockwise motion. The white squiggly lines in one such element suggest sound or jarring movements.

The avant-garde regarded the machine as an untapped source of artistic inspiration. Severini's choice of subject for his pastel was consistent with Futurist theories and reflected the vanguard enthusiasm for the dynamic energies of contemporary life and the Machine Age. FG

Oto Gutfreund

Czech, 1889–1927

Cubist Bust, 1912–13

Bronze, 4/6, cast early 1960s
24 1/2 × 23 1/4 × 17 3/4 in. (62.2 × 58.9 × 45 cm)
Partial gift of Mr. and Mrs. Jan V. Mladek and
Joseph H. Hirshhorn Purchase Fund, 1987 (87.9)

Although Oto Gutfreund had learned of Cubism while studying in Paris in 1909–10, he created his most innovative sculptures in that style between 1911 and 1914 in Prague during his membership in the avant-garde Skupina Vývarných Umělcu (Group of Creative Artists). Differing from works by Georges Braque and Pablo Picasso that were exhibited in that city in 1912–13, Gutfreund's prewar heads and figures paralleled and even anticipated developments among Parisian Cubists, German Expressionists, and Italian Futurists.

Originally titled *Head IV,* the Hirshhorn bust is the last in a series of portraits of the artist's father, who died in September 1912. In it, Gutfreund made a radical break with the centuries-old tradition of modeling a figure. The sculpture has neither the naturally solid mass of a head nor the surface facets of early Analytical Cubist works. Rather, the artist used compositional elements analogous to those in architectural construction: girderlike supports and windowlike openings. As Gutfreund noted in his diary around 1910–11: "To be a sculptor, it is not enough to be able to model; a sculptor must be a mathematician who fashions his material according to a preconceived plan, thus also an architect." Gutfreund devised complex interpenetrations of geometric volumes and voids, so that space functions as an integral and active component. This liberation of sculpture from solid mass presaged the openwork compositions of Russian and German Constructivists in the 1920s. VJF

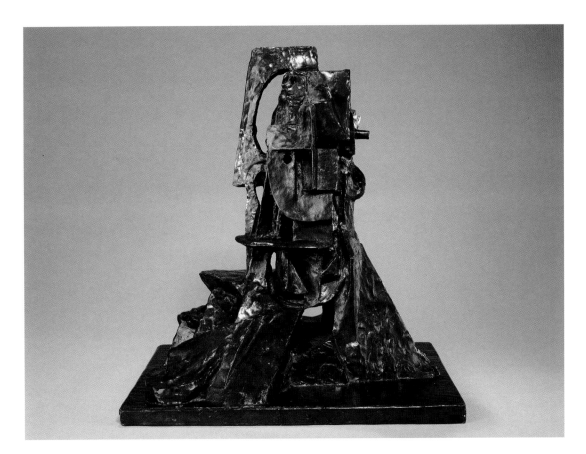

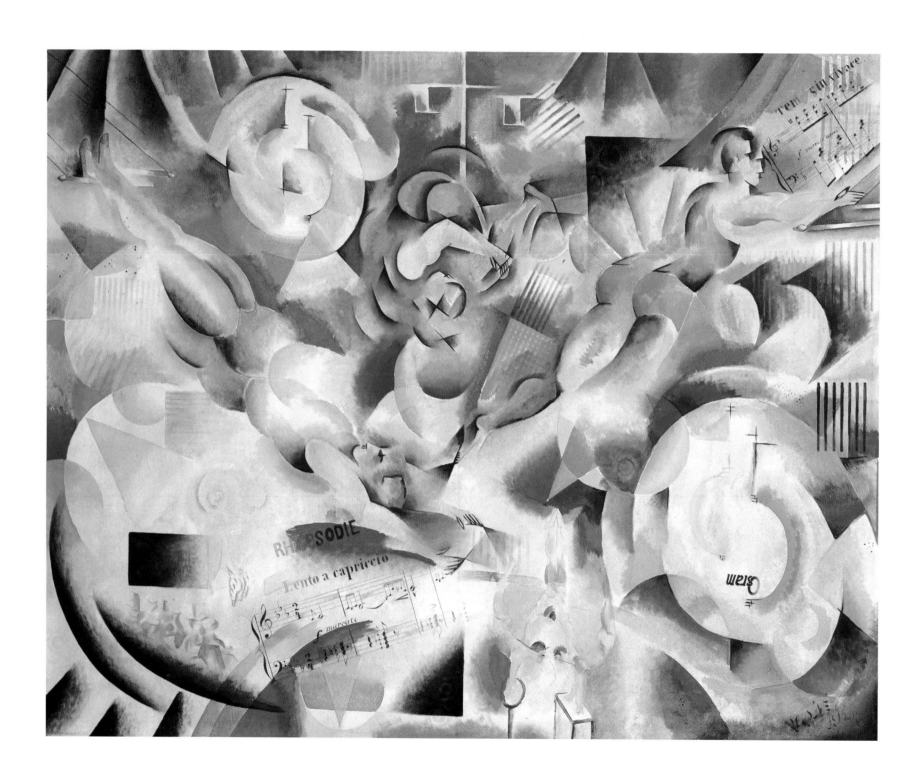

Daniel Vladimir Baranoff-Rossiné

Russian, 1888–1944

Capriccio Musicale (Circus), 1913

Oil and pencil on canvas

51³/₈ × 64¹/₄ in. (130.4 × 163.1 cm)

Gift of Mary and Leigh B. Block, 1988 (88.8)

First exhibited in 1914 in Paris and Amsterdam, Daniel Vladimir Baranoff-Rossiné's *Capriccio Musicale (Circus)* unites two favorite motifs in modern art: the circus and music. A kaleidoscopic array of swirling shapes captures the rhythmic movement of three trapeze artists performing to music under spotlights. Below the aerialists, in the lower left corner, the circus audience is indicated by a few deft strokes of gray paint. Faintly discernible at the bottom center, three acrobats perform their precarious routine far below the trapeze act.

After sketching the entire composition in pencil, Baranoff-Rossiné used a spray technique over stencils to cover the surface with a subtle pattern of tinted disks and grids. The circus scene is merged into a dynamic design of glowing pastel colors. Baranoff-Rossiné's successful simulation of movement typified the abstract styles of Cubo-Futurism and Orphism, with their simultaneous representations of shifting perspectives and prismatic colors.

Fascinated by the analogy between color and sound, Baranoff-Rossiné intensified the sensual atmosphere of his painting with specific allusions to music. In the lower left he inscribed the score for the opening measure of Franz Liszt's Hungarian Rhapsody no. 2 in C Minor, and he added another, unidentified score in the upper right. He may have intended the inscribed word "OSRAM" (a German electrical company) to symbolize his own experiments with electric piano for his *Piano Optophonique*. In its innovative spray technique and evocative musical analogy, *Capriccio Musicale (Circus)* epitomized the adventurous spirit of the European vanguard in the early twentieth century. JZ

Stanton Macdonald-Wright

American, 1890–1973

Conception Synchromy, 1914

Oil on canvas, 36 × 30¹/₈ in. (91.3 × 76.5 cm)

Gift of Joseph H. Hirshhorn, 1966 (66.3189)

Conception Synchromy embodies Stanton Macdonald-Wright's principles of pure color composition. In 1913 he explained his theory in a statement for an exhibition at the Bernheim-Jeune Gallery in Paris:

> Form is expressed in my mind as color.… Each color has a position of its own in emotional space and possesses a well-defined character. I conceive space itself as endowed with a plastic significance that is expressed by color. Since form is not the volume of each object seen separately, I organize my canvas as a block, as much in depth as in surface.… Space is expressed by a spectrum that somehow unfolds in the sense of depth.

Accordingly, he arrayed prismatic color disks in a kaleidoscopic design to create a sense of simultaneous movement within space. In collaboration with Morgan Russell, Macdonald-Wright developed a style of abstraction based on color theories, an interest he shared with Robert Delaunay and the Orphists. Macdonald-Wright also studied in Paris with the Canadian artist and color theorist Ernest Tudor-Hart.

Macdonald-Wright's title alludes to the musical analogy that supported such color theories. The term *synchromy* literally means "with color" just as *symphony* means "with sound." The artist also intended that the painting evoke the mystery of creation. Both he and Russell often conjured such themes through the titles of their abstract canvases. In *Conception Synchromy*, Macdonald-Wright transformed the spectrum bands and color wheels of the theorists into the visual equivalent of the mythical music of the spheres. JZ

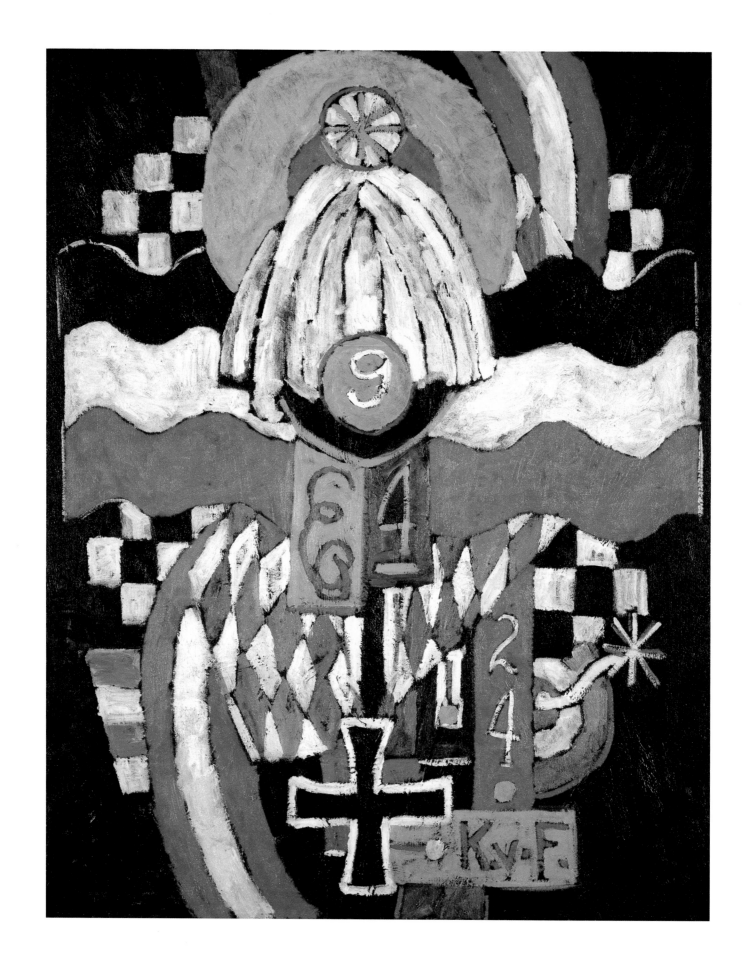

Marsden Hartley

American, 1877–1943

Painting No. 47, Berlin, 1914–15

Oil on canvas, 39½ × 31⅝ in. (100.1 × 81.3 cm)
Gift of Joseph H. Hirshhorn, 1972 (72.148)

Created in Berlin during World War I, *Painting No. 47, Berlin* belongs to Marsden Hartley's renowned series of abstract "officer portraits." Fusing the brilliant colors and emblems of German military dress into a bold composition, Hartley transformed fragmented imagery, derived from the Synthetic Cubist paintings of Pablo Picasso, into a work of symbolic and emotional power. In response to the rising anti-German sentiment in the United States before the American entry into World War I, Hartley initially denied the symbolism implicit in the series. Yet *Painting No. 47, Berlin* is clearly a memorial portrait of Hartley's intimate friend Karl von Freyburg, a German officer killed in action in October 1914. The initials "KvF" appear in the lower center of the painting; "E," "4," and "9" signify von Freyburg's regiment, and "24" represents his age at the time of his death. The artist arrayed the military accouterments of his slain friend in a symmetrical composition. The helmet with tassels, epaulets, spur, and the hues of the German flag evoke the pomp and ceremony of the Prussian military. The Iron Cross, featured prominently in the painting, was awarded to the young officer the day before he died in battle. In his use of black, the traditional color of mourning, for the background, Hartley provided a somber counterpoint to the colorful military regalia. In this symbolic portrait, the American artist paid tribute to his friend and, by extension, to the lost youth of World War I. JZ

Childe Hassam

American, 1859–1935

The Union Jack, New York, April Morn, 1918

Oil on canvas, 36 × 30⅛ in. (91.3 × 76.5 cm)
Gift of Joseph H. Hirshhorn, 1966 (66.2402)

In *The Union Jack, New York, April Morn,* Childe Hassam commemorated the first anniversary of the United States' entry into World War I. The painting belongs to the renowned "Flag" series of about two dozen cityscapes that he produced between 1916 and 1918, at the height of the war. Hassam was inspired by the panoply of Allied flags that were customarily displayed on the buildings along Fifth Avenue, New York's principal thoroughfare for parades and civic celebrations. His choice of subject matter evolved naturally from his prewar interest in street scenes and flag imagery. As early as 1910 in the painting *July 14, Rue Daunoue,* Hassam had depicted a flag-filled Paris street on Bastille Day, and he re-created that holiday spirit in a New York street scene, *Fourth of July, 1916.*

In his "Flag" series of 1916–18, Hassam infused such urban scenes with patriotic symbolism in celebration of the Allied cause. In this canvas, Hassam depicted the British Union Jack and the American Stars and Stripes dominating the pedestrian-filled avenue lined with tall buildings. The artist's deft, flickering brushwork evokes the bustle of the crowd, while his asymmetrical alignment of fluttering flags complements the rigid geometry of the skyscrapers bordering the avenue. In paintings such as *The Union Jack,* Hassam captured the vitality of a crowded city and the patriotic spirit of a nation. JZ

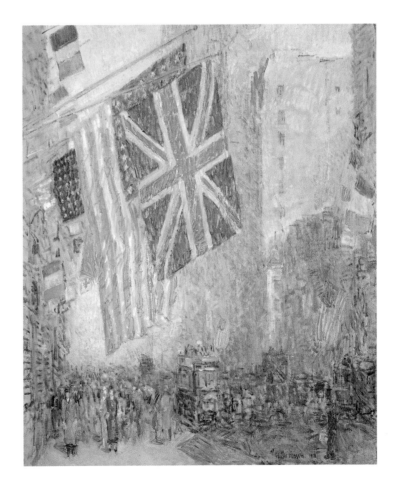

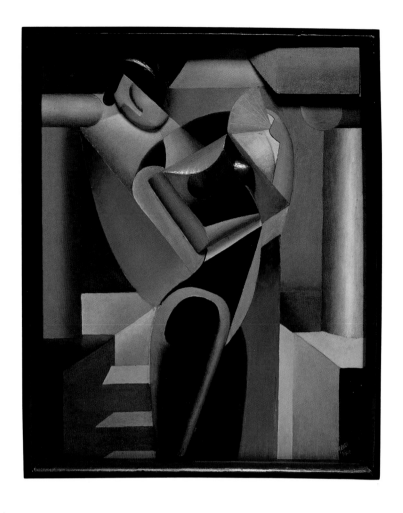

Walt Kuhn
American, 1877–1949

The Tragic Comedians, c. 1916
Oil on canvas, 96 x 45 in. (243.8 x 114.3 cm)

Gift of Joseph H. Hirshhorn, 1966 (66.2834)

A versatile artist and theater designer, Walt Kuhn played a significant role in the development of twentieth-century American art. *The Tragic Comedians* reveals his early mastery of modern figure composition and his fascination with the theme of the circus. Using a narrow canvas, he created an enigmatic double portrait of two larger-than-life circus performers. The stylized elongation of the figures endows them with an imposing presence. While the red-haired woman at the left turns away, her male companion gazes at the viewer from behind his sorrowful mask of white greasepaint. Kuhn's somber palette of umbers and ochers contributes to the brooding mood of the painting. He applied the paint in broad, flat areas accented with bold touches of red, blue, and white. The abstract color patterning is reminiscent of Kuhn's earlier exploration in Post-Impressionism. The elegant simplicity of the figures also recalls the paintings of such modern artists as André Derain and Ernst Ludwig Kirchner. Kuhn, one of the organizers of the Armory Show in 1913, was well acquainted with European modernism.

Kuhn owed his lifelong enthusiasm for circus imagery in part to his mother's love of the theater. He was aware, too, of the venerable tradition of commedia dell'arte figure painting from the sixteenth through the eighteenth centuries and the harlequin imagery of Picasso. In *The Tragic Comedians,* Kuhn blended pathos with a forceful figural style to imbue a pair of anonymous circus performers with an engaging monumentality. JZ

Alexander Archipenko
American, born Ukraine, 1887–1964

Woman with a Fan II, 1915
Painted wood and fiberboard

18 1/8 x 14 3/4 x 1 in. (46 x 37.5 x 2.4 cm)

Gift of Joseph H. Hirshhorn, 1966 (66.80)

Soon after emigrating from Moscow to Paris in 1908, Alexander Archipenko became involved with a group of artists eager to define and disseminate the radical new style known as Cubism. Developing ideas introduced by Pablo Picasso and Georges Braque, they created works comprising boldly simplified geometric forms. A crucial Cubist concept was to merge the traditionally separate media of painting and sculpture. Working in Paris and Nice, Archipenko achieved a remarkable fusion of media in a series of reliefs called sculpto-paintings, starting with *Woman with a Fan I* in 1914 (Tel Aviv Museum).

Usually constructed of wood and painted in vivid colors, the sculpto-paintings deceive the eye by creating an optical illusion that confuses painting with tangible forms. In *Woman with a Fan II,* for example, the figure's left arm and leg are painted flat surfaces, while her right arm and leg protrude; the one-sided weightiness is offset by other high-relief forms on her left side (hair and breast). The architectural setting is almost entirely two-dimensional, as Archipenko painted with linear perspective to establish an illusion of depth; he then emphasized the artificiality of that method by adding a solid relief element in the upper right. Such gentle challenges to the traditional concept of painting helped redefine modern sculpture as an intellectual construct rather than a means of copying observed reality. VJF

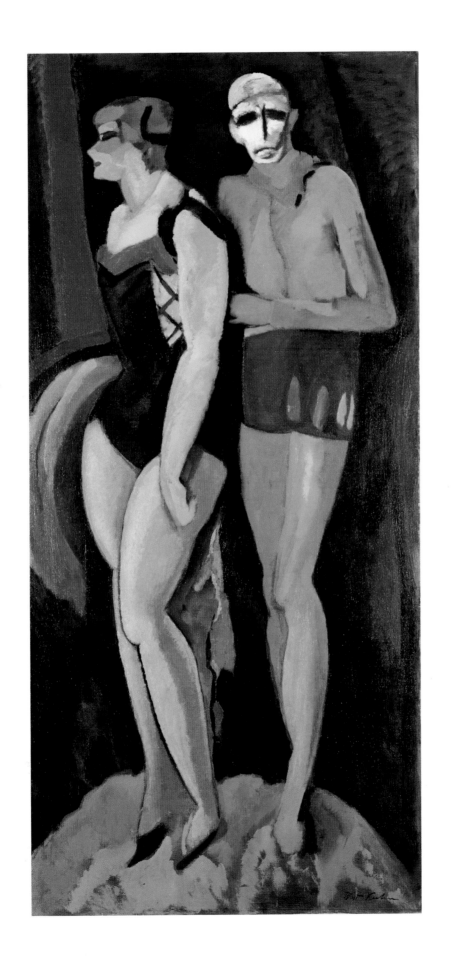

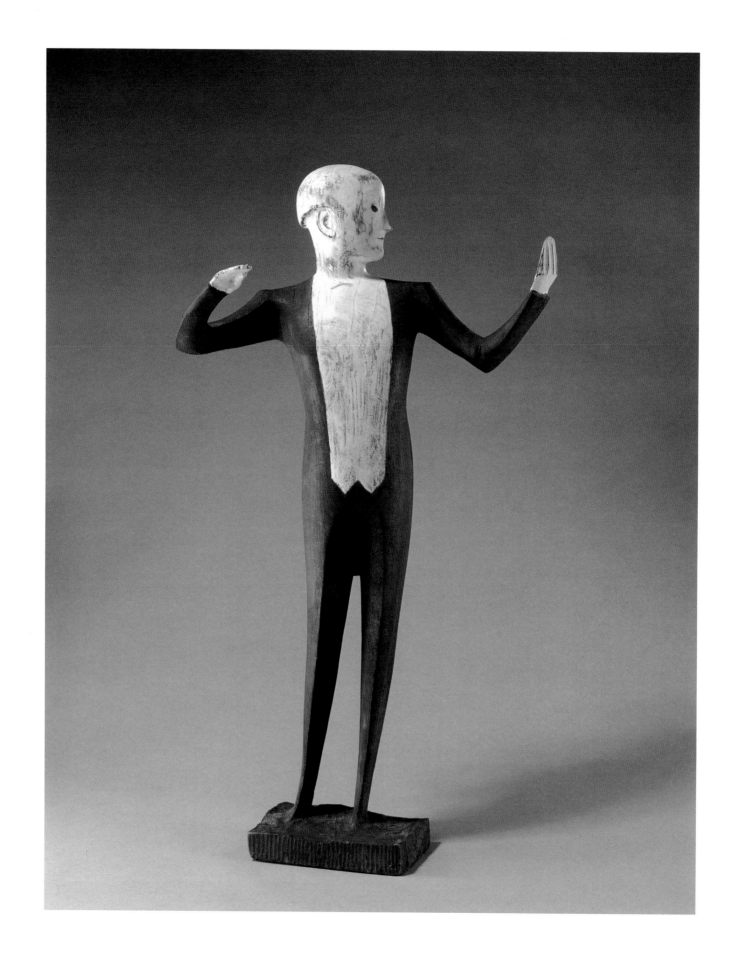

Elie Nadelman

American, born Poland, 1882–1946

Orchestra Conductor, 1918–19

Stained, gessoed, and painted cherry wood

38 1/2 × 21 1/4 × 11 3/4 in. (97.8 × 54 × 29.8 cm)

Gift of Joseph H. Hirshhorn, 1966 (66.3769)

After emigrating from Warsaw to Paris in 1904, Elie Nadelman developed in his sculpture simplified curvilinear shapes tending toward abstraction. Influenced by Art Nouveau and archaic Greek sculptures, he sought a classical modernism in his early female heads and nudes in marble and bronze. With the onset of World War I, Nadelman left for New York, where his subjects changed to contemporary men and women in everyday activities. A pioneering connoisseur of American nineteenth-century folk carvings, Nadelman incorporated their naïveté, humor, simplicity of gesture, and humble materials into his art. This "debasement" of his earlier classicizing style led the critics to reject his new sculptures as satirical and undignified when they were exhibited at Knoedler's Gallery in 1919. Today, however, his rare wood figures, which capture the gay insouciance of the pre-Depression era, are considered his most innovative contribution to modern art.

In Nadelman's original conception of *Orchestra Conductor*, the subject was intended to be a virtuoso violinist in the act of drawing the bow across his instrument. But Nadelman removed the violin and retitled the piece, using the arms to convey an impresario's upbeat gesture. Elegantly attired in his tuxedo, the orchestra leader epitomizes poise and concentration. Balanced on tiny feet, the slender body and legs have a fluid upward movement that gracefully bifurcates into the arms. VJF

Guy Pène du Bois

American, 1884–1958

The Lawyers, 1919

Oil on wood, 20 × 15 1/8 in. (50.8 × 38.2 cm)

Gift of Joseph H. Hirshhorn, 1966 (66.1443)

The Lawyers typifies the stylized realism that would win Guy Pène du Bois success as a chronicler of the "Roaring Twenties." He had studied under Robert Henri, the leader of the Independent realist movement, and he shared his teacher's credo that art must depict contemporary life. Whereas Henri and the painters of the so-called Ashcan School chose to portray the urban poor of the Lower East Side of New York, du Bois extended the range of realist subject matter to encompass the prosperous sophisticates of the urban upper classes.

The Lawyers was inspired by the artist's observation of Edward Stanchfield, a prominent member of the New York bar, challenging prospective jurors in a civil case. In his memoirs, du Bois explained, "The thing I had mainly sought to catch was the marked difference between the two actors on that stage, a difference between subtlety and brutality." Fittingly, du Bois silhouetted the legal pair against a jewel-like blue background that heightens the tension of the scene. The jury pool arranged across the background has become the audience for an unfolding legal drama. JZ

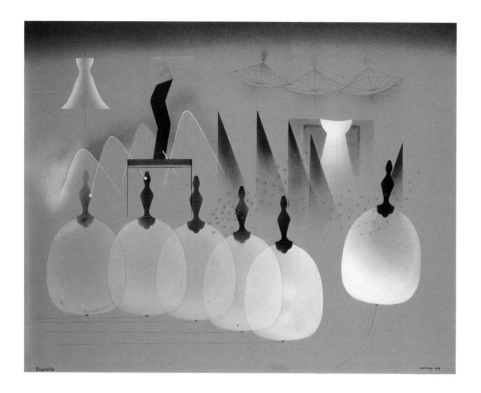

Man Ray

American, 1890–1976

Seguidilla, 1919

Airbrushed gouache, pen and ink, pencil, and colored pencil
on paperboard, 22 x 27⅞ in. (55.8 x 70.6 cm)
Joseph H. Hirshhorn Purchase Fund and Museum
Purchase, 1987 (87.15)

Seguidilla, which conjures the joyful Spanish dance of
the same name, belongs to a group of some two
dozen airbrush paintings, or aerographs, that Man Ray
produced between 1917 and 1919. First exhibited in
New York in November 1919, *Seguidilla* testifies to the
artist's superb control of the airbrush technique, a
skill he developed by experimenting after-hours on his
job as a commercial artist. In his autobiography, *Self-
Portrait,* Man Ray claimed that the airbrush freed him
to create "automatically":

> I worked in gouache on tinted and white cardboards—
> the results were astonishing—they had a photographic

quality, although the subjects were anything but figura-
tive…. It was thrilling to paint a picture, hardly touching
the surface—a purely cerebral act, as it were.

In *Seguidilla,* Man Ray used Japanese fans as stencils to
create visual metaphors for the swirling skirts and
contoured bodices of the performers he admired in a
Spanish dance troupe. Against the silver-gray back-
ground, female performers surround the silhouetted
male dancer who commands the tabletop in the left
center. At the upper right, three whirling tops echo
the dancers' rhythmic movements. Man Ray used
dark gray cones and red stippled spots across the
center of the aerograph to evoke the colored stage
lights that illuminated such performances. The clarity
and delicate abstract pattern of his design correspond
to the angular movements and graceful precision of
the Spanish dance. The indeterminate space, floating
figures, and elegant, mechanized choreography of
Man Ray's *Seguidilla* anticipated the dream world of
the Surrealists. JZ

Constantin Brancusi

Romanian, 1876–1957

Torso of a Young Man, 1924

Bronze on stone and wood bases
18⅛ x 11½ x 9⅛ in. (46.1 x 29.2 x 23 cm); combined
bases 40⅜ x 20 x 18¼ in. (102.4 x 50.5 x 46.1 cm)
Gift of Joseph H. Hirshhorn, 1966 (66.611)

In 1917, Constantin Brancusi carved the first version of
Torso of a Young Man (Philadelphia Museum of Art)
from the fork of a maple tree. When he decided to
cast two bronzes of the image in 1924, the change
from wood to metal led him to emphasize an almost
industrial precision in the crisp lines joining the legs to
the torso and in the perfect reflective surface. He
also revised the proportions and angles of the forms
to a machinelike regularity, rather like pistons in a
new engine.

The Hirshhorn's version of *Torso of a Young Man*
presents Brancusi's aesthetics at their zenith; its
deceptive simplicity encompasses many subtleties. The
subject of a nude male torso has a long and presti-
gious tradition, notably in classical Greek and Roman
sculptures. Yet Brancusi's geometric simplification of
the form is seen equally as a phallus. The work thus
becomes a modern fertility symbol or sexual icon, its
erotic quality tempered by coolly disciplined geome-
try. In style and composition the customary distinction
between the sculpture and its base has been eliminat-
ed here in favor of an integrated overall geometric sil-
houette. The rhomboid, rectangular, and cylindrical
shapes, sculpted in contrasting textures and colors,
accentuate the inherent beauty in each material. The
juxtaposition of hand-hewn natural brown wood
(recalling "primitive" or folk art) with highly polished
metal (equated with the technological skills of moder-
nity) linked humble crafts with fine art in an unprece-
dented synthesis. VJF

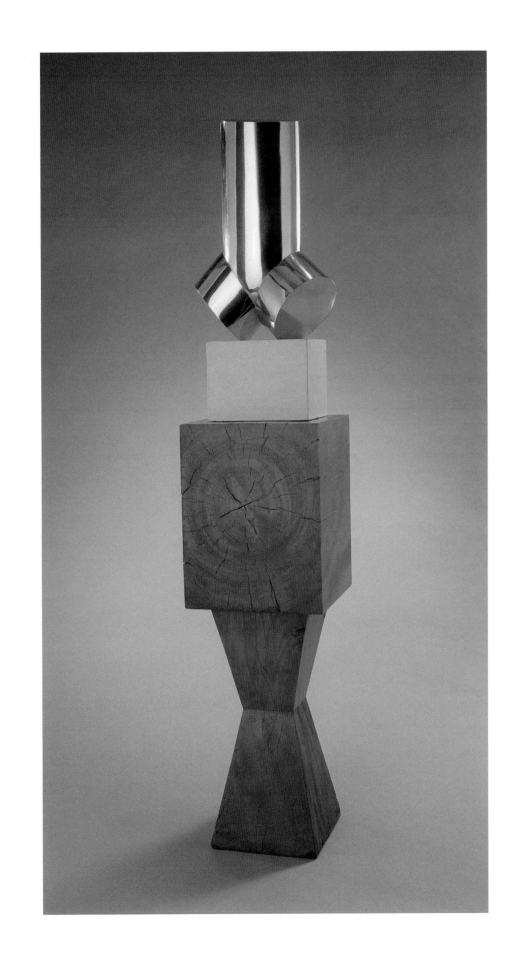

Joseph Stella

American, born Italy, 1877–1946

Factories (By-Product Plant), 1918–20

Pastel, charcoal, and metallic paint on paper mounted
on paperboard, 22⅞ x 29 in. (58.1 x 73.7 cm)
Gift of Joseph H. Hirshhorn, 1966 (66.4776)

In 1918, Joseph Stella accepted a commission from the
Pittsburgh sociological journal *The Survey* to illustrate a
series on the city's steel mills. *Factories (By-Product
Plant)*, which belongs to that group, appeared in the
magazine's March 1924 issue. Stella probably traveled
to Pittsburgh to record the industrial architecture; he
also may have relied on photographs for several of the
drawings. With his dramatic use of color and tone
here, however, Stella exceeded the bounds of journal-
istic illustration.

Although his pastel renderings of factories have
been likened to the industrial landscapes of such
painters as Louis Lozowick and Charles Sheeler,

Stella's romantic depictions of modern industry dif-
fered from the immaculate geometric designs of his
contemporaries. He was an admirer of Walt
Whitman and Edgar Allan Poe and invoked their
poetry to explain his drawings of American industry.
In this pastel, for example, he accentuated the stark
silhouette of buildings against a smoke-filled night sky
glinting with a menacing red haze. In an essay in 1929,
he wrote:

> During the last years of the war I went to live in Brooklyn.
> … War was raging with no end to it…. Opposite my stu-
> dio a huge factory—its black walls scarred with red stig-
> mas of mysterious battles—was towering with the
> gloom of a prison…. Smoke, perpetually arising, perpet-
> ually reminded of war.

Factories (By-Product Plant) reflects Stella's association
of industrial architecture with the modern war
machine. JZ

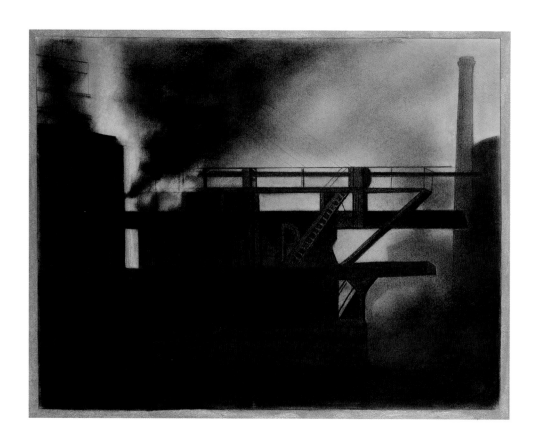

Thomas Hart Benton

American, 1889–1975

People of Chilmark (Figure Composition), 1920

Oil on canvas, 65⅝ x 77⅝ in. (166.5 x 197.3 cm)
Gift of the Joseph H. Hirshhorn Foundation, 1966 (66.468)

At the time he painted *People of Chilmark (Figure
Composition)*, Thomas Hart Benton had not yet settled
on the familiar themes of American life for which he
would become known as a leading regionalist painter.
A newspaper cartoonist turned painter, Benton in 1912
adopted the Synchromist style of abstract color com-
positions. By 1921 he had rejected abstraction in favor
of monumental figure painting inspired by American
history.

The townspeople of Chilmark on Martha's
Vineyard, Massachusetts, where Benton summered in
the 1920s, provided him with fresh subjects as he
began to forge his new representational style.
Benton's wife, Rita, their friend the critic Thomas
Craven, and other Chilmark neighbors posed for this
exuberant scene of recreation at the beach. Here,
Benton transformed the lives of ordinary people into
epic dramas. Just as he exaggerated the commotion
of figures encircling the man holding a beach ball,
Benton enlarged the scale of the figures to heroic
proportions. While he modeled clay figurines as a
means to develop three-dimensionally robust figures
in his work on canvas, Benton's muscular treatment of
human form also emulates the monumental paintings
of Renaissance artists, notably Michelangelo. Benton
called the painting "one of a number of exercises in
multiple figure design, based on sixteenth-century
precedents, which I made in the early twenties before
I turned my attention toward more specific subjects
of the American scene." *People of Chilmark* reflects
the artist's preoccupation with formal composition
and color harmony, while its epic presentation of the
commonplace anticipates his later homages to small-
town America. JZ

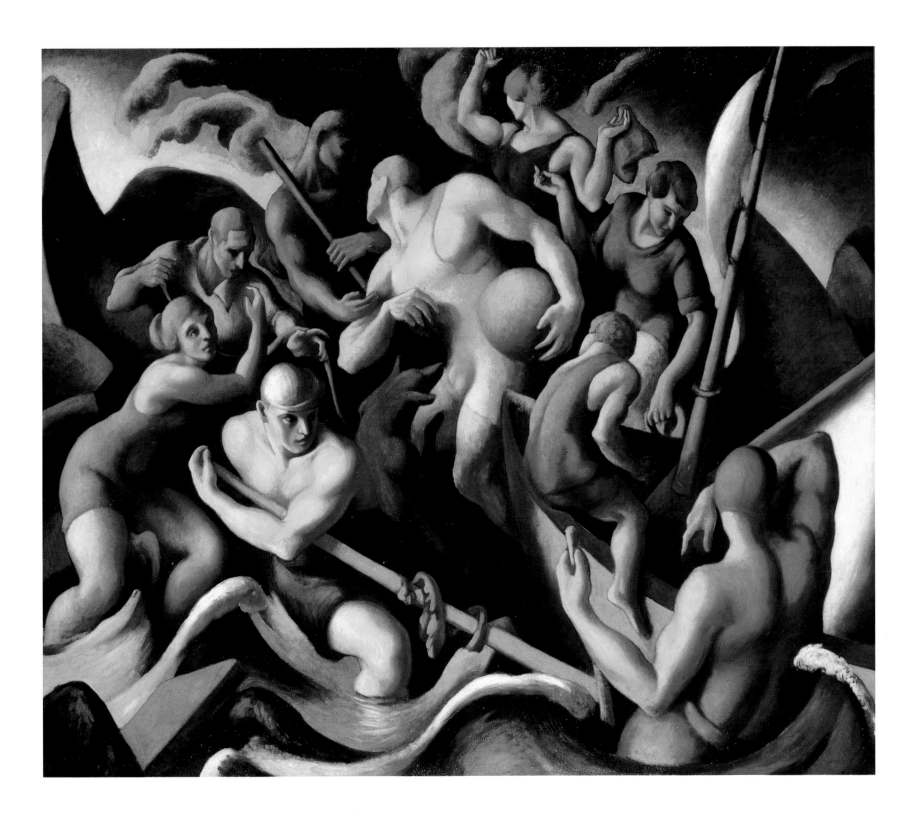

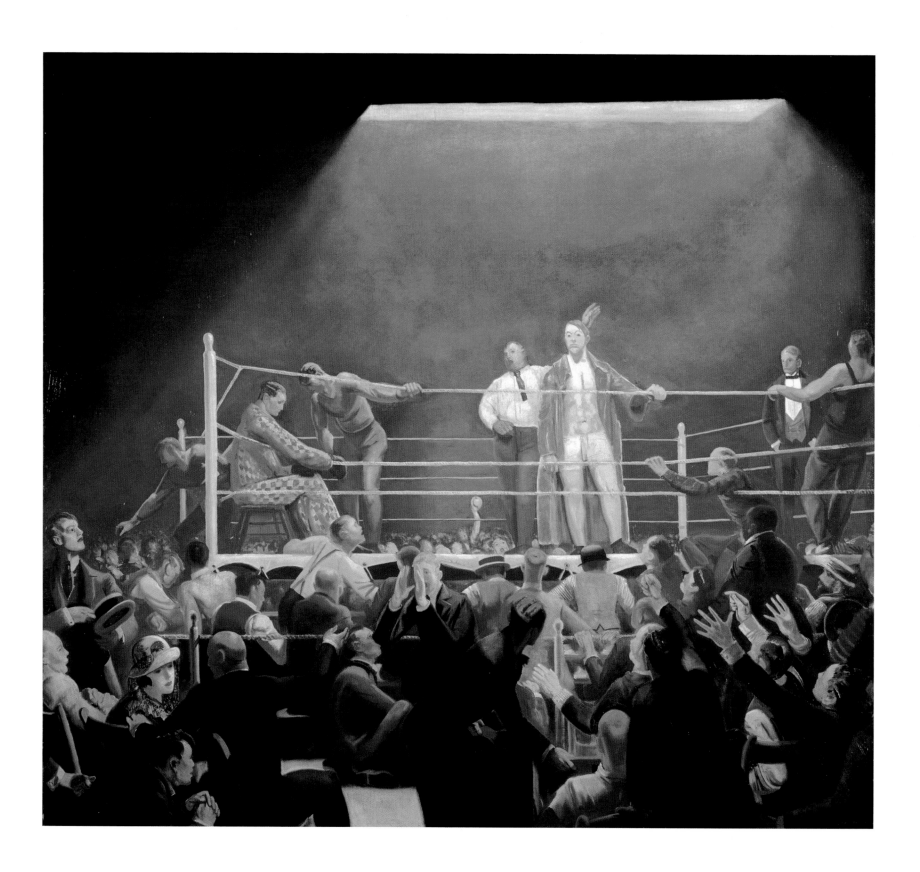

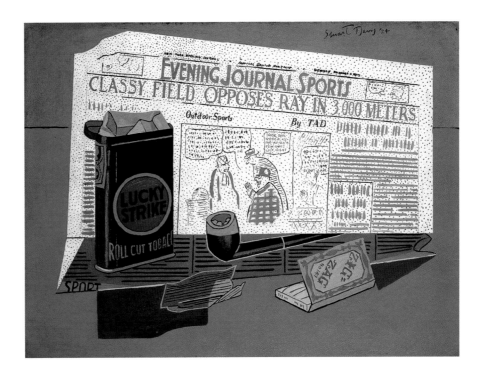

George Bellows

American, 1882–1925

Ringside Seats, 1924

Oil on canvas, 59 1/4 × 65 1/8 in. (150.5 × 165.5 cm)

Joseph H. Hirshhorn Bequest, 1981 (86.306)

George Bellows painted portraits, seascapes, and scenes of urban life. Among his most celebrated works are the six paintings and numerous drawings and prints of 1907 and 1908 that depict prizefighting as the sport then existed in New York: a back-room activity relegated to private clubs. By the time he painted *Ringside Seats,* boxing had become a public, if still brutal, contest.

The largest of Bellows's boxing images, *Ringside Seats* is probably set in the old Madison Square Garden, New York's famous arena. The painting is unusual for Bellows in that it does not portray an actual event; instead, it is based on an illustration he had created for a short story in *Collier's* magazine. As in many of his other fight pictures, however, the audience appears at least as aggressive as the combatants. Here, the crowd provides an ironic foil for the stoicism of the boxer who is being introduced in the ring. Bellows's muted colors convey the dark and smoky interior of the arena. The stable composition, dictated by the inverted asymmetrical pyramid of light, reflects his interest in geometric organization and "dynamic symmetry." The flattened space and the poses and rhythmic alignment of the figures along the foreground rope reveal the artist's interest in classical relief sculpture. Together these elements create a ceremonial or elegiac mood in which the sporting arena is pictured as a scene of complex psychological and physical action. PR

Stuart Davis

American, 1892–1964

Lucky Strike, 1924

Oil on paperboard, 18 × 24 in. (45.6 × 60.9 cm)

Museum Purchase, 1974 (74.228)

Between 1921 and 1924, Stuart Davis created a group of abstract paintings based on images of tobacco packaging. *Lucky Strike,* one of the last in the series, displays Davis's inventive fusion of subject matter derived from American popular culture with the sophisticated compositional methods of French Cubism. Across a horizontal brown field, Davis depicted a package of Lucky Strike Roll Cut tobacco, a partially folded cigarette paper, a package of Zig-Zag brand cigarette papers, and a pipe, all casually strewn before the sports section of a newspaper.

Originally an advocate of urban realism, Davis had become intrigued with European modern art at the 1913 Armory Show. The arbitrary juxtaposition of still-life elements in *Lucky Strike* resulted from his experiments with Cubism. Although the ambiguous space in which the imagery appears to float has been likened to a landscape filled with a looming billboard, the horizon line near the top might also define the table surface in a traditional still life. Combining fragmented forms with typography, Davis introduced explicitly popular images, notably the comic strip. In this case, he borrowed from a cartoon titled "Indoor Sports" that appeared in the sports section of the February 16, 1924, edition of the New York *Evening Journal.* Written by the journalist and cartoonist Thomas Aloysius Dorgan, the original cartoon centered on three partygoers discussing their "morning-after" ailments. Painted in the era of Prohibition, when an antitobacco campaign was under way, *Lucky Strike,* with its emblems of male pleasure, represents Davis's subversive celebration of American popular culture. JZ

Josef Albers

American, born Germany, 1888–1976

Fugue II, 1925

Sandblasted and painted flashed glass, 6 1/4 × 22 7/8 in. (16 × 58 cm)
Gift of the Joseph H. Hirshhorn Foundation, 1972 (72.4)

Although Josef Albers is best known for his painting series "Homage to the Square" dating from 1949 through the 1970s, those abstract color studies culminated years of exploring geometric forms in various media. In his youth in Germany he had worked in the traditional craft of stained glass, which imposes its own structural logic in the leaded black lines that meld together the colored glass sections. But the innovative curriculum at the Bauhaus school, where Albers enrolled in 1920, encouraged him to adopt a more radical style that incorporated rationally arranged, pristine, geometric forms. He soon taught the glass workshop and the basic course, emphasizing unusual materials, and he espoused the Bauhaus's commitment to devising new methods for producing art in the Machine Age. From 1925 to 1929, Albers created works in glass using industrially produced sheets of glass layered in two or three basic colors (usually black, white, and red). Applying stenciled acids and sandblasting on the back, he uncovered sections of each colored layer to produce geometric compositions of stacked rectangles. He also experimented with paint made from pigment and molten glass. *Fugue I* (Kunstmuseum Basel) and *Fugue II* are among his largest and most complex glass pieces. Albers often created such compositions in pairs as controlled experiments in design, varying each version only slightly. His series of glass works ended with the onset of the Great Depression, but he would return to their linear style for several large-scale pieces in other media in the 1960s and 1970s. VJF

Charles Sheeler

American, 1883–1965

Staircase, Doylestown, 1925

Oil on canvas, 25 1/8 × 21 1/8 in. (63.2 × 53.1 cm)
Gift of the Joseph H. Hirshhorn Foundation, 1972 (72.265)

Staircase, Doylestown embodies Charles Sheeler's deep admiration for early American architecture. The subject of the painting is the spiral staircase in a pre-revolutionary house that he and fellow modern painter Morton Schamberg had rented for summer weekends in the Doylestown, Pennsylvania, countryside. Around 1915, Sheeler produced a dozen photographs of the house, including an image of the stairwell. In 1925, working from the photograph and memory, he constructed a precisely balanced composition based on the spiraling pattern of the stair treads. He later remarked, "Two things are going on at the same time in the picture, irrelevant to each other but relevant to the whole, one in the room downstairs, one leading to the room upstairs. I meant it to be a study in movement and balances."

During the 1920s, Sheeler had developed a classically structured, hard-edge painting style known as Precisionism, which matched the sharp focus and formal patterning of his photographs. In its simple geometric form and dynamic composition, *Staircase, Doylestown* reveals the underlying structural unity of Sheeler's Precisionist paintings. Best known for his images of industrial America, Sheeler acknowledged his debt to rural American folk culture in his unpublished autobiography:

> Interest in early American architecture and crafts has, I believe, been as influential in directing the course of my work as anything in the field of painting. The way in which a building or a table is put together is as interesting to me, and as applicable to my work, as the way in which a painting is realized.

JZ

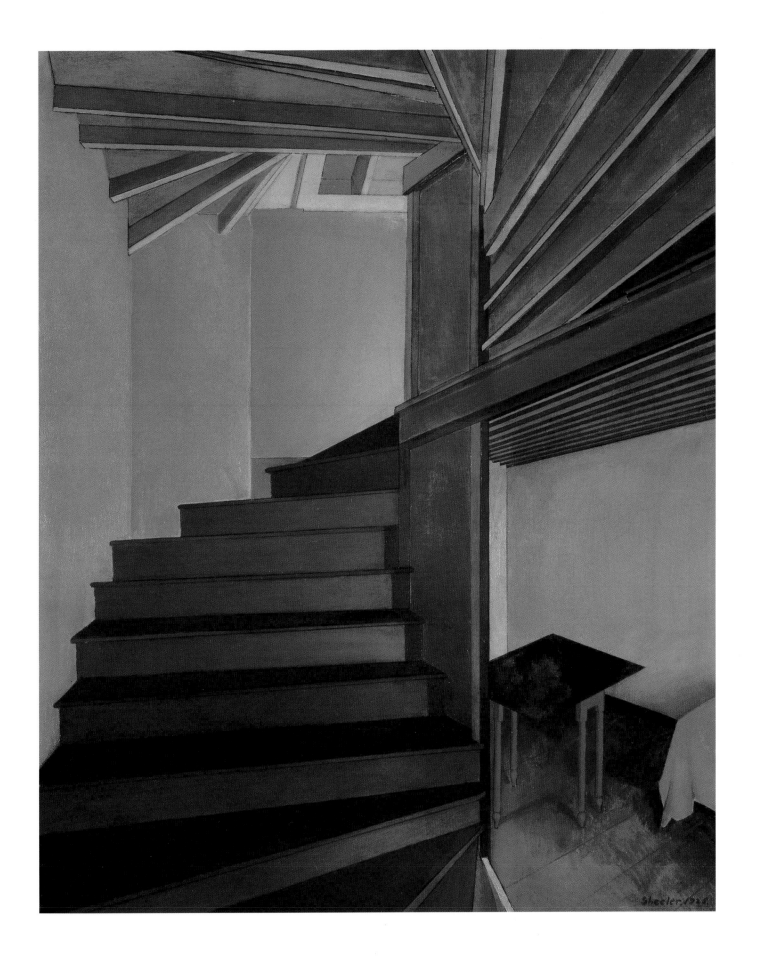

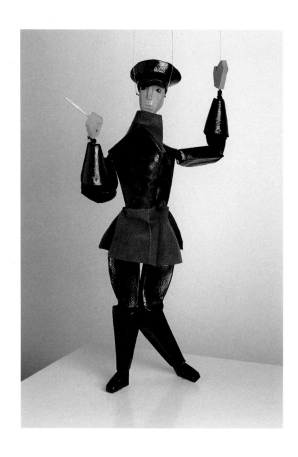

Alexandra Exter

Ukrainian, 1882–1949

American Policeman, 1926

Painted wood, fabrics, metal, thread, and plastic
23$\frac{1}{2}$ × 9$\frac{1}{4}$ × 9$\frac{1}{8}$ in. (59.5 × 23.3 × 23 cm)
Gift of Leonard Hutton Galleries, New York, 1977 (77.23)

Before World War I, Alexandra Exter developed an avant-garde geometric style derived from Italian Futurism and French Cubism. With the upheaval of the Russian Revolution in 1917, she joined the Constructivist artists, who applied their radical styles to building a utopian society. Exter turned to theater design, producing dynamic stage sets and boldly patterned costumes for performances in Moscow and Leningrad.

After abandoning the Soviet experiment in 1924, Exter settled in Paris, where she was recognized as an exceptionally innovative designer among many others seeking to redefine modern theater and cinema. In 1926 the Danish filmmaker Peter Urban Gad proposed a movie featuring marionettes rather than actors. (Puppetry, which had been popular since the seventeenth century, had recently been revived in several European countries in fairs, marketplaces, and theaters.) Exter conceived at least forty marionettes, which were fabricated by her Russian expatriate colleague Neehama Szmuskowicz. They were made out of traditional painted wood and fabrics (cotton, silk, leather), combined with new industrial materials (steel, copper, celluloid).

Although the plot of Gad's film is not known, the surviving marionettes include a range of characters, some from the commedia dell'arte (such as Harlequin, Pierrot, and Punch and Judy) and others from modern urban life, exemplified by *American Policeman*. In the 1920s many Europeans were fascinated by the vitality of American culture, which they discovered partly through popular silent films. *American Policeman* may have been inspired by the various tragicomic characters portrayed by Charlie Chaplin, Buster Keaton, and the Keystone Kops. VJF

César Domela

Dutch, born 1900

Relief Construction No. 11A, 1929

Glass, painted glass, painted metal, chrome-plated brass, and painted wood, 35$\frac{3}{8}$ × 29$\frac{5}{8}$ × 1$\frac{3}{4}$ in. (89.8 × 75.2 × 4.2 cm)
Gift of Joseph H. Hirshhorn, 1966 (66.1397)

After devoting his first efforts to painting in 1920, César Domela espoused pure geometric abstraction in 1923. He made the critical transition to sculpture in 1929 by means of constructed reliefs. One of only four known to survive from that year, *Relief Construction No. 11A* incorporates equally the aesthetics of Neoplasticism and Constructivism. Its composition of superimposed squares mounted diagonally on a rectangular board embodies the Neoplastic ideal of horizontal and vertical elements in balanced opposition, intended as an abstract metaphor for a harmonious state of mind. Domela's choice of materials reflects the ideas of Russian and Bauhaus Constructivists who exhibited in Berlin (notably those grouped around Vladimir Tatlin and László Moholy-Nagy). Rather than carve or model his reliefs, Domela constructed them from nontraditional materials, such as industrially produced metals and glass, which the Constructivists considered emblematic of the new Machine Age that they fervently desired as a better era for humanity.

In *Relief Construction No. 11A*, Domela superimposed a square steel grill (with a red square in the center and black-gray edges) onto a transparent glass square (with a yellow square in the center and translucent sandblasted edges). Each layer allows the viewer to see through to the next, while the geometric components interlock in a complex counterpoint of textures and shapes that reveal various patterns of solidity, transparency, and coloration. VJF

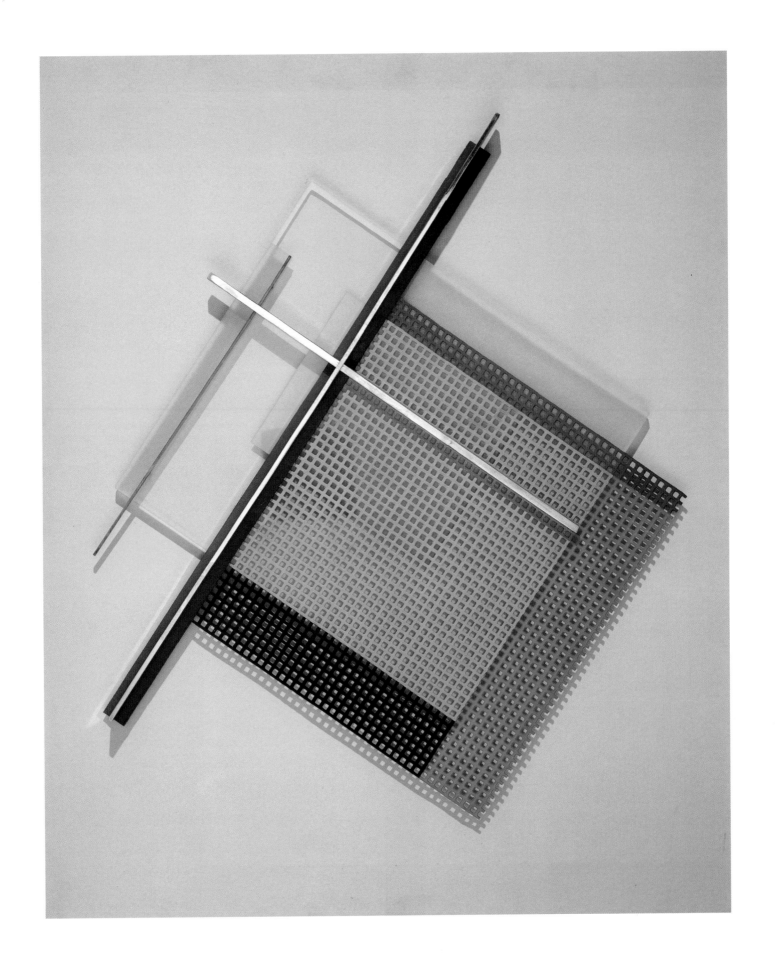

Jacques Lipchitz

American, born Lithuania, 1891–1973

Figure, 1926–30

Bronze, 7/8, cast 1958–61
85 3/8 × 38 1/2 × 29 1/4 in. (216.8 × 97.7 × 74.3 cm)
Gift of Joseph H. Hirshhorn, 1966 (66.3101)

Figure occupies a pivotal position between Jacques Lipchitz's youthful and mature aesthetics during his thirty years in Paris. The interlocking geometric forms in a frontal, symmetrical, vertical composition summarize his Cubist art from 1915 through 1925, while the curved shapes and open spaces developed from his recent "transparent" sculptures formed from cutout cardboard. Yet as Lipchitz's first monumental sculpture, *Figure* also prompted him to redirect his efforts toward public commissions and an expressive Neo-Baroque style.

During a visit to Ploumanach on the Brittany coast in the summer of 1926, Lipchitz had been intrigued by the unusual rock formations—huge boulders sculpted into fantastic shapes that balance precariously atop one another. He translated their forms into a small abstract sculpture in his Paris studio. When a collector saw the model and commissioned an enlarged version, Lipchitz revised the forms further, simplifying the composition into an intimidating totem of interlocking curves topped by an oval head with staring eyes. The frightening intensity of the abstracted figure recalls some of the African carvings that Lipchitz had collected years earlier, although he did not consciously derive inspiration from any single object. Displeased with this transformation, the collector returned the work to the artist. But the Surrealists welcomed Lipchitz's change of style and published the plaster in their *Minotaure* magazine in 1933. Political upheavals in Europe temporarily prevented further interest, but after immigrating to the United States in 1941, Lipchitz finally cast the work in bronze for outdoor display. VJF

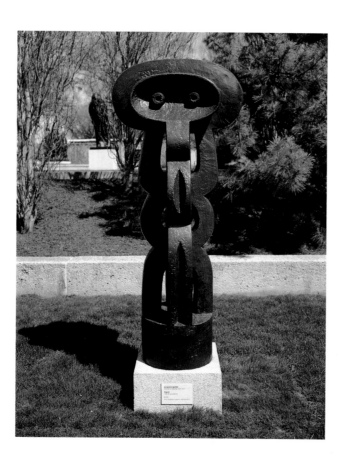

Fernand Léger

French, 1881–1955

Nude on a Red Background (Seated Woman), 1927

Oil on canvas, 51 1/4 × 32 in. (130.1 × 81.4 cm)
Gift of the Joseph H. Hirshhorn Foundation, 1972 (72.173)

Abandoning the multiple perspectives and shifting color planes of Cubism, Fernand Léger became a leader in the classical revival and stylistic retrenchment of the French vanguard after World War I. The austere, geometric style that he developed has sometimes been labeled Purism. In figurative and still-life paintings, he pursued analogies between the classic ideal of harmony and the utopian dreams of a rational Machine Age. By melding classic design with machinist imagery, he emerged as one of the principal architects of twentieth-century aesthetics.

Nude on a Red Background marks the culmination of Léger's series of monumental figure paintings from the 1920s. Rendered in steely grays against a stark red ground, the half-kneeling, seated nude exemplifies Léger's bold style. Deliberately conjuring allusions to modern industry, Léger emphasized the outlines of standardized body parts—face, joints, limbs—in the woman's well-tooled body. He objectified the human figure in the same way that he emphasized the concrete physical attributes of still-life objects. At the same time, he intended the geometric structure of the composition and the sobriety of the figure to recall Roman mosaics. The woman's compact pose with crooked arms derives from the classic motif of a water carrier or urn-bearing figure. By fusing antiquity and the Machine Age in paintings such as *Nude on a Red Background,* Léger perfected what he called the "Nordic spirit" in modern art. JZ

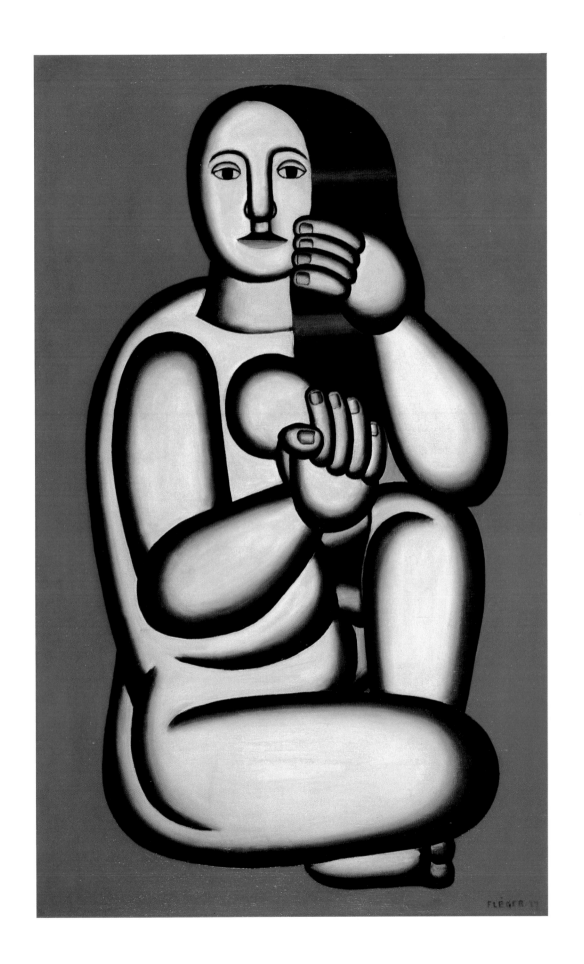

Burgoyne Diller

American, 1906–1965

Construction, 1934

Painted wood and fiberboard, 24 x 24 x 1 in. (61.1 x 61 x 2.4 cm)
Gift of Joseph H. Hirshhorn, 1966 (66.1373)

Burgoyne Diller ranks among the most accomplished practitioners of geometric abstraction in twentieth-century American art. Trained at New York's Art Students League under Jan Matulka, George Grosz, and Harry Holtzman, Diller developed a keen interest in abstract art, particularly the rigorous geometric style of Piet Mondrian and his compatriots in the Dutch movement De Stijl. By 1934, Diller was already producing daringly abstract relief assemblages such as *Construction*. Composed of painted wood disks and an irregularly shaped wood element mounted on a black fiberboard panel, the relief demonstrates Diller's growing command of the principles of geometric abstraction. The three disks form an implied triangle that intersects with the eccentrically shaped component, the curvature of which echoes the rounded forms of the disks. While the red, yellow, and white circles recall formal elements of Alexander Calder's mobiles and assemblages of the same period as *Construction*, the square relief format and black field reveal Diller's familiarity with the Russian Constructivists and Suprematists whose works were represented in the Société Anonyme, a pioneering collection of modern art founded by his friend Katherine Dreier. Despite the nonrepresentational character of Diller's formal vocabulary, his array of primal disks floating in a black field evokes celestial imagery. Diller created an entire universe with the elemental language of geometric abstraction. JZ

Joan Miró

Spanish, 1893–1983

Painting (Circus Horse), 1927

Oil and pencil on burlap, 76³/₄ x 110³/₈ in. (195 x 280.2 cm)
Gift of the Joseph H. Hirshhorn Foundation, 1972 (72.202)

After settling in Paris, Joan Miró co-founded the Surrealist movement, and its emphasis on metamorphosis and fantasy permeated his art. He sometimes used the new "automatist" method, which allowed the subconscious mind to direct spontaneous movements of the hand in creating works of art. He also adapted Jean Arp's biomorphic abstractions derived from natural sources such as clouds, plants, and liquids. The whimsical creatures in Miró's paintings often literally began as one entity and evolved into something different.

This painting belongs to Miró's series of circus horses from 1927. The subject of the circus had become popular with Parisian artists as early as the 1880s. During the late 1920s, Alexander Calder gave popular weekly performances of his wire-figure *Circus*, which Miró would have seen. Miró's white biomorphic "horse" is not literally described (its appendages appear more like wings than legs). It cavorts in a vast brown space without measurable scale—the realm of imagination and dreams. When Miró was asked in 1946 about a related painting, he gave a deliberately equivocal reply:

It's a horse, isn't it?
—Yes, yes.
But no, it's a bird.
—Yes, yes.

In the elegantly simplified composition, the V-shaped line suggests a barrier that the horse must jump over, or perhaps it is an abstract equivalent for the crack of the ringmaster's whip. The painting presents no specific narrative but instead encourages the viewer to imagine the spectacle and gaiety of a circus of the heart and mind. VJF

Joaquín Torres-García

Uruguayan, 1874–1949

Composition, 1932

Oil on canvas, 28 1/2 x 23 5/8 in. (72.5 x 60 cm)
Gift of Jon N. Streep through the Joseph H. Hirshhorn
Foundation, 1972 (72.296)

After struggling for years to formulate a classical modernist style in Spain and Italy, Joaquín Torres-García settled in Paris from 1926 to 1932. There he discovered the rigorously abstract paintings of Piet Mondrian, who purified compositions into grids of horizontal and vertical lines intended to facilitate a transcendent state of calm, harmony, and spirituality. But Torres-García considered that absolute geometry too inaccessible, so he introduced deceptively simple representational forms—archetypal images derived from objects in daily life, children's drawings, ancient Egyptian hieroglyphs, medieval Christian symbolism,

the occult, architecture, and tribal African artifacts. Seeking to merge Old and New World aesthetics, Torres-García also introduced motifs from Mexican and Peruvian Pre-Columbian art, such as the face in the upper right of *Composition*. The earthy brownish hues of this painting suggest a terra-cotta or other aged treasure excavated by archaeologists.

Torres-García's credo, which he called Universal Constructivism, was meant to appeal to viewers of differing cultural and educational backgrounds. He relied on each viewer's subconscious associations to invest his works with limitless meanings. A fish, for example, refers not only to food but also to a vocation, science, Christian symbolism, and more. Torres-García favored ideograms that suggest transition from one domain to another (boat, bridge, ladder, key), enlightenment (church, eye, triangle), and the renewal of life (sun, spiral)—all of which imply an evolution from mundane physical reality to a higher spiritual dimension. VJF

Piet Mondrian

Dutch, 1872–1944

Composition with Blue and Yellow, 1935

Oil on canvas, 28 3/4 x 27 1/4 in. (73 x 69.6 cm)
Gift of the Joseph H. Hirshhorn Foundation, 1972 (72.205)

Composition with Blue and Yellow epitomizes the austere geometry of Piet Mondrian's mature abstract style. The right-angle intersection of one pair of parallel vertical lines with two sets of double horizontal lines provides the structure for this asymmetrically balanced composition. Two exquisitely poised planes of color—a yellow square in the upper left and a small blue rectangle at the bottom center—endow the canvas with timeless harmony.

A co-founder of the Dutch vanguard movement De Stijl (The Style), which promoted a utopian ideal of harmony in all the arts, Mondrian believed that painting must be reduced to essential forms and colors. The right-angle intersection of vertical and horizontal lines became his organizing principle. He limited his palette to primary colors (red, yellow, and blue) and neutral colors (black, white, and gray). Although he occasionally adopted a diamond format in the 1920s, Mondrian regularly made use of nearly square canvases. During the 1930s, he also introduced the device of double parallel lines. In the Hirshhorn's painting, the stark intersections of these linear bands produce optical afterimages that result in implied chromatic values, according to some critics. Within the self-imposed limits of his rigorous art, Mondrian transformed geometric grids with interlocking color planes into a visual metaphor for the modern utopian ideal. JZ

George Grosz

American, born Germany, 1893–1959

Thunderbeard (Donnerbart), A Man of Opinion, 1928

Watercolor and colored ink on paper, 26 x 18⁷/8 in. (66 x 48 cm)
Gift of Joseph H. Hirshhorn, 1966 (66.2273)

George Grosz gained international acclaim for the incisive social criticism in his graphic art. He was one of the first to sign the German Dada Manifesto in 1918 and soon began publishing drawings that depicted military officers and capitalists as arrogant, brutal, and degenerate. True to the Dada movement, which attempted to overturn traditional values, Grosz created a collection of visual "types" that contrasts members of the avaricious ruling class with the oppressed proletariat.

Grosz's contempt for German society is apparent in *Thunderbeard*. Although the work's subtlety mitigates the artist's usual vehemence, the didactic intent is in keeping with the rest of his oeuvre. In this scene an aged, overfed member of the National Socialist (Nazi) party stands among the well-to-do vacationers at the seashore. A plump blonde girl provides a foil to the old man with his wrinkled face and bloodshot eyes. In light of the work's title, the man's lecherous gaze directed at the youthful, pigtailed bather produces a biting satire.

At the end of the 1920s, with Germany in political turmoil and the Nazi party on the rise, Grosz abandoned his efforts to affect the social order. In April 1932, having accepted an invitation from the Art Students League to teach, he sailed for New York, returning to Germany only after World War II ended. FG

David Alfaro Siqueiros

Mexican, 1896–1974

Zapata, 1931

Oil on canvas, 53¹/4 x 41⁵/8 in. (135.3 x 105.7 cm)
Gift of Joseph H. Hirshhorn, 1966 (66.4605)

David Alfaro Siqueiros and his older colleagues Diego Rivera and José Clemente Orozco championed a public art that looked to Mexico's indigenous past and advocated social reforms. After the Mexican Revolution, Siqueiros was sent by the new government to study painting in Europe. Traveling around the Continent from 1919 to 1922, he encountered avant-garde movements such as Cubism and Futurism, studied Italian Renaissance frescoes, and met Rivera. In 1922, Siqueiros returned to his home country at the urging of the government, which had embarked on an ambitious cultural program that included murals in public buildings in celebration of the revolution.

Emiliano Zapata was one of the major figures of the revolution who demanded and fought for agrarian reforms. Born a mestizo peasant, he began with a small group of followers and eventually amassed an army. Zapata was killed in 1919 by a rival band and became a popular symbol of the revolution and frequent subject of the Mexican Muralists. In this portrait, Siqueiros presents Zapata with his customary mustache and sombrero in what appears to be a confined room with encroaching walls. The emblematic portrayal of Zapata is typical of Siqueiros's depictive style, revealing his interest in the simplified forms of Pre-Columbian art and reflecting his desire to produce an art that would clearly and forcefully communicate ideas to his countrymen. AC

Pablo Picasso

Spanish, 1881–1973

Portrait of Dora Maar, 1938

Pencil on paper mounted on fiberboard
30⁹/₁₆ × 22⁷/₁₆ in. (77.5 × 57 cm)
Gift of Joseph H. Hirshhorn, 1966 (66.4043)

Images of Pablo Picasso's mistresses, wives, and friends often became subjects of his personal and artistic analysis. In these portraits he subordinated formal and abstract perfection to reveal subtle emotions imbued with vitality. In the 1930s, Picasso worked in representational, classical, and abstract styles, and his drawings, paintings, sculptures, and prints reflect his various innovative approaches. Using techniques he had developed in his earlier experiments with Cubism and Surrealism, he emphasized emotional content in many of his figural paintings and drawings by dislocating facial features and extremities. His works ranged from exuberant to somber and included themes of violence and death, as in the monumental *Guernica,* 1937.

In 1936 the poet Paul Éluard introduced Picasso to Dora Maar, a young painter and photographer who was interested in the Surrealist movement and the artists associated with it. That year she became Picasso's model and companion, and her relationship with him lasted about seven years. This portrait presents Maar's face with distorted, though not unrecognizable, features. Her face, simultaneously shown frontally and in profile, is divided into two parts, with one eye gazing out into the world while the other looks inward. Although the ingenious technique was derived from Cubism, it may also reflect Picasso's perception of her emotional state. The vantage point makes it seem as if we are looking up at the model, as though she were a statue set in a niche above our heads. FG

Julio González

Spanish, 1876–1942

Woman with Bundle of Sticks, 1932

Iron, 14³/₈ × 6⁷/₈ × 4¹/₈ in. (36.5 × 17.4 × 10.5 cm)
Gift of Joseph H. Hirshhorn, 1966 (66.2113)

Born to a family of goldsmiths and metal artisans, Julio González first worked in his father's atelier, then studied drawing and painting at the Escuela de Bellas Artes in Barcelona. In 1900 he moved to Paris, where he associated with avant-garde artists, including the Spanish expatriate sculptors Manolo Hugué and Pablo Gargallo. While making decorative metalwork to support his family, González painted and sculpted sporadically. In 1928 he provided technical assistance on constructing iron sculptures for Pablo Picasso—a collaboration that would be renewed from 1930 to 1932. The experience with Picasso prompted González to turn seriously to sculpture in 1929, fabricating works from thin sheets of iron, which he cut, bent, and welded into a series of small figure compositions in relief format. He returned to that method briefly in 1932 for *Woman with Bundle of Sticks.* This sculpture, like the others, depicts a woman performing ordinary activities, a subject that expresses González's concern for the rural poor during the Great Depression. The Hirshhorn's sculpture portrays a peasant woman who has gathered sticks of wood to burn for her daily cooking and heating. She stands against an abstract geometric background, vaguely architectural in shape, perhaps the open door of her home. Although González's welded iron sculptures were shown in various exhibitions in Paris during the early 1930s to critical acclaim, the onset of war in 1939 led to material shortages that effectively terminated his efforts in metal sculpture. Nonetheless, his works inspired the postwar generation of sculptors, notably David Smith in the United States, to construct their works from iron and steel. VJF

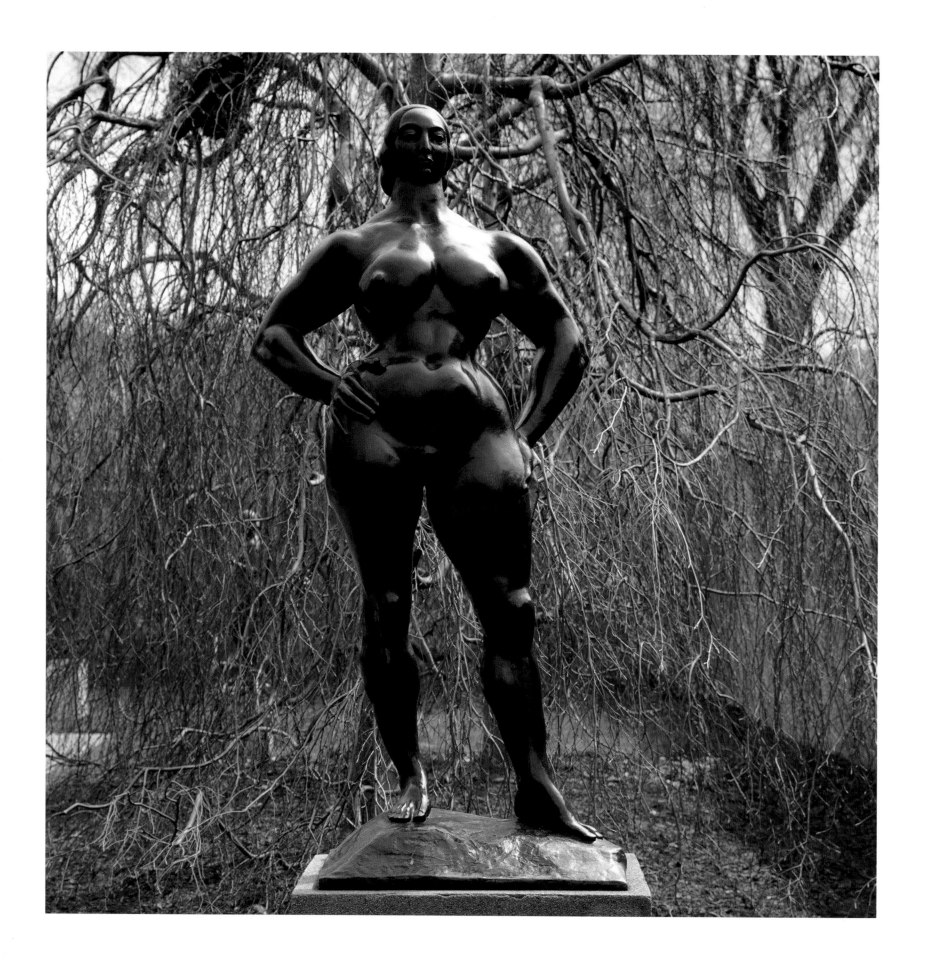

Gaston Lachaise

American, born France, 1882–1935

Standing Woman, 1932

Bronze, 5/8, cast 1981

88¼ × 44¾ × 25⅜ in. (224 × 113.6 × 64.3 cm)

Museum purchase with funds provided by Smithsonian
Collections Acquisition Program, 1981 (81.2)

Originally trained at the École des Beaux-Arts in
Paris, Gaston Lachaise immigrated to the United
States in 1906. From 1913 until 1921, while working as
Paul Manship's assistant, Lachaise developed a person-
al style of figure sculpture that paid homage to his
companion and wife of many years, Isabel Dutaud
Nagle. The sculptor always credited her as his primary
source of inspiration in both body and spirit, causing
him to focus almost exclusively on the female nude
as subject. Diverging from the slender goddesses
portrayed in nineteenth-century and Art Deco
sculptures, Lachaise made full-bodied nudes with
excessively large breasts and hips, prominent abdo-
mens, and sometimes almost muscular power.
Although vilified by traditional critics, Lachaise's figures
were intended to express his concept of Woman as
the incarnation of spiritual strength, emotional and
physical nourishment, and maternal and sexual love.
The proportions of his nudes, such as *Standing Woman*,
derive partly from carvings of fertility goddesses from
Neolithic cultures, which revered the procreative and
nurturing powers of women. *Standing Woman* provided
a sharp contrast to the fashionably thin bodies of the
"flapper" women of the 1920s, as well as the abstract
geometric sculptures by many other artists at the
time. VJF

Boris Lovet-Lorski

American, born Lithuania, 1899–1973

Winged Sphinx, 1930–32

Egyptian granite, 22⅛ × 40½ × 14½ in. (56.1 × 102.7 × 36.8 cm)

Bequest of the artist, 1978 (78.101)

The majority of Boris Lovet-Lorski's sculptures are
portrayals of real and allegorical women, although he
also produced male portrait heads. He preferred rare
and exotic materials such as black marble, lava, onyx,
jade, slate, pewter, and red copper. The artist skillfully
matched the particular characteristics of these mate-
rials—their translucence, hardness, and color—to the
nature of his subjects and sitters. To further heighten
their dramatic impact, Lovet-Lorski polished his sculp-
tures, thereby setting them apart from the rough-sur-
faced work of his contemporaries.

As befits its title, *Winged Sphinx* is fashioned from
Egyptian granite. The dark-speckled, dense, and highly
burnished stone seems as impenetrable as the enig-
matic pose and veiled expression of the creature it
embodies. Lovet-Lorski gave the sphinx almond-
shaped eyes and accentuated its musculature, hair,
and wings with stepped, architectonic shapes.
Together the forms conjure not only images of
ancient Egyptian figures, such as those found in the
tomb of King Tutankhamen (opened in 1922), but also
of Pre-Columbian and Cubist sculpture. At the same
time, the hard and precise geometry of *Winged
Sphinx* seems more machine-made than handcrafted.
Lovet-Lorski's synthesis in *Winged Sphinx* of ancient
motifs and the cold, elegant linearity of manufactured
goods typifies the Art Deco style of the 1920s and
1930s. ALM

Reginald Marsh

American, born France, 1898–1954

George C. Tilyou's Steeplechase Park, 1936

Egg tempera on fiberboard, 36 x 48 in. (91.4 x 121.9 cm)

Gift of the Joseph H. Hirshhorn Foundation, 1966 (66.3356)

In *George C. Tilyou's Steeplechase Park,* Reginald Marsh captured the frenetic energy of a scene of mass pleasure at a popular amusement park in New York. Located at Coney Island, Steeplechase Park was founded by the impresario George Cornelius Tilyou, who made a career of developing parks dedicated to popular entertainment for the burgeoning urban middle class. Marsh was a frequent visitor to Coney Island and drew inspiration from such scenes of everyday city life. A graduate of Yale University and the Art Students League, he shared an enthusiasm for urban realism with his teachers John Sloan and George Luks, both leaders of the New York group known as the Ashcan School. Following their example, Marsh became a major exponent of urban realist painting in the 1930s.

Unlike the earlier generation of realists, however, Marsh imbued paintings such as *George C. Tilyou's Steeplechase Park* with an underlying classical structure and a monumental figurative style derived from his admiration for Renaissance and Baroque art. Using the demanding medium of egg tempera, Marsh carefully rendered the myriad figures in a dizzying array of classical poses. He arranged his subjects in three semicircular rings that convey the centrifugal force of the Coney Island rides. By infusing scenes of contemporary urban life with vital immediacy and alluding to the heritage of Western art, Marsh transformed the realism of the Ashcan School into a monumental figurative style. JZ

Edward Hopper

American, 1882–1967

Eleven A.M., 1926

Oil on canvas, 28⅛ x 36⅛ in. (71.3 x 91.6 cm)

Gift of the Joseph H. Hirshhorn Foundation, 1966 (66.2504)

The preeminent American realist Edward Hopper transformed mundane images of the city and interior scenes into haunting visions of the anonymity and existential isolation of modern life. *Eleven A.M.* introduced symbolic themes that would recur in many of Hopper's later paintings. It depicts an anonymous woman, naked except for her shoes, seated in an urban interior. With her face hidden behind her long hair, she appears to gaze out the window at the far right of the composition. The implied intimacy of her nude body is deliberately contrasted with the impersonal geometry of the city buildings glimpsed in the background. Hopper used the play of light across the room and the nude figure to capture a mood of quiet contemplation. The critic Wallace Spencer Baldinger detected a latent classicism in Hopper's simple and understated style:

> *Eleven A.M.* … is characteristic of his art at its ripest…. It is as coolly impersonal as the architecture bounding its space. Contours are precise, forms integrated and balanced, essential details revealed clearly in shadows as in sunlight. The structure of the composition is solid, the movement is measured and disciplined.

Such paintings may be regarded as expressions of loneliness, but Hopper welcomed solitude and intended his isolated figures to embody complex emotional symbolism. In focusing on the theme of morning light seen through a window, Hopper imbued the woman's solitary figure with an expectant longing that humanizes the apparent impersonality of her urban world. JZ

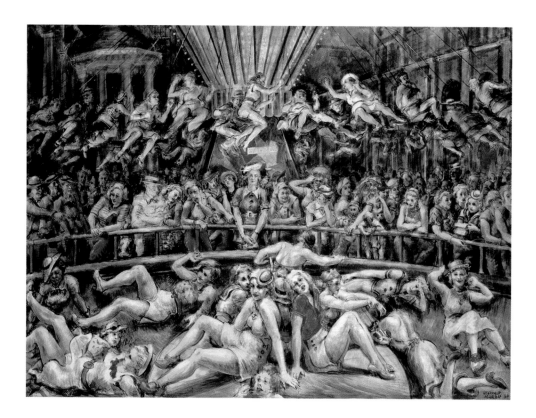

Ben Nicholson
British, 1894–1982

1938 White Relief (Large Version), 1938

Oil on carved wood
47½ x 72⅜ x 2¾ in. (120.6 x 183.8 x 7 cm)
Gift of Joseph H. Hirshhorn, 1972 (72.215)

An architectonic composition of carefully balanced rectangular forms, *1938 White Relief (Large Version)* belongs to Ben Nicholson's second series of white reliefs from the late 1930s. As an outgrowth of his earlier practice of incising the surfaces of his paintings, Nicholson developed a method of hand carving abstract reliefs in 1933. "The artificial conditions produced by painting on a stretched rectangular canvas," he explained in 1969, "have forced painting out of its true direction and out of its natural and direct relationship to our lives." Believing that the tactility of relief would invigorate painting, Nicholson sought to attain "total forms" by combining the craft of carving with the principles of pure abstraction. Inspired in part by the art of Piet Mondrian, he reduced his imagery to geometric planes and the single color white. This work and others from the second series of white reliefs display a greater formal complexity than the earlier series.

Nicholson developed the Hirshhorn relief from a small piece that he characterized as a "maquette" for the larger version. Through an intricately balanced interplay of superimposed and interlocking planes with precisely carved edges, Nicholson transformed the reductive geometry of *1938 White Relief (Large Version)* into a vehicle for poetic contemplation. He wrote in 1941: "The geometrical forms often used by abstract artists . . . are nothing in themselves and are alive only in the instinctive and inspirational use an artist can make of them in expressing a poetic idea." JZ

Henry Moore
British, 1898–1986

Stringed Figure No. 1, 1937

Cherry wood and string on oak base
22⅜ x 5⅜ x 6⅝ in. (56.6 x 13.5 x 16.8 cm)
Joseph H. Hirshhorn Purchase Fund, 1989 (89.28)

Inspired by the abstract biomorphic forms initially conceived by Jean Arp and developed by the Surrealists in Paris, Henry Moore devised a unique organic style of sculpture. He also adopted the "direct carve" aesthetic of Constantin Brancusi, who favored the natural grains and textures of wood and stone. During the 1920s and 1930s, Moore directed his efforts primarily to sensuous carvings of highly stylized human figures, which established his reputation. From 1937 to 1939 he also fashioned eighteen sculptures incorporating string, tautly threaded as in a violin or net. He made only six sculptures combining string with carved wood, and he kept *Stringed Figure No. 1* in his personal collection for fifty years. Other artists had made stringed sculptures—among them, Giacomo Balla's Futurist construction of 1915 and Pablo Picasso's guitar assemblages of 1912 to 1914—but they were not widely known. Moore was inspired instead by mathematical models in the London Science Museum. He became fascinated by how string can sustain a linear pattern that is both rigorously disciplined and delicately transparent, providing a distinct visual contrast with the curves and solidity of the supporting wood. Moore's stringed compositions predate comparable works by his colleague Naum Gabo. They also influenced later sculptors, who developed the concept into more complex structures using sophisticated engineering principles. VJF

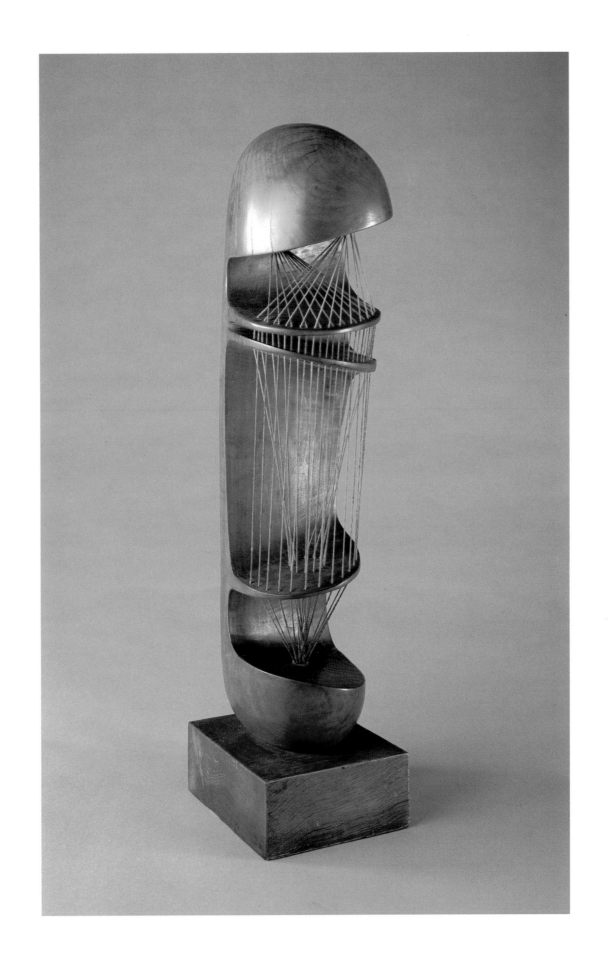

Giorgio Morandi
Italian, 1890–1964

Still Life, 1943
Oil on canvas, 9 x 14 in. (22.8 x 35.3 cm)
Gift of the Marion L. Ring Estate, 1987 (87.30)

During a period of intense activity in World War II, Giorgio Morandi painted this still life at his summer home in Grizzana, Italy. An atmospheric suffusion of warm gray tonalities unifies the simple arrangement of ceramic vessels. Morandi usually began painting with bright colors, then muted the chromatic range in the final version. On a visit to Morandi's studio in Bologna, the writer John Rewald noticed a parallel between the subtle hues and soft textures of his still lifes and the "dense, gray, velvety dust" that enveloped the objects there. Morandi explained in 1958:

I am essentially a painter of the kind of still-life composition that communicates a sense of tranquillity and privacy, moods which I have always valued above all else…. Nothing is more alien to me than an art which sets out to serve other purposes than those implied in the work of art itself.

Although his paintings have been likened to those of the eighteenth-century French painter Jean Siméon Chardin, the balanced structure, ambiguous space, and quiet color of this still life are the product of a modern sensibility. Morandi himself claimed:

Nothing can be more abstract, more unreal, than what we actually see. We know that all that we can see of the objective world, as human beings, never really exists as we see and understand it. Matter exists, of course, but has no intrinsic meaning of its own, such as the meanings that we attach to it. Only we can know that a cup is a cup, that a tree is a tree.

JZ

Giacomo Manzù
Italian, 1908–1991

Self-Portrait with Model at Bergamo, 1942
Bronze, unique, cast by 1960
$52^{1}/_{4}$ x $38^{5}/_{8}$ x $10^{1}/_{8}$ in. (132.7 x 98.1 x 25.7 cm)
Gift of Joseph H. Hirshhorn, 1966 (66.3293)

Although the centuries-old academic practice of working directly from a model was rejected by many modern artists, others such as Pablo Picasso and Henri Matisse relied on models for inspiration. Giacomo Manzù is best known for sculptures of robed cardinals, but some of his finest paintings and sculptures depict male and female nudes. Although he usually worked in Milan or Rome, he made *Self-Portrait with Model at Bergamo* in his hometown in northern Italy. The studio in Bergamo became his refuge during World War II, when daily life was characterized by violence, political oppression, and material hardship. Manzù's composition alludes to wartime shortages: unable to afford to heat the studio, the artist sits hunched at his easel wearing an overcoat and hat, painting because bronze was not available for sculpture. In contrast to the artist, the nude model stands in a graceful contrapposto pose, serenely indifferent to the cold. Her sensuously modeled physique, defined in high relief against the scumbled background surfaces, provides an image of fullness and vitality—a symbolic promise of a better life. Such symbolism increased in importance for Manzù as the war intensified: in this final version the nude is represented more prominently than in the smaller preliminary studies of 1940. VJF

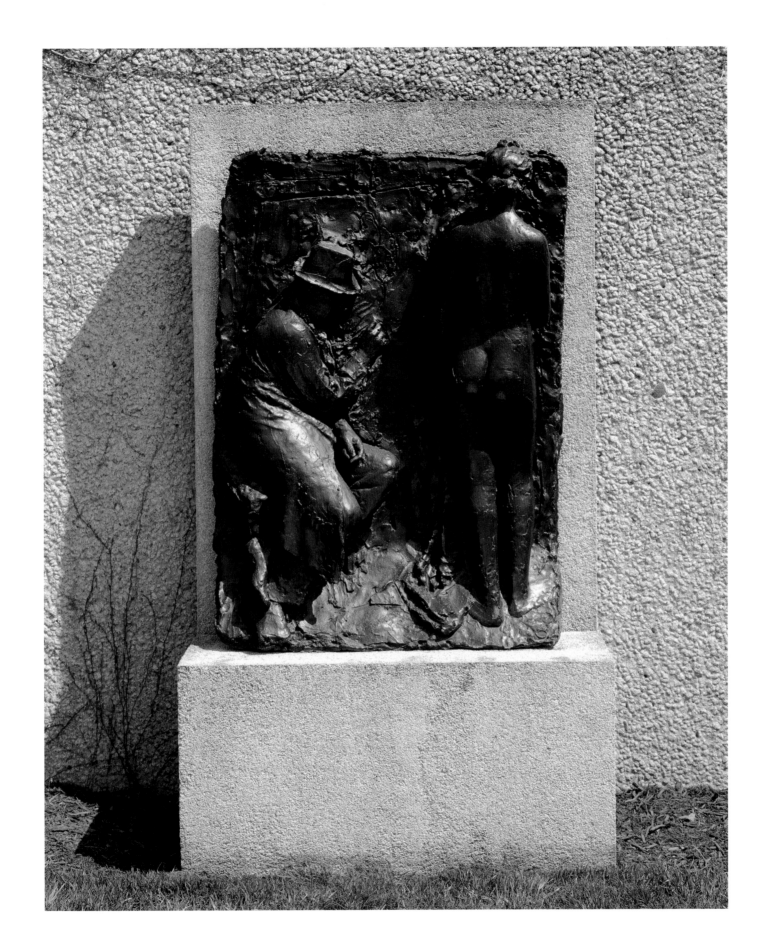

Arthur G. Dove

American, 1880–1946

City Moon, 1938

Oil and wax emulsion on canvas, 34⅞ x 25 in. (88.6 x 63.4 cm)

Gift of Joseph H. Hirshhorn, 1966 (66.1413)

Arthur Dove transformed the American landscape tradition with his abstract style of nature symbolism. After mastering a bold Post-Impressionist style, Dove began around 1910 to develop daring color abstractions based on natural and landscape motifs. About 1935 he started a series of paintings in which the luminous orb of a sun or moon predominated. His choice of such imagery reflected his admiration for the work of fellow American modernists, notably Georgia O'Keeffe and Oscar Bluemner, both of whom used dramatic abstractions of solar and lunar disks as early as 1917 and 1927–28, respectively. Soon after visiting Bluemner's solo exhibition in 1928, Dove wrote to him: "The 'Red Moon' I liked. It burns harder than fire. I like that sort of heat."

In *City Moon* a subdued palette and abstract natural forms produce an almost somber, contemplative mood. By applying an experimental mixture of oil paint and wax emulsion, Dove created an opalescent light in aureoles of subtle hues emanating from the moon. The artist inscribed the face of the moon with schematic features that animate his vision of nature and imbue his painting with melancholy whimsy. The pale yellow disk appears behind a linear network that suggests both a windowpane and the bars of a prison. Such dual allusions may reflect Dove's ambivalence toward city life and his mystical attachment to nature. JZ

Alexander Calder

American, 1898–1976

Constellation, 1943

Painted wood and wire

22⅝ x 28⅝ x 25⅝ in. (57.4 x 72.5 x 65 cm)

Gift of Joseph H. Hirshhorn, 1972 (72.55)

While working in Paris from 1926 to 1933, Alexander Calder was attracted by the Surrealists' emphasis on imagination and fantasy. A lifelong interest in the forms and structures of the cosmos inspired many of his sculptures, including the "Universe" series from the early 1930s, the "Constellations" from 1943 to 1945, and his famous later mobiles and stabiles. He intended those abstract compositions to serve as lyrical symbols or evocations of nature's systems: beautiful and ordered, yet tenuous and subject to change.

Although Calder preferred to work in steel, the wartime need to conserve metal led him to make the "Constellations" from painted wood and wire. Partly inspired by the series of gouaches by Joan Miró dating from 1939 to 1942, Calder developed the "Constellations" from his earlier mobiles—kinetic sculptures that hang by a thread from the ceiling. The Hirshhorn's tremulous structure appears fixed, yet it quivers at the slightest vibration. With the wires pointing in several directions, *Constellation* also suggests optical movement extending out into the universe. The open-form construction has complex spatial interplays of solids with energized space, and when lit from above, the sculpture takes on an ephemeral dimension in the patterns of light and shadow. The delicacy and elegance of *Constellation* generate an impression of lighthearted freedom. VJF

Isamu Noguchi

American, 1904–1988

Lunar Landscape, 1944

Magnesite cement, cork, fishing line, electric lights, and acetate
on wood mount, 34$^{1}/_{2}$ x 24$^{3}/_{4}$ x 7$^{7}/_{8}$ in. (87.5 x 62.8 x 20 cm)
Gift of Joseph H. Hirshhorn, 1966 (66.3867)

Son of a Japanese poet and an American writer,
Isamu Noguchi relied on his dual heritage to create
an art of poetic effect and technical innovation. His
sculpture was first defined by admiration for the carv-
ings of Constantin Brancusi, with whom Noguchi
worked in the late 1920s in Paris. Stone would remain
Noguchi's favorite material, but he also worked with
clay and paper and was well known as a designer of
landscapes, stage sets, and furniture. At the New
York World's Fair of 1939, he was impressed with the
malleability and strength of a new material, magne-
site, which he used in the "Lunar" series. The
Hirshhorn sculpture is a rare surviving example, in
which Noguchi used abstract biomorphic forms to
create a fantastic topography, ostensibly the moon's
cratered surface, with bobbing corks hovering like
satellites. Yet, as a vertical relief, Lunar Landscape also
suggests a theatrical backdrop for some mysterious
event, an effect enhanced by colored lights that shine
from hidden recesses. Writing to the Hirshhorn in
August 1972, Noguchi noted that he had created
Lunar Landscape after seven months in an internment
camp with other Japanese Americans:

> The memory of Arizona was like that of the moon, a
> moonscape of the mind…. Not given the actual space of
> freedom, one makes its equivalent—an illusion within the
> confines of a room or a box—where the imagination may
> roam to the further limits of possibilities, to the moon
> and beyond.

VJF

Theodore J. Roszak

American, born Poland, 1907–1981

Ascension, 1945

Painted wood, brass, and metal
108$^{1}/_{4}$ x 13$^{1}/_{2}$ x 13$^{1}/_{2}$ in.(274.8 x 34.1 x 34.1 cm)
Gift of Agnes Gund in honor of Sydney Lewis, 1991 (91.12)

Like many others in the early twentieth century,
Theodore Roszak welcomed modern technology,
industrial methods, and scientific discoveries as the
means toward a better life. Believing that art could
help engender this new order, he adopted the
abstract styles and new materials advocated by the
European Constructivists, who thought that a work
of art should serve as a metaphor for a future utopian
society. Machine-tooled metals, high-gloss paint in
bright colors, and crisp geometric forms characterize
Roszak's sculptures from 1930 to 1945, such as
Ascension. Devoid of references to past art or society,
this sculpture has a streamlined appearance in keep-
ing with industrial designs for mass-produced inven-
tions. To today's viewers, Ascension also resembles a
rocket or space station—futuristic imagery that
Roszak knew from extensive science-fiction readings.
Yet Ascension lauds not only material advances; its title
and verticality also imply an uplifting moral dimension.
The upward progression through the tapering cylin-
der to a sphere surmounted by an inexplicable brass
element suggests a progression of the human spirit
toward a higher consciousness—an interpretation fur-
thered by Roszak's use of blue and white, colors tradi-
tionally associated with spirituality. Furthermore,
Ascension may allude to the precarious nature of any
ideal existence: the sculpture's exquisite components
are assembled in a delicate balance that could be easi-
ly destroyed. Ironically, this was one of Roszak's last
Constructivist works, as the wartime horrors that
were revealed to the world in late 1945 led him to
abandon his utopian style for a savage expressionism.
VJF

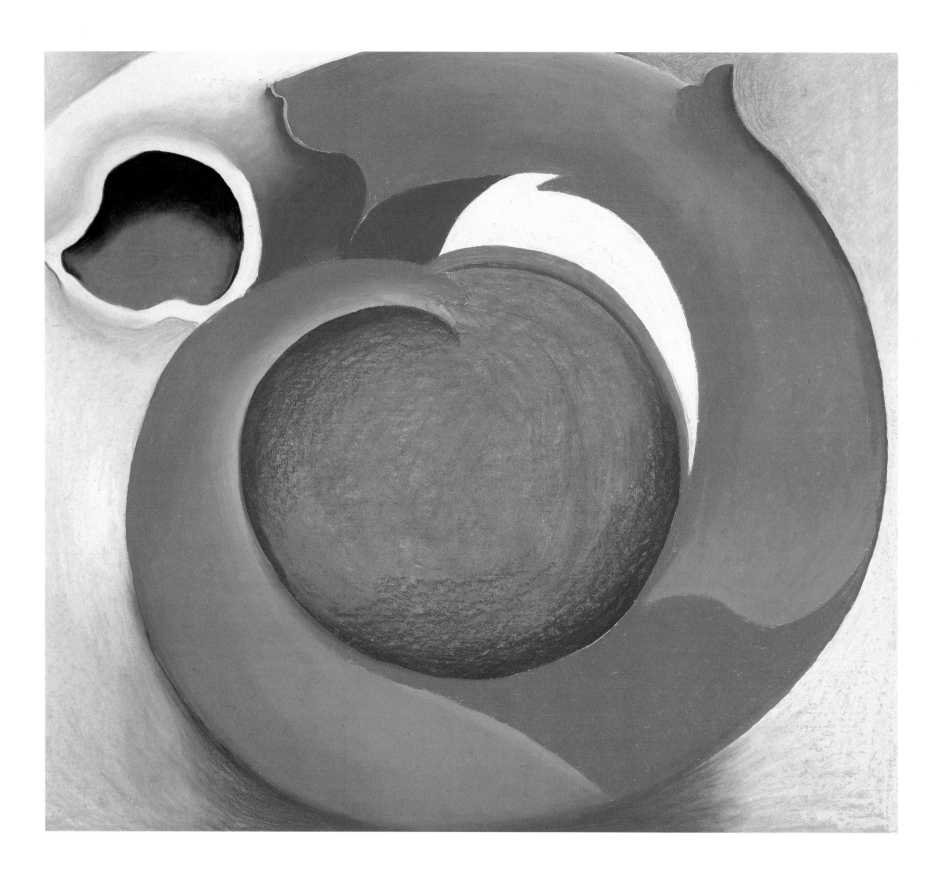

Georgia O'Keeffe

American, 1887–1986

Goat's Horn with Red, 1945

Pastel on paperboard, mounted on paperboard

27⁷/₈ x 31¹¹/₁₆ in. (70.7 x 80.4 cm)

Gift of Joseph H. Hirshhorn, 1972 (72.217)

Fusing her love for the New Mexico desert with her mastery of closely focused still-life imagery, Georgia O'Keeffe produced visionary paintings and pastels from such unlikely subjects as the animal skulls and bleached, skeletal fragments that she collected from that stark, arid landscape. From the early to the mid-1940s, she created a series of paintings based on the motif of the pelvis bone, in which she used the irregular curves of the bones to frame an expanse of blue sky. In composition and subject, the pastel *Goat's Horn with Red* is directly related to the austere imagery of that series. In 1943, O'Keeffe explained her unusual perspective for these works:

> I was most interested in the holes in the bones—what I saw through them—particularly the blue from holding them up in the sun against the sky as one is apt to do when one seems to have more sky than earth in one's world.

Here, O'Keeffe used the goat's horn as a compositional device much as she had used the pelvis bones, but she substituted the blood red of desert sands or the setting sun for the pure blue sky. Created during the last year of World War II, *Goat's Horn with Red* may represent O'Keeffe's oblique commentary on the war, for she believed that the sky and the landscape would survive "after all man's destruction is finished."
JZ

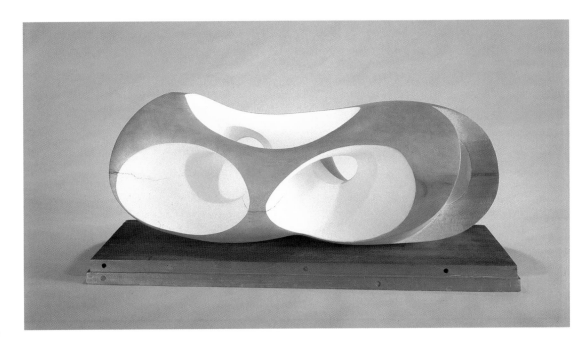

Barbara Hepworth

British, 1903–1975

Pendour, 1947–48

Painted plane wood

12¹/₈ x 29³/₈ x 9³/₈ in. (30.6 x 74.5 x 24 cm)

Gift of Joseph H. Hirshhorn, 1966 (66.2444)

Together with her friend Henry Moore and husband Ben Nicholson, Barbara Hepworth pioneered abstract art in Great Britain during the 1930s. After visits to Paris, she developed her style from Surrealist biomorphic forms, with their evocative associations of organic sources. Hepworth also espoused the "direct carve" aesthetic of Constantin Brancusi, which suited her own love of nature and natural materials. After initially working in London, she relocated in 1939 to the coastal town of St. Ives in Cornwall, where she found inspiration in the regional countryside. Henceforth, the sculptor wanted her works to have affinities with the forms and contours of that landscape, and she used colors as equivalents for the depth and coolness of water, caves, and shadows. Yet she never stooped to merely literal transpositions of geographic features (she invented the title only after a sculpture was completed). Rather, her compositions convey the rhythm and flow of water-smoothed rocks and coves, ancient hills, and prehistoric menhirs. *Pendour* was her first sculpture to have a specific place name: Pendour Cove is located on the north side of the Penwith peninsula, several miles west of St. Ives. Even without knowledge of its origins, a viewer can appreciate the sculpture's elegant and subtle play of curving shapes as they flow from outer contours through gently varied apertures. VJF

Horace Pippin

American, 1888–1946

Holy Mountain III, 1945

Oil on canvas, 25¼ x 30¼ in. (64.6 x 76.8 cm)

Gift of Joseph H. Hirshhorn, 1966 (66.4069)

Serving in an African American regiment during World War I in France, self-taught artist Horace Pippin received a wound that partially paralyzed his right arm. Thereafter, Pippin used painting as physical therapy, and in 1931 he was able to complete his first oil painting. Although his earliest works are somber depictions of his wartime experiences, his later scenes about World War II are hopeful and imbued with religious faith. In them he borrows imagery from the Bible, the lives of historical figures and friends, and memories of his childhood in small-town America.

Holy Mountain III is based on the biblical passage Isaiah 11:6–9, a prophecy that describes a peaceful world in which predatory animals live in harmony with their prey. Pippin's "Holy Mountain" series may have been inspired by the works of self-taught artist and Quaker minister Edward Hicks, who a century earlier had made some fifty paintings depicting Isaiah's prophecy. Rather than the Christ child of the parable, here a Black shepherd leads the flock. He stands in a flowered field surrounded by the docile beasts. A dense forest is suggested by a dark row of trees at the upper portion of the canvas. Although Pippin has hidden between the trees small, barely perceptible forms that disturb the utopia, he was convinced that peace would reign in the world. AC

Jean Dubuffet

French, 1901–1985

Limbour as a Crustacean, 1946

Oil and sand on canvas, 45¾ x 35 in. (116 x 88.8 cm)

Gift of the Joseph H. Hirshhorn Foundation, 1972 (72.100)

Jean Dubuffet, one of the most significant European artists of the postwar era, invented a body of imaginative work based on his iconoclastic concept of *l'art brut* (raw art). Rejecting traditional notions of beauty, he found authentic expression in the art of children, the insane, and the self-taught. By using unconventional materials and deliberately crude forms, he achieved a similarly powerful impact with works such as *Limbour as a Crustacean*. One of many portrait likenesses that he produced in 1946 and 1947, this painting was included in a controversial exhibition in Paris of Dubuffet's caricatures. In the postwar climate of suspicion that pervaded that city, Dubuffet portrayed the Parisian intelligentsia, many of whom were resistance leaders and a few of whom were suspected collaborators. In the exhibition catalogue, Dubuffet proclaimed: "These people are more handsome than they think: Long live their true faces." This painting represents the artist's lifelong friend the writer Georges Limbour, a member of the Surrealist movement who belonged to a circle of intellectuals associated with the underground resistance during the war. The frontally posed figure, incised like graffiti in an earth-toned paste of paint and sand, appears as a crablike creature with an enlarged carapace for a head and elongated appendages for arms. While the caricature typifies Dubuffet's *l'art brut*, such visual satire also belongs to the venerable tradition of political caricature created by Honoré Daumier. JZ

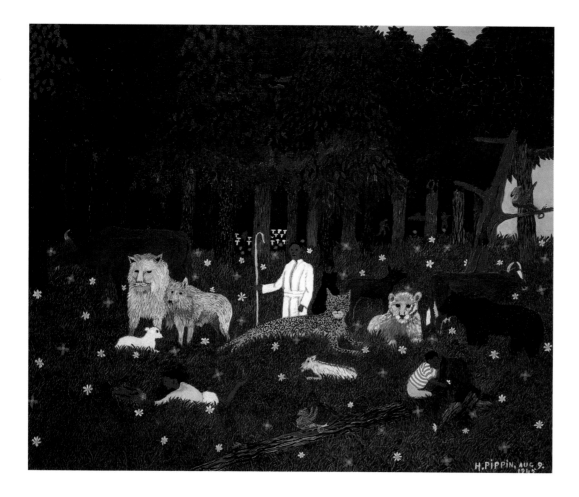

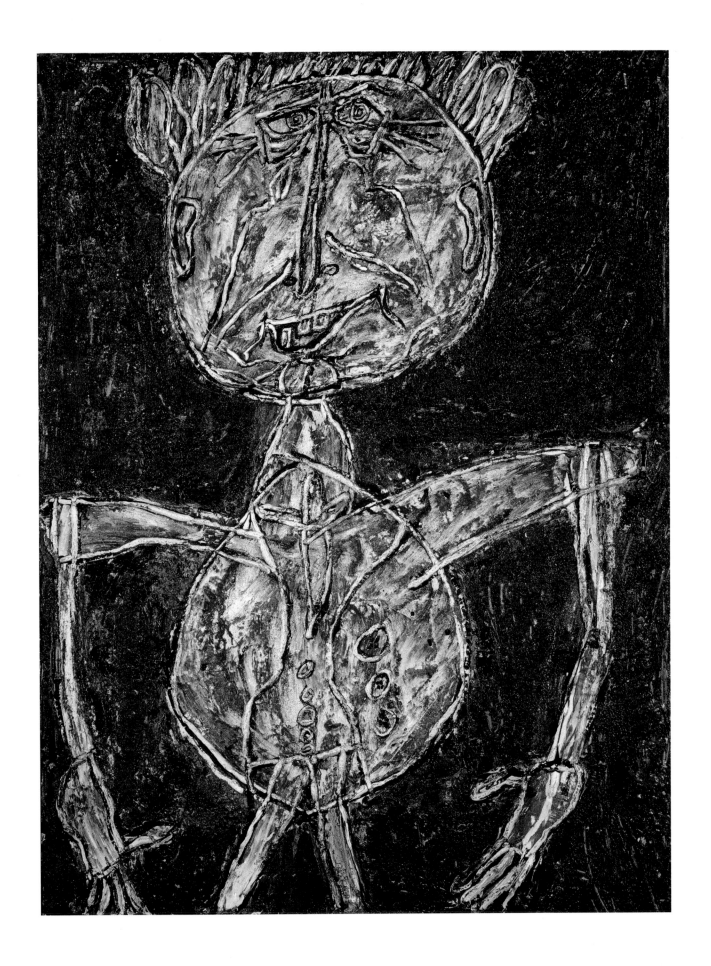

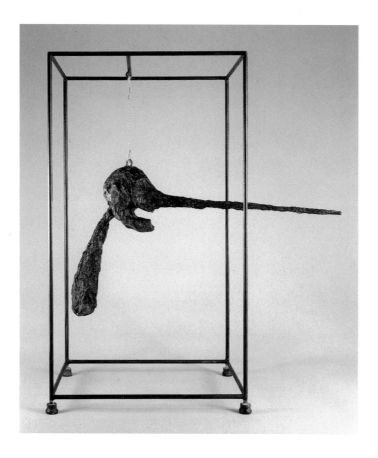

Alberto Giacometti

Swiss, 1901–1966

The Nose, 1947

Bronze, iron, twine, and steel wire, 1/6, cast late 1950s
32 × 28 1/2 × 15 3/8 in. (81.2 × 72.2 × 39.1 cm)
Gift of Joseph H. Hirshhorn, 1972 (72.132)

Working in Paris, Alberto Giacometti first gained renown for his Surrealist sculptures from 1929 to 1935. Their semi-abstract iconography introduced intriguing yet disturbing themes of sexuality, fantasy, and violence. In the aftermath of World War II, haunted by the horrors of death and suffering yet encouraged by their cessation, he developed an expressive figurative style, portraying startlingly skeletal nudes with attenuated proportions and expressionistically roughened surfaces. Their emaciation, anonymity, isolation, and intense stares impressed critics and the public as powerful metaphors for the human condition in a disillusioned age.

The Nose subsumed Giacometti's Surrealist penchant for violent themes into his postwar style. The pointed nose thrusts almost unbelievably outward—an assaultive form aimed at the viewer like a rifle or sword—and the macabre impression is accentuated by the gaping toothless grin and hollow eyes. The overall shape of the head was inspired by a bamboo-and-bark mask from the Baining people of New Britain in the collection of Museum für Völkerkunde, Basel, and by the shaved, emaciated skulls of prisoners liberated from Nazi concentration camps. By suspending the head inside a cage, Giacometti emphasized the theme of imprisonment, but he went beyond a specific reference to war and instead created a symbol for myriad states of mind: The Nose expresses the mental prison of one's own fears, or the possibility of extending beyond physical or psychological cages, or, conversely, the need to contain or restrain the potential of an inner evil. VJF

Jean Dubuffet

French, 1901–1985

The Soul of Morvan, 1954

Grape wood and vines mounted on slag base, with tar, rope, and metal, 18 3/8 × 15 3/8 × 12 3/4 in. (46.5 × 38.9 × 32.4 cm)
Gift of Mary and Leigh B. Block, by exchange, 1989 (89.19)

Jean Dubuffet began his art studies at the Académie Julian in Paris in 1918 but returned to Le Havre in 1925 to join his family's wine business. Only in 1942, at the age of forty-one, did he decide to devote himself to art full-time. The Soul of Morvan, part of a series of objects titled "Little Statues of Precarious Life" produced in 1954, is among Dubuffet's first significant attempts at sculpture. Continuing his earlier interest in assemblage, he turned to unrefined natural materials, such as charcoal, sponges, and slag, to create the bizarre and humorous cast of characters that make up the series.

The only sculpture in the series employing a narrative theme, The Soul of Morvan is an unorthodox, three-dimensional rendering of a figure in a landscape. The artist literally used the grapevines from the area to evoke a weatherworn man laboring in a vineyard in the wine-growing region of Morvan, west of Burgundy, France. By employing organic materials in their rough state, Dubuffet capitalized on the expressive potential of their earthiness. Rejecting traditional notions of beauty and reason in favor of visual rawness and instinct, Dubuffet was an iconoclast who created an inventive and sometimes shocking body of work that expanded the parameters of the subject matter and materials of art. AC

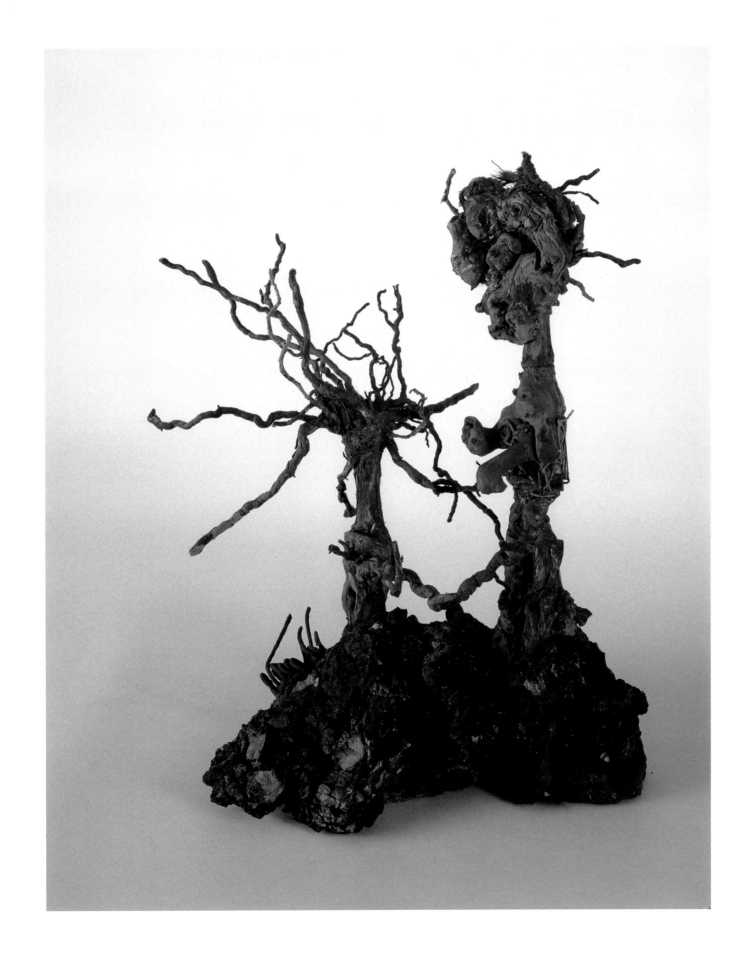

Balthus

French, born 1908

The Golden Days, 1944–46

Oil on canvas, 58¼ x 78⅜ in. (148 x 199 cm)
Gift of the Joseph H. Hirshhorn Foundation, 1966 (66.347)

In *The Golden Days,* Balthus (born Balthasar Klossowski de Rola) fused his reverence for the figurative tradition in Western painting with his predilection for disquieting eroticism. Within a subdued and well-ordered interior, a languorously reclining adolescent girl gazes in a mirror. To the far right, in the background, an anonymous male figure tends a fire in the hearth. The resulting opposition of two isolated figures creates a mysterious sexual tension. Balthus explained, "In all dialogue, there is an invisible wall between the two people speaking…. I simply try to realize something … a painting which corresponds to an interior vision that I possess within myself."

The warm glow suffusing *The Golden Days* conjures a mood of reverie. It has been suggested that Balthus derived the composition and theme from the seventeenth-century Neoclassical painting *Echo and Narcissus* by Nicolas Poussin. Yet the pose of Balthus's adolescent owes as much to the motif of Venus with a mirror as to the image of Narcissus. The novelty of Balthus's conception lies in his choice of a pubescent girl as the central figure. In this context, the male figure tending the fire may derive from Vulcan, husband of Venus and god of war, at his forge.

Concentrating on technical mastery, Balthus reworked the composition over two years. He later admitted, "I am only able to paint when the light is nearly motionless, a moment that hardly lasts at all." *The Golden Days* may allude to the conflagration of war and the self-absorption of the arts. JZ

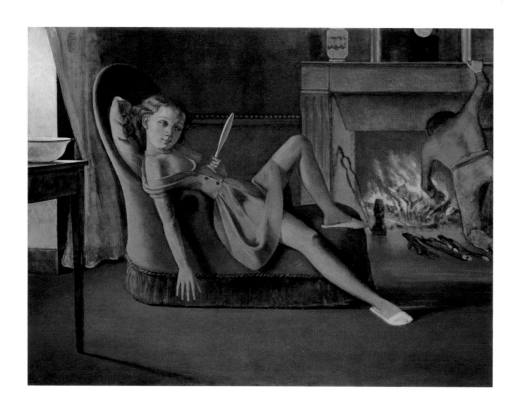

René Magritte

Belgian, 1898–1967

Delusions of Grandeur II, 1948

Oil on canvas , 39⅛ x 32⅛ in. (99.2 x 81.5 cm)
Gift of Joseph H. Hirshhorn, 1966 (66.3199)

Delusions of Grandeur II typifies the mordant wit and disturbing power of René Magritte's mature paintings. The image of a nude female torso, divided into three successively smaller sections, provides the focal interest of the canvas. With smooth, almost polished surfaces that belie its lifelike flesh tones, the tripartite torso assumes an ambiguous role as a metaphor of aggrandizement or diminution. The torso divided in this way was a recurrent motif in Magritte's work, appearing as early as 1938 in his painting *The Course of Summer.* That same year, he explained in a letter his obsessive fascination with the tripartite torso: "That was just a dream about the present: each torso section represents a past generation."

In *Delusions of Grandeur II,* Magritte juxtaposed the statuesque torso against a stone sill on which a white candle burns in broad daylight. Beyond the window, white clouds, a tiny hot-air balloon, and sky blue cubes float above a calm sea. Each element is rendered with a hard-edge realism that has been likened to Flemish Renaissance painting. Through his meticulous technique, Magritte imbued the incongruous and the improbable with a magic verisimilitude. In the last year of his life, Magritte supervised the casting of bronze sculptures based on the central image of this painting, a cast of which is in the Hirshhorn collection. JZ

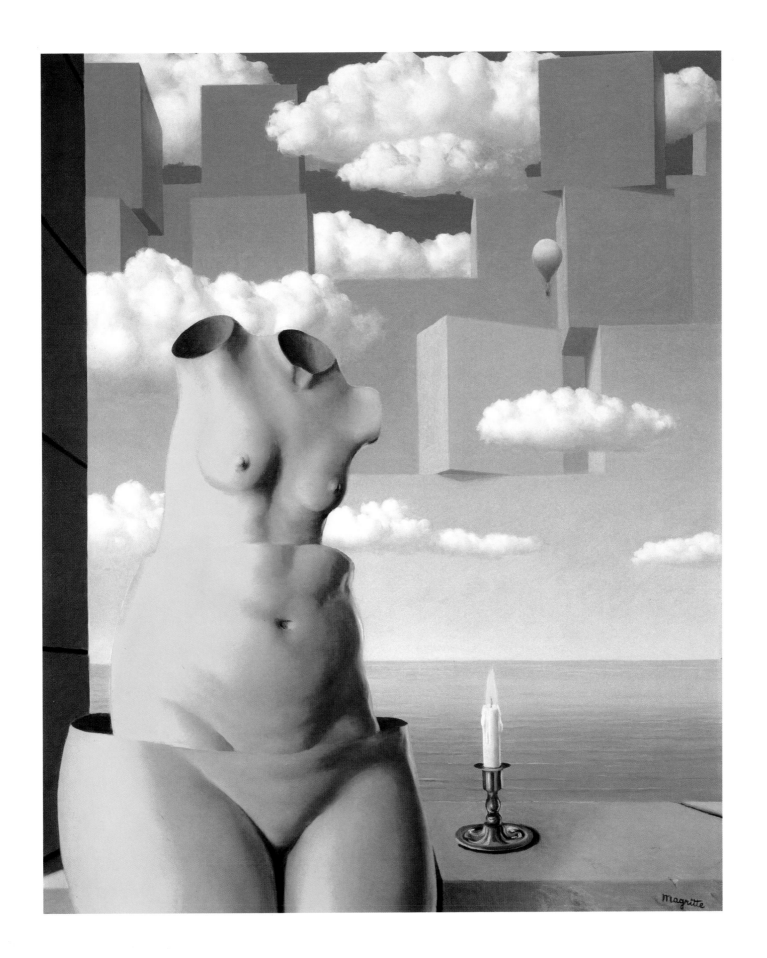

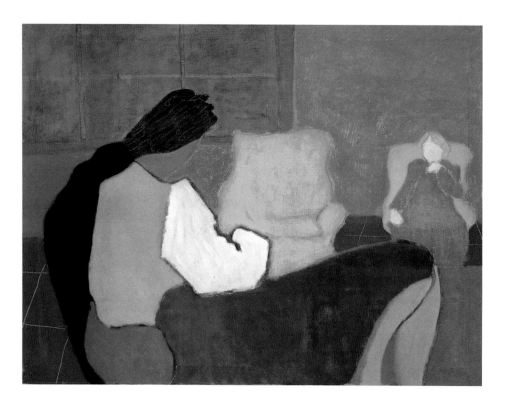

Willem de Kooning
American, born The Netherlands, 1904

Woman, 1948
Oil and enamel on fiberboard
53⁵/₈ × 44⁵/₈ in. (136.1 × 113.2 cm)
Gift of the Joseph H. Hirshhorn Foundation, 1966 (66.1197a)

In the late 1940s, Willem de Kooning, whose daring black-and-white compositions had established his reputation as a leader of the New York avant-garde, transformed Cubist abstraction into an expressionist style of painting. In this *Woman* of 1948—from his second "Woman" series—de Kooning explored figure painting with methods derived from his abstractions. Violent anatomical distortions and vigorous brushstrokes merge figure and ground to produce an ambiguous pictorial space and a powerfully emotive image. De Kooning would later recall, "The *Woman* became compulsive."

Occupying the center of the panel, the figure appears to stare both at the viewer and at the yellow sunburst in the upper left. The simultaneous presentation of the face in profile and full view emulates Pablo Picasso's technique of facial distortion. The exaggerated solar or astral image at the left evokes a hieroglyphic emblem and a cartoonlike sign from a commercial advertisement. To the upper right of the woman, a drawing of a house—a motif common in de Kooning's abstractions of the period—contributes to the painting's spatial ambiguity. The schematic rendering of the woman's body below her shoulders resembles the activated surfaces of de Kooning's abstractions. Heavy black lines define her breasts, while her arms, torso, and blonde hair seem to dissolve in the matrix of colors and black drips. Half-hidden under the layers of transparent paint, pencil and charcoal drawings of indeterminate shapes indicate that de Kooning continuously revised the painting to attain the explosive force of the final image. JZ

Milton Avery
American, 1885–1965

Sally and Sara, 1947
Oil on canvas, 33 × 43⁷/₈ in. (83.8 × 111.5 cm)
Gift of the Marion L. Ring Estate, 1987 (87.21)

In the summer of 1947, Milton Avery and his wife, Sally, visited art collector Sara Blaffer at her estate outside Toronto. A sketch that Avery made of the two women there became the basis for this painting, an intimate domestic scene in which the artist creates monumental imagery. A subtle colorist who would win critical acclaim for the formal purity and chromatic resonance of his paintings, Avery here built his composition with bright areas of thinly applied pigment. His use of vivid hues, decorative lines, and flat pattern reveal his debt to Henri Matisse. Echoing the ideas of the French artist, Avery wrote in 1951:

I work on two levels. I try to construct a picture in which shapes, spaces, colors, form a set of unique relationships, independent of any subject matter. At the same time I try to capture and translate the excitement and emotion aroused in me by the impact with the original idea.

By generalizing the figures and the interior surroundings into planes of intense colors, Avery has rendered the women anonymous and made the primary impact of the scene formal rather than anecdotal. Avery, whose happy domestic life and the New England countryside served as ideal subjects for his increasingly abstract paintings, gained national renown as a resolutely independent modern artist and one of this country's most subtle colorists. His wife, daughter, and their friends often were his models for his spare but colorful canvases. JZ

Arshile Gorky

American, born Armenia, 1904–1948

Soft Night, 1947

Oil, india ink, and conté crayon on canvas
38⅛ x 50⅛ in. (96.7 x 127.1 cm)
Joseph H. Hirshhorn Bequest, 1981 (86.2341)

Born Vosdanik Adoian in Khorkom, Armenia (now eastern Turkey), Arshile Gorky immigrated to the United States in 1920, at age sixteen, after experiencing ethnic persecution and continuing poverty and starvation during World War I. In 1925 he chose his adopted name, claiming to be related to the Russian writer Maxim Gorky, whose name also was invented. During the late 1920s and early 1930s, Gorky painted portraits, still lifes, and abstract compositions with successive references to the styles of Paul Cézanne, Joan Miró, Pablo Picasso, and other European avant-garde artists. Less well known was his interest in Armenian religious art, which linked the imagined with the real. Gorky synthesized these influences and, liberated by Surrealist concepts of automatism, became a central, if tragic, figure in the transition of American art during the 1940s from a regional to an international focus.

Gorky often combined sensual drawing and color applied in either rich, opaque layers or thin, transparent washes. *Soft Night* is distinguished by Gorky's sinuous line, the thin layer of paint accented with bits of red, yellow, purple, and green, and the biomorphic, bonelike forms that became his personal symbol and motif. Many of Gorky's paintings from the 1940s are vibrantly colored; *Soft Night* is rare in its use of velvety grays that, like its title, create a sense of mystery and melancholy. Many works from the same period are similarly constructed around a series of vertical forms that undulate across the surface of the canvas, like plants growing in a field. PR

Clyfford Still

American, 1904–1980

1948-C, 1948

Oil on canvas, 80⅞ x 68¾ in. (205.4 x 174.6 cm)
Joseph H. Hirshhorn Purchase Fund, 1992 (92.8)

North Dakota native Clyfford Still played a pivotal role in the rise of the postwar vanguard on both the East and West coasts. An influential teacher at the California School of Fine Arts in San Francisco from 1946 to 1948, he was also involved with the formation of the "Subjects of the Artist" School, an informal New York group closely associated with the Abstract Expressionist movement. During the 1940s, Still developed a personal style of abstraction distinguished by deeply troweled surfaces and expanses of rich color. Responding to a variety of sources, from the philosophy of Friedrich Nietzsche to the art of Native Americans, Still sought to evoke in his work the power of primordial nature and primal symbolism. The painting *1948-C* reveals the painter's expressive gesture in its characteristic jagged forms and richly textured surface and his reduced subject of suggestive shapes within fields of color. His practice of using dates and letters to identify canvases reflected the Abstract Expressionists' efforts to transcend the bounds of language and communicate on a universal level. Still experimented with technique by varying the color, texture, and shapes within similar canvases; several variants of the composition of *1948-C* exist. This painting is notable for the subtle variation of its intense golden hues, while the bright yellow streak across the upper right energizes the composition with the force of a lightning bolt. Combining sublime color with emotive mystery, *1948-C* exemplifies Still's mastery of color and texture in an expansive field. JZ

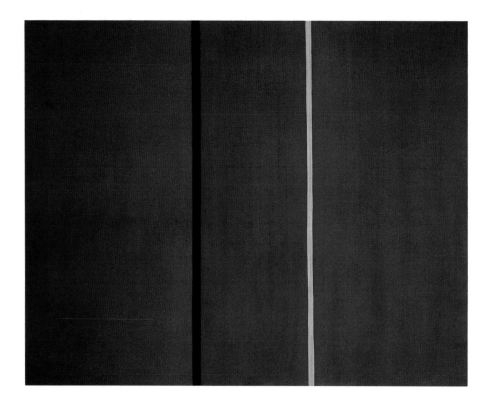

Barnett Newman

American, 1905–1970

Covenant, 1949

Oil on canvas, 47³/₄ × 59⁵/₈ in. (121.3 × 151.4 cm)
Gift of Joseph H. Hirshhorn, 1972 (72.213)

Together with his painter friends Jackson Pollock, Mark Rothko, and Clyfford Still, who became associated with the New York School, Barnett Newman sought an art that was new, American, and sublime. In 1948 he painted *Onement*, a monochromatic canvas of dark cadmium red with a single stripe of light cadmium running through its center. That radically simplified work provided the formal basis for his subsequent paintings, the basic element of which is a flat, unmodulated color field interrupted only by varying numbers of vertical stripes. *Covenant*, painted the following year, is an early example: its deep, maroonish red is intersected by one dark and one yellow stripe. In such a simplified format each component of the painting assumes equal compositional importance.

Critical interpretations of Newman's work often focused on its purely formal qualities of flatness and nonreferentiality. Newman, however, believed in the metaphysical content of his work. For him the broad expanses of color in the paintings represented a "sublime void," or the unknowable, and the vertical stripes, or "zips," that divided it signified energy and pure, subjective reality. Although Newman created visual means to express his metaphysics, he sometimes also evoked thoughts on creation and being through his titles. *Covenant,* for example, alludes to the pact between God and humanity recorded in the Old Testament. PR

Jackson Pollock

American, 1912–1956

Number 3, 1949: Tiger, 1949

Oil, enamel, metallic enamel, string, and cigarette fragment on canvas mounted on fiberboard
62¹/₈ × 37¹/₄ in. (157.7 × 94.6 cm)
Gift of Joseph H. Hirshhorn, 1972 (72.235)

Around 1947, Jackson Pollock began to create his "poured" paintings. To make works such as *Number 3, 1949: Tiger,* he spread the canvas on the floor, then poured, dripped, and spattered paint onto it from a brush or stick. The concept of creating an image directly on the ground is partially derived from Native American and Asian religious pictorial traditions. With that method, Pollock also introduced "allover," or nonrelational, composition, in which all areas of the picture are equally emphasized (in traditional Western compositions, on the other hand, parts are balanced against one another). In his work, line is melded with form rather than used to define shapes.

Pollock's process of painting was deliberately apparent in the final form: the image itself contains the record of its making. In this way, Pollock was identified more than any other artist of his generation with the idea of artwork as an extension of the artist's being, meaning that every movement of the artist's hand or arm is recorded in the finished picture. Because the artist's motions are thought to be dictated by the unconscious psyche, the artist is seen to be baring his soul in a heroic gesture. Paintings such as *Number 3, 1949: Tiger* retain the freshness and vigor of accidental drops of paint and unplanned convergences of line and color. Its seemingly random, explosive energy is contained within successive skeins of paint that form repeated rhythms within the borders of the painting. PR

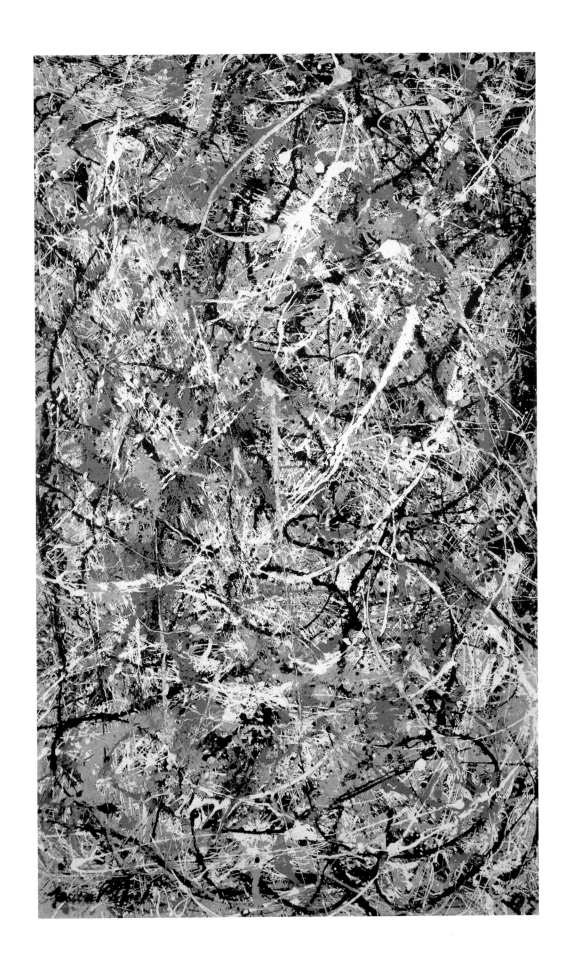

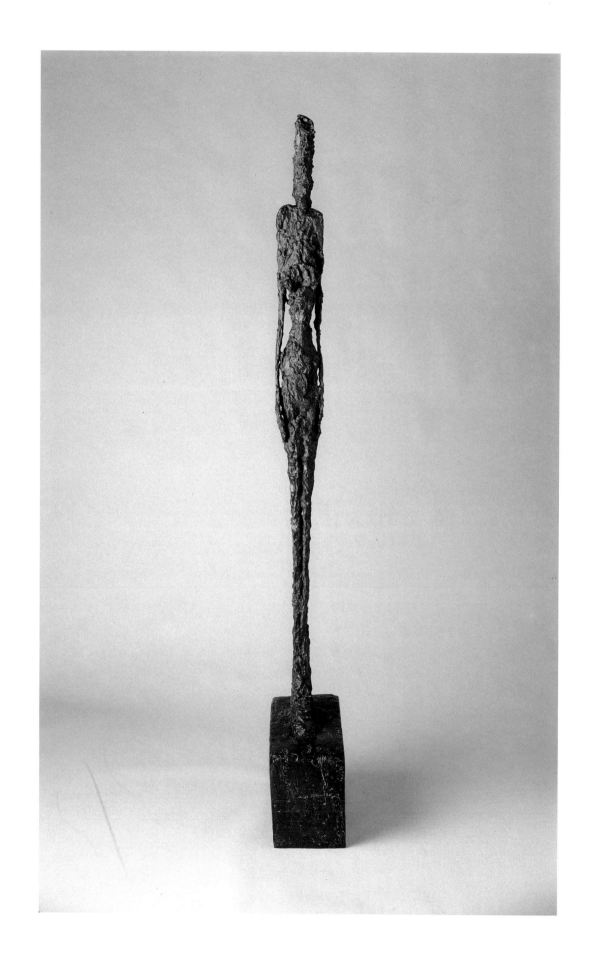

Alberto Giacometti

Swiss, 1901–1966

Tall Figure, 1947

Bronze, 1/8
79¼ x 8⅜ x 16⅝ in. (201.2 x 21.1 x 42.2 cm)
Gift of Joseph H. Hirshhorn, 1966 (66.2031)

Alberto Giacometti's interest in the female nude as a subject for drawings, paintings, and sculptures extended through his entire career. Early sculptures include the African-inspired *Spoon Woman* of 1926–27 and the Surrealist *Invisible Object* of 1934, but with his return to figuration in 1935 the subject became crucial. After obsessively working on, and destroying, tiny figurines during the war years, Giacometti then modeled a series of gradually larger, hauntingly gaunt female nudes that helped establish his international reputation. Subsequent nude sculptures of the 1950s tended to be smaller and more naturalistic, although in 1959–60 he returned to the "Tall Figure" type in monumental scale for an unrealized commission for the Chase Manhattan Plaza in New York.

With few exceptions, Giacometti's female nudes present a consistent image: an iconic, immobile, unapproachably remote persona with hands fixed rigidly at her sides and feet anchored in a heavy base. Yet despite her apparent passivity, *Tall Figure* serves as an archetype of indestructible human nature. Despite struggles and sufferings that seem to have ravaged her flesh, the irreducible essence of this woman—a symbol for humanity through the ages—has survived. Like the ancient sculptures of Egypt that Giacometti so admired, *Tall Figure* has a mythic, eternal grandeur. The sense of her aloofness and mystery is reinforced by the expressionistic modeling: the rough surfaces can be understood only from a certain distance. VJF

Louise Bourgeois

American, born France, 1911

The Blind Leading the Blind
c. 1947–49

Painted wood, 70⅜ x 96⅞ x 17⅜ in. (178.7 x 246.1 x 44.1 cm)
Smithsonian Collections Acquisition Program with matching funds from the Jerome L. Greene, Agnes Gund, Sydney and Frances Lewis, and Leonard C. Yaseen Purchase Fund, 1989 (89.17)

Living in New York during the mid-1940s, when World War II cut her off from friends and family in France, Louise Bourgeois created vertical wood sculptures that she exhibited as solitary figures loosely grouped. These objects represented sorely missed people and her own loneliness and isolation in America. In 1948, Bourgeois made the first of five variations of this work as pairs of legs which, unable to stand alone, were bound together for strength by lintel-like boards. The figures appear to walk tentatively on tiptoe under the boards, the weight of which presses down on the individual pairs even as it holds them together as an uneasy collective. One of the artist's most abstract works, this sculpture takes on an anthropomorphic presence by resting directly on the floor and sharing the viewer's space.

After being called before the House Un-American Activities Committee in 1949, Bourgeois named the series "The Blind Leading the Blind." The title paraphrases Jesus' description of the hypocritical Pharisees and scribes (Matthew 15:14): "Let them alone, they are blind guides. And if a blind man leads a blind man, both will fall into a pit." Exposing the folly of untested belief, unscrutinized ritual, and regimented thinking, the parable has been used as a subject by other artists. Most notable is the satirical painting of the same name by the sixteenth-century Netherlandish artist Pieter Brueghel the Elder. ALM

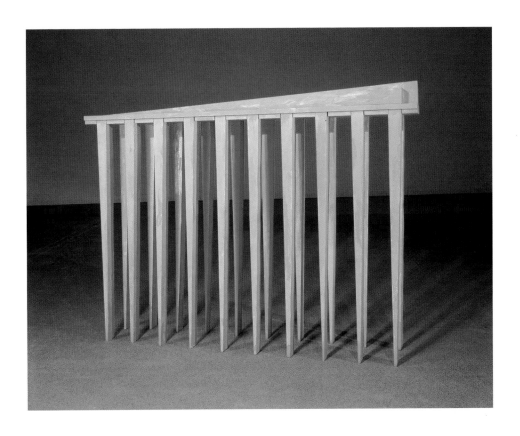

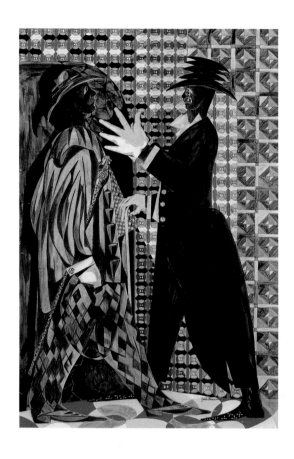

Jacob Lawrence
American, born 1917

Vaudeville, 1951

Tempera on fiberboard with pencil

28⁷/₈ × 19¹⁵/₁₆ in. (75.9 × 50.7 cm)

Gift of Joseph H. Hirshhorn, 1966 (66.2913)

After spending his early childhood in Pennsylvania, Jacob Lawrence moved with his family to Harlem in 1930. The flourishing cultural scene of the Harlem Renaissance nurtured the young artist, who attended after-school art classes taught by painter Charles Alston. Lawrence's earliest paintings were small-scale genre scenes depicted in cutout-like forms. Working within a narrative representational style, he explored themes of African American life and struggle. Lawrence often used series to depict historical and autobiographical events. The first of these, begun in 1937, was based on the life of the Haitian independence leader Toussaint L'Ouverture. In 1938, Lawrence joined the easel division of the Federal Art Project of the Works Progress Administration, for which he produced art devoted to the abolitionists Frederick Douglass and Harriet Tubman.

Vaudeville was inspired by the famous Apollo Theater, which Lawrence viewed as a reflection of Harlem life. He later commented:

> The Apollo was a most popular vaudeville house ... during the 1930s and early 1940s.... The comedians mirrored the cultural mores and everyday life of the people within the Harlem community. Through the comedians, the people of Harlem could laugh at themselves.

Vaudeville is one of twelve works in Lawrence's "Theater" series, which incorporates colorful patterned backgrounds and abstract elements. Here, two actors appear in profile against an elaborate backdrop, the gloved hand of one performer prominently reaching toward the other. The bright colors, shallow space, and figures and objects rendered in flat, simple forms are characteristic of Lawrence's oeuvre. AC

Stuart Davis
American, 1892–1964

Rapt at Rappaport's, 1952

Oil on canvas, 52 × 40 in. (131.8 × 101.4 cm)

Gift of the Joseph H. Hirshhorn Foundation, 1966 (66.1165)

Merging everyday subjects with the formal inventions of European modernism, Stuart Davis created a distinctively American style of painting. In late works such as this he blended inventive spatial design, bold color, and images from popular culture to capture the vitality and boisterous tempo of modern city life. Here, the sharp color contrasts, lively pattern, and inscribed words evoke the vibrant aesthetics of American jazz. The composition of *Rapt at Rappaport's* is based on a canvas Davis had painted thirty years earlier, *Landscape, Gloucester*, 1922. Explaining that the Gloucester scene sparked a "chain reaction" of visual associations, Davis transformed a Cubist view of a shanty by a dockside into a brilliant amalgam of color, abstract shapes, letters, and words. A methodical worker and theorist who often reworked and transposed earlier compositions, Davis recorded ideas about this painting in preparatory sketches and studies; he developed the final painting by dividing the canvas into sections with tape so that he could concentrate separately on each one. Flat areas of blue, orange, violet, and black and white accent and complement the dominant green background. Although "Rapt at Rappaport's" might be a play on words referring to a New York toy store, it is more likely that Davis selected the words for the alliterative power of their sound. JZ

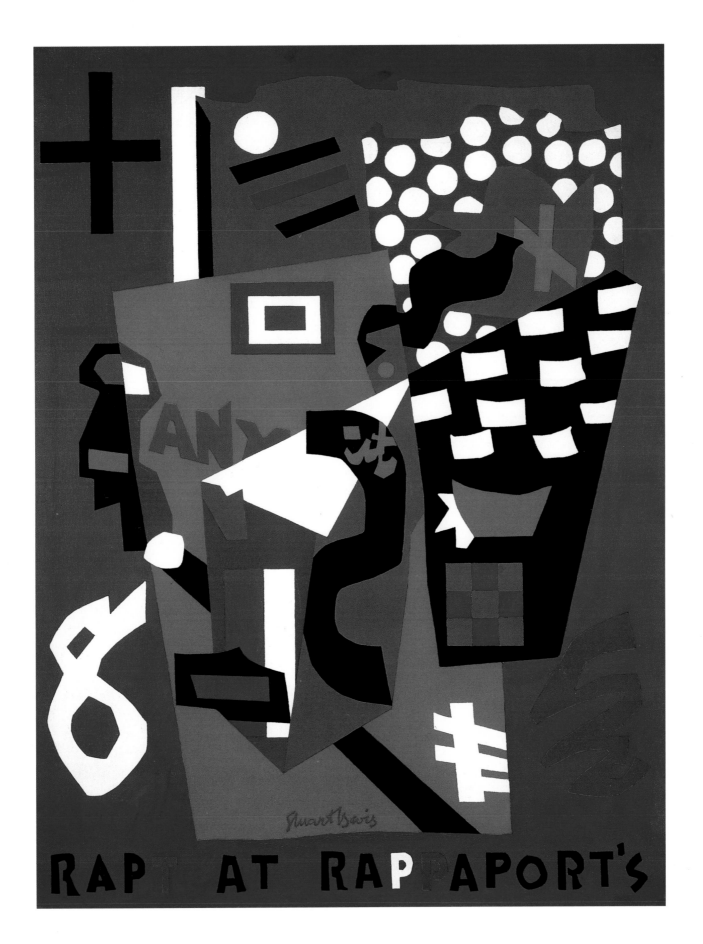

Edward Hopper

American, 1882–1967

First Row Orchestra, 1951

Oil on canvas, 31 1/8 x 40 1/8 in (79 x 101.9 cm)

Gift of the Joseph H. Hirshhorn Foundation, 1966 (66.2506)

Among Edward Hopper's favorite urban subjects were the theaters and movie houses of Manhattan. *First Row Orchestra* belongs to this group of richly evocative paintings. Hopper and his wife, Josephine Nivison Hopper—a painter and former actress—were frequent theater- and moviegoers. As an illustrator early in his career, Hopper had occasionally produced commercial illustrations on theatrical themes. While the performing arts had long provided subject matter for modern artists (notably Edgar Degas), Hopper most often chose to depict the audience rather than the performers.

For *First Row Orchestra* he selected an oblique vantage point that accentuates the perspectival recession of the stage and orchestra seats that seem to converge on the stylishly attired couple seated at the far right. The gentleman in tuxedo and his companion in a fur coat share a playbill before the performance begins. The psychological distance between man and woman is at odds with the intimacy of their shared action. Working in his characteristically spare style, Hopper recast the public sphere of the theater as the setting for a private drama of modern life. JZ

Edwin Walter Dickinson

American, 1891–1978

Self-Portrait, 1954

Oil on canvas, 26 1/4 x 24 3/8 in. (66.6 x 61.8 cm)

Gift of the Joseph H. Hirshhorn Foundation, 1966 (66.1359)

With a mastery of the difficulties of delineating space, foreshortening figures, and capturing complex effects of lighting, Edwin Dickinson created paintings with unusual perspectives. His seemingly disorganized, dreamlike fantasies are governed by an underlying sense of order, with each essential form realized with precision and refinement.

Dickinson was sixty-three years old when he completed this self-portrait. The viewer sees the artist's face from a low perspective, his head tilted and his mouth slightly open, as though he is about to speak.

A strong horizontal element behind him implies an indistinct and ambiguous space while it also thrusts his head forward and creates drama. Lighting directs the viewer to the face, which is carefully formed with subtle passages of light and dark muted colors. In contrast, expressive brushstrokes describe the subject's jacket and hint at the background.

In this introspective self-portrait, one of many such works in which Dickinson probed his own psyche, he portrays himself with the same care and imagination evident in his portraits of relatives and friends. Here, the aging artist's fierce expression is accompanied by a hint of subdued rage. Combining naturalistic skill and imagination in his paintings, Dickinson achieved a free, expressive style that challenged academic conventions as well as the avant-garde trends of twentieth-century American art. FG

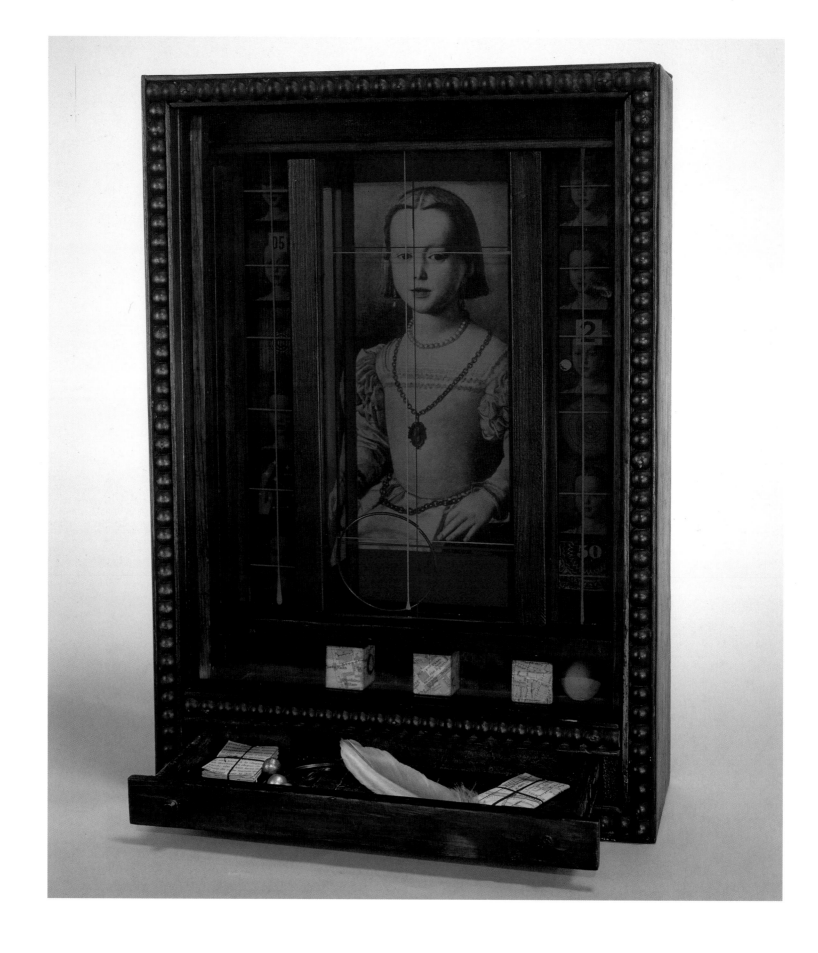

Joseph Cornell

American, 1903–1972

Medici Princess, c. 1952

Wood box with photomechanical reproductions, painted and
colored glass, painted paper, metal rings, plastic balls, and a
feather; $17^5/8 \times 12^1/4 \times 4^3/4$ in. (44.5 × 31.1 × 12.1 cm)
Museum Purchase, 1979 (79.275)

Working in his home in Queens, New York, Joseph
Cornell assembled an intriguing array of objects into
glass-fronted wood boxes—self-contained imaginary
worlds filled with emblems of his fantasies, musings,
yearnings, dreams, delights, and regrets. Through the
boxes, he speculated about historical personages and
explored foreign lands.

From 1942 to 1954, Cornell created the "Medici"
series, featuring images of the famed family that ruled
Florence during the Renaissance. *Medici Princess* cen-
ters on Agnolo Bronzino's portrait of Bia, an illegiti-
mate daughter of the great Duke Cosimo I (whose
image appears on her necklace). Born around 1536,
the little girl had every material comfort, yet her
father's wealth and power could not prevent her
death at age five. Using reproductions of Bronzino's
elegant portrait (Galleria Uffizi, Florence) in at least
nine boxes, Cornell sealed her image behind blue
glass in the Hirshhorn work, making the girl appear
ethereal and remote. The portrait is repeated in
ancillary compartments, puzzlingly juxtaposed with
numbers and circles. At the bottom, below excerpts
from a map of Florence, a drawer reveals a blue
feather, five faux pearls, two bracelets, and cut-up
pages from an old book tied into two packets like the
precious memorabilia of a past life. The box's formal
structure seems to imply a narrative, yet the mysteri-
ous components reveal no forthright message.
Rather, the work invites viewers to imagine stories,
travel into the past, and play and dream the way a
child does. VJF

Jasper Johns

American, born 1930

Untitled, c. 1954

Painted wood, painted plaster cast, photomechanical
reproduction on canvas, glass, and nails
$26^1/4 \times 8^7/8 \times 4^3/8$ in. (66.6 × 22.5 × 11.1 cm)
Smithsonian Collections Acquisition Program with matching
funds from the Thomas M. Evans, Jerome L. Greene, Joseph H.
Hirshhorn, and Sydney and Frances Lewis Purchase Fund,
1987 (87.20)

In the 1950s, Jasper Johns began to incorporate graph-
ics, repetition of forms, and mass-market objects and
images in his work, bridging the gaps between the
painterly textures of Abstract Expressionism, the ana-
lytic formalism of Minimalism, and the popular iconog-
raphy of Pop Art. Like Johns's other early works, this
untitled box construction breaks down distinctions
between painting and sculpture. It predates by one
year the artist's well-known *Target with Four Faces*,
1955, a painting of a circular target surmounted by
four plaster casts of fragments of a human face. The
Hirshhorn piece incorporates such collage elements
as an image of an ear, bits of Chinese calligraphy, and
labels written in Hungarian and German, including
one of a Brooklyn piano maker with a German name.
What appears to be a palmistry chart on the back of
the box suggests an interesting link with the box con-
structions of Joseph Cornell.

In 1954, Johns destroyed all the work in his posses-
sion. *Untitled* was spared, however, because it was
owned by Rachel Rosenthal, a performance artist
based in Los Angeles who was an early mutual friend
of Johns, composer John Cage, and dancer Merce
Cunningham. It is a cast of her face in this memento-
like construction. PR

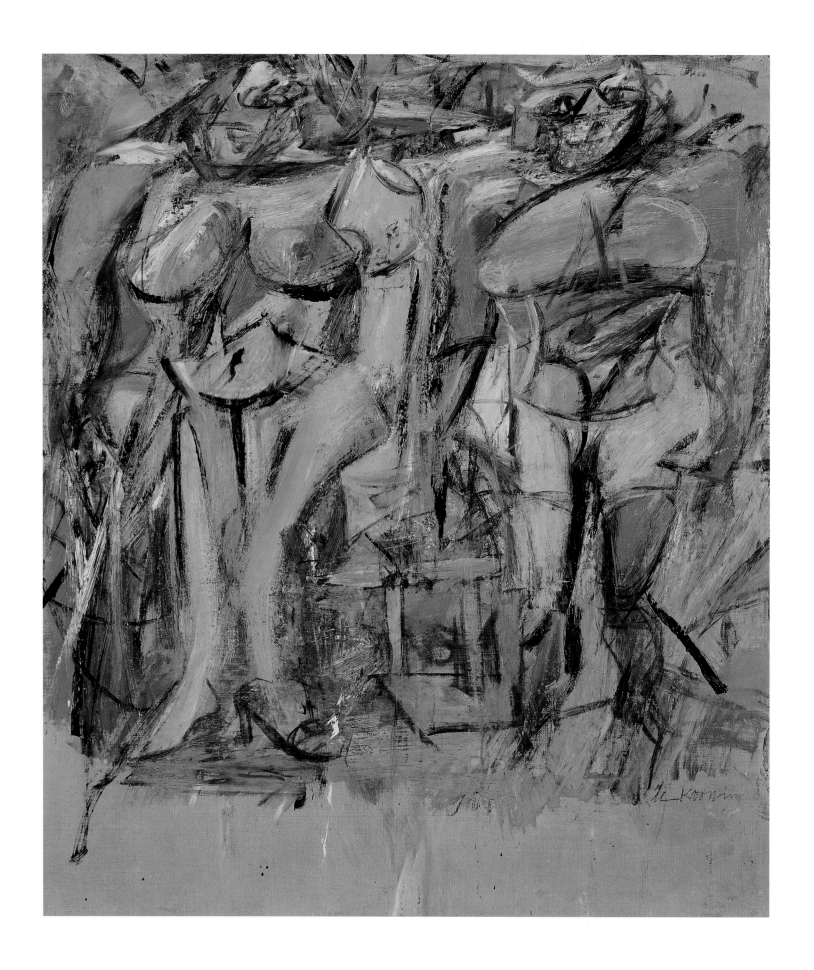

Willem de Kooning

American, born The Netherlands, 1904

Two Women in the Country, 1954

Oil, enamel, and charcoal on canvas
46⅛ × 40¾ in. (117.1 × 103.5 cm)
Gift of Joseph H. Hirshhorn, 1966 (66.1200)

Two Women in the Country belongs to Willem de Kooning's violently expressive "Woman" paintings of the early 1950s, the third and most controversial of his series. The earlier works were situated in an undefined space; here, he explores figure-ground relationships. Two frontally posed nudes are suspended like marionettes from the top of the canvas. With brutal brevity, charcoal line and slashes of black paint describe their anatomy. Yet the pink flesh tones of their bodies are submerged within an overall nexus of colors in which they seem to float. Repetition of the curves of their breasts and the dark circles of their navels creates a visual interplay between two otherwise isolated figures. High heels on one figure accentuate the shock of her nudity.

In all of his "Woman" paintings, de Kooning combined disparate sources, ranging from the ancient to the contemporary: prehistoric fertility goddesses, early West Asian and Cycladic and Sumerian sculpture, Greek kouroi, the expressionism of the Lithuanian-born painter Chaim Soutine, and female models in the advertisements of American popular culture. Having spent the summer of 1954 at a beach resort, de Kooning also found fresh inspiration in the figures of bathers. Yet, paradoxically, the gritty palette and violently activated surfaces of the "Woman" paintings evoke urban associations rather than the pastoral reference of the painting's title. With its bold, gestural style, *Two Women in the Country* presaged de Kooning's growing involvement with landscape during the later 1950s and early 1960s. JZ

Henry Moore

British, 1898–1986

King and Queen, 1952–53

Bronze, 3/7
64¾ × 59⅛ × 37⅜ in. (164.5 × 150 × 94.8 cm)
Gift of Joseph H. Hirshhorn, 1966 (66.3635)

During World War II, Henry Moore was impressed by the courage and fortitude of ordinary citizens surviving in appalling circumstances. In response, he shifted his style away from biomorphic abstraction toward figuration and created a humanist iconography in homage to universal themes such as dignity, motherhood, and creativity. Moore also changed his technique from carving to making small plaster models intended for enlargement and casting into bronze for outdoor display. During the 1950s he devised many compositions of seated figures, usually in pairs or groups, that allude to the renewal of life in postwar Britain. The couple depicted in *King and Queen*, however, has greater public significance. The subject emerged as Moore worked on figures inspired by an Egyptian *Seated Royal Couple* from the eighteenth century B.C. displayed in the British Museum. The serenity and stateliness of Moore's figures, completed in the same year as the young Queen Elizabeth's coronation, may also reaffirm Britain's monarchy as a symbol of continuity and triumph after the country's near destruction by war. The bodies have a fluid naturalism, but the king's head fuses cranium, beard, beak, and crown into a bizarre combination, which the artist described in 1955 as his attempt "to have something animal and Pan-like about it, as well as human … to bring out the contrast between human grace and the concept of power in primitive kingship." Moore placed the first two casts of this work outdoors in Belgium and Scotland, where the figures appear to survey their domains. VJF

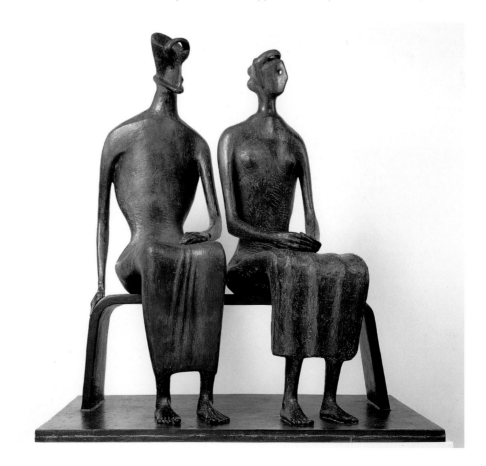

Richard Diebenkorn

American, 1922–1993

Man and Woman in a Large Room, 1957

Oil on canvas, 71 1/8 x 62 1/2 in. (180.7 x 158.5 cm)

Gift of the Joseph H. Hirshhorn Foundation, 1966 (66.1371)

Richard Diebenkorn's early series of abstract paintings marked the emergence of Abstract Expressionism among West Coast artists. Although the early works earned critical recognition, he soon abandoned Abstract Expressionism in favor of figurative painting, a shift that coincided with his friendship with David Park and Elmer Bischoff. Opposed to the absence of discernible subject matter in Abstract Expressionism, the three artists, all influential teachers, became leading adherents of a movement known as Bay Area Figurative Art.

Diebenkorn completed this painting at the height of his involvement with that movement. To evoke the light and atmosphere of a California interior, he fused figurative imagery with the loose brushwork of the Abstract Expressionists. Placing a male and a female figure at the far left of the composition, he used broadly painted planes of color to define the space. The blue-gray tones of the far wall and the dark brown hue of the floor intensify the luminosity of the pale blue sky glimpsed through windows on the far side of the room. At the extreme right, bright bands of color seen through the open doorway suggest the brilliance of the landscape outdoors. The luminosity is reminiscent of the interior scenes of Henri Matisse, while the stark room with its anonymous occupants recalls the work of Edward Hopper. By accentuating the subtle, abstract geometry of the interior space, Diebenkorn counterbalanced the asymmetrical placement of the couple and thereby transformed an everyday genre scene into an evocative painting of timeless and stable harmony. JZ

Francis Bacon

British, born Ireland, 1909–1992

Study for Portrait of Van Gogh III, 1957

Oil and sand on linen, 78 1/8 x 56 1/8 in. (198.4 x 142.5 cm)

Gift of the Joseph H. Hirshhorn Foundation, 1966 (66.186)

Unallied with any school or movement, British painter Francis Bacon attained preeminence among postwar figurative artists by making images that evoke the violence and anguish of modern life. In exquisitely composed canvases depicting crucifixions, screaming popes, or tortured bodies, Bacon transcribed the brutality and isolation of those pushed to the limits of physical and emotional endurance. He also created portraits of friends or historical figures imbued with an intense expressionism.

Study for Portrait of Van Gogh III belongs to a group of eight paintings inspired by Vincent van Gogh's self-portrait Painter on the Road to Tarascon, 1888 (destroyed in World War II). Bacon, who had never seen the original painting, became obsessed with a color reproduction. He later said that the "haunted figure on the road seemed … like a phantom of the road." Bacon frequently would find inspiration in the work of other artists, ranging from Diego Velázquez to Pablo Picasso. Often working in series, he occasionally relied on photographic reproductions to develop his own imagery. For the Study for Portrait of Van Gogh III, Bacon conjured the wraithlike figure of the Dutch painter emerging from the vividly colored and expressionistically distorted landscape. Using sand for added texture, Bacon applied the brilliant colors in a rich impasto that lends the painting a vibrant sensuality. Yet the gaunt silhouette of the figure and the bare trees in the background contribute to the aura of melancholy that pervades all the paintings in this memorable series. JZ

Reuben Nakian

American, 1897–1986

The Rape of Lucrece, 1955–58

Painted steel, 141 1/4 x 87 1/8 x 154 5/8 in. (358.8 x 221.3 x 392.8 cm)

Gift of Joseph H. Hirshhorn, 1974 (74.2)

Trained in traditional figurative styles and methods, Reuben Nakian eventually developed a style that combined those origins with the modernist emphasis on abstraction and process. Working in terra-cotta during the late 1940s, he depicted subjects from classical mythology, especially erotic themes emphasizing the female nude. At first he incised images into small clay tablets, but during the 1950s his compositions became more ambitious. With its monumental scale, abstract geometry, and industrial material, *The Rape of Lucrece* marked a major departure. After developing the concept in a series of increasingly abstract drawings, Nakian strove for three years to create the sculpture. Unaccustomed to such a recalcitrant material, he bent, cut, and welded steel sheets and then ripped off and replaced hundreds of them. His active struggle imbued the sculpture with a sense of energy, evident in the contrasting curved and straight forms, rough and smooth edges. Although abstract, the sculpture is referential: the welded rods and plates form a discontinuous skeletal web of lines and shapes that suggest two "figures" confronting each other from separate bases. The two sections are physically linked by interpenetrating hollow rods, a structural metaphor for the subject: Lucretia (the woman's name in Latin), daughter of a prefect of ancient Rome, was raped by the king's son and then committed suicide, which incited the insurrection that overturned the monarchy in favor of rule by consul. While this subject recurred in post-Renaissance European literature, Nakian's direct source was Tintoretto's painting *Lucretia and Tarquinius,* c. 1560 (The Metropolitan Museum of Art, New York). VJF

Franz Kline

American, 1910–1962

Delaware Gap, 1958

Oil on canvas, 78 1/4 x 106 1/8 in. (198.6 x 269.5 cm)

Gift of the Joseph H. Hirshhorn Foundation, 1966 (66.2751)

Recognized as a leading Abstract Expressionist, Franz Kline began his artistic career as a painter of landscapes and city views recalling those of the Ashcan School. In the mid-1940s he befriended a number of vanguard painters, notably Willem de Kooning, and turned from urban realism to abstraction. He achieved a stylistic breakthrough when, in about 1949, he used an Opticon projector in de Kooning's studio to enlarge details of his more realistic works to an expansive scale. He discovered that he could transform landscapes or city scenes into sweeping abstract images. Kline used housepainters' broad brushes and often limited his palette to black and white, a device favored by other abstract painters, including de Kooning, Jackson Pollock, and Barnett Newman. Kline's bold abstractions of the 1950s and early 1960s epitomize the spontaneity, grand scale, and painterly gesture of what would become known as Action Painting.

Delaware Gap typifies the power and grandeur of Kline's mature work. Using his characteristic black and white palette, he created a vast abstract landscape that evokes contemplation and awe. Broad areas of black paint sweep across the horizontal expanse of white canvas and converge in a central triangle that suggests a dark valley. Although Kline's free brushwork seems to result from improvisation, he actually planned such paintings carefully. The title refers to a natural landmark in the Pennsylvania countryside of the artist's youth. In *Delaware Gap,* Kline's elegiac vision of the natural landscape becomes a source of somber meditation. JZ

Frank Stella

American, born 1936

Arundel Castle, 1959

Enamel on canvas, 121 3/8 × 73 1/8 in. (308.1 × 186.1 cm)

Gift of Joseph H. Hirshhorn, 1972 (72.276)

Throughout his career, Frank Stella has tried to redefine pictorial space. *Arundel Castle* belongs to his early groundbreaking series, "Black Paintings," in which he aimed to eliminate illusionistic space from the canvas by painting allover patterns that could be grasped immediately. After first sketching out the design, Stella painted bands of black separated by thin white lines of raw canvas. To focus on the flat, emblematic configurations he had drawn, he used only black paint. His stretchers (approximately three inches deep, thicker than the more conventional ones of approximately one and one-half inches) create a shadow that helps lift the painted plane away from the flat wall on which it hangs. The paintings are meant to convey structure at a glance, and the artist made no attempt to hide accidental drips or the freehand quality of the brushwork.

Stella named *Arundel Castle* after an apartment building in Bedford-Stuyvesant, a depressed area of Brooklyn. Although titling a painting implies a meaning or personal association, Stella has long asserted that his subject matter is only forthright formal problem solving, in this case making static imagery command space. *Arundel Castle* imparts no underlying message. In Stella's own words, "What you see is what you see." ALM

Robert Rauschenberg

American, born 1925

Dam, 1959

Oil, photomechanical reproductions, cloth, and metal object on canvas, 75 1/2 × 61 5/8 in. (191.7 × 156.5 cm)

Gift of Joseph H. Hirshhorn, 1966 (66.4187)

Borrowing the energy of Abstract Expressionism but applying it to a new form of contemporary expression, Robert Rauschenberg introduced a fresh sensibility to American art. In the early 1950s, Rauschenberg created a series of flat, all-white paintings. He then made a series of paintings in which he pasted torn and crushed newspapers to a canvas, then painted them with black enamel to produce an irregular surface. These black paintings evolved into large collage constructions in which Rauschenberg combined real objects, such as pieces of newspaper, string, photographs, and nails, and, eventually, large three-dimensional items. Rauschenberg coined the term *combine painting* for these works, the creation of which enabled him, in his words, "to act in the gap between art and life." In combine paintings such as *Dam,* signs, stenciled letters, photographs, and newspaper clippings are silk-screened or mounted on canvas, evoking references to daily life and the speed and fragmentation of the modern urban milieu. Rauschenberg's embrace of the temporal, contemporary, and day-to-day was antithetical to the Abstract Expressionists' quest for the universal and the sublime. While Rauschenberg's work extended a traditional use of collage, it reveled in the messiness of real life and, together with that of Jasper Johns, anticipated the Pop Art iconography of the 1960s. PR

Morris Louis

American, 1912–1962

Point of Tranquility, 1959–60

Magna on canvas, 101 3/4 x 135 3/4 in. (258.2 x 344.9 cm)

Gift of Joseph H. Hirshhorn, 1966 (66.3111)

The works of Morris Louis fuse the luminosity of Impressionist painting with the fluidity of the water-color medium. Without fixed focal points in their compositions, overall fields of color dominate the canvases. *Point of Tranquility* belongs to Louis's third group of color abstractions, the "Florals." For his first two series, "Veils" (1954) and "Bronze Veils" (1958), Louis poured layers of thinly washed, transparent paint onto enormous expanses of unprimed canvas. The blended colors soaked into the weave of the fabric, producing a glowing screen of subtle, variegated hues. In contrast, the washes of saturated colors in the "Florals" interact directly without fully blending into a uniform veil. By controlling the flowing and pooling of liquid pigment, Louis attained in his large-scale works the effects previously possible only in more intimate, easel-size paintings.

Louis's remarkably free style was achieved with the use of Magna, a resin-based acrylic paint manufactured by Louis's friend Leonard Bocour. In Louis's Washington, D.C., studio, which was so cramped that he could never view any painting in its entirety as he worked, he surmounted the physical limitations of the small space by tacking and folding an uncut roll of canvas on a horizontal wood stretcher, then pouring successive layers of Magna over the surface as he constantly manipulated the canvas to control the flow of pigment. The rich blossoms of bleeding colors in *Point of Tranquility* achieve the artist's goal, which was to create paintings, he said, that "produce a delicious pain in the eye." JZ

Mark Rothko

American, born Russia, 1903–1970

Blue, Orange, Red, 1961

Oil on canvas, 90 1/4 x 81 1/16 in. (229.2 x 205.9 cm)

Gift of the Joseph H. Hirshhorn Foundation, 1966 (66.4420)

Together with many painters and sculptors of the post–World War II period, Mark Rothko came to believe that recognizable images were obstacles to a direct experience of art. His compositions of color floated in vertical sections constitute his solution and signature statement. His expanses of color allow intimacy and suggest vastness, contributing to a sense of what critics of the period called "the sublime." Rothko was able to create paintings of either intense melancholy or radiant luminosity within the basic compositional format he had developed by 1949. In *Blue, Orange, Red*, deep fields of blue and energized orange, achieved by a feathered application of paint that allows a hint of underlying colors to show through, are set atop an intense red ground. The vibrant colors in this painting contrast with Rothko's generally more somber and brooding work of the 1960s. Owing to their scale and the artist's expressive use of nonrepresentational form, Rothko's paintings were aligned with Abstract Expressionism, a label he continually rejected. Although his brush marks and scumbling action are evident in his paintings, the muted surfaces of his works produce an effect more meditative and less gestural than the works of artists Willem de Kooning and Jackson Pollock, for example. Rothko condensed complex relationships of color, form, and structure in a unified whole that focused painting on its essence. PR

Cy Twombly

American, born 1928

August Notes from Rome (Ferragosto), 1961

Oil, oil crayon, and pencil on canvas

64³/₄ x 78⁷/₈ in. (164.5 x 200.3 cm)

Gift of Joseph H. Hirshhorn, 1966 (66.5029)

In the mid-1950s, Cy Twombly initiated his own stylistic approach to abstraction. Although influenced by Abstract Expressionism, Twombly, like Jasper Johns and Robert Rauschenberg, developed a highly personal mode of painting. Twombly covers his canvases in an allover style generally associated with, but quite different from, Jackson Pollock's work. The physical, gestural act of drawing is evident in this painting, which is activated by visual tensions between thick clumps of paint and thin pencil lines. Twombly's work reminds us of blackboard drawings or graffiti.

One of the sources of Twombly's art is his interest, since childhood, in the classical world, which was reinforced after he settled in Rome in 1957. His paintings and drawings often include symbols of ancient culture. The title of this work refers to the Feast of the Assumption, a religious holiday observed on August 15. Interwoven into the composition are streaks and blotches of oil paint, with casual pencil notes delineating a roughly drawn square with corners numbered; seemingly random marks combine with spare calligraphy (the title of the painting and the artist's signature) and cryptic imagery (such as a sketchy drawing of a male organ in the upper right). Some paint appears to have been scattered onto the canvas, while other marks are carefully separated from one another. The imaginative composition of words, marks, and paint strokes reflects the artist's feelings about Rome in August. Its cerebral, allusive quality suggests rather than openly states its subject. FG

Ellsworth Kelly

American, born 1923

Red White, 1961

Oil on canvas, 62³/₄ x 85¹/₄ in. (159.5 x 216.6 cm)

Gift of Joseph H. Hirshhorn, 1966 (72.161)

Ellsworth Kelly is known for his rectilinear and shaped canvases of unmodulated color, as well as for sculpture, prints, and drawings. Within a fairly restricted pictorial vocabulary, he has produced a wide variety of work, often using geometric and organic forms within his paintings and combining single-color canvases. During a stay in Paris from the late 1940s to the early 1950s, Kelly spent much of his time in museums, studying independently and sketching ancient Egyptian, Asian, Byzantine, and Romanesque art. Increasingly, he came to draw and photograph the buildings and bridges of Paris. He also sketched plants, created relief objects, and began experimenting with the Surrealist technique of automatic drawing. In 1949 he made his first nonobjective paintings—abstractions of what he observed in his travels, such as architectural elements and the patterns produced by shadows upon structures.

In his paintings from the early 1960s, Kelly often used a rectangular format and paired white with a bright, saturated color. The organic shapes, which seem to emanate and extend from the edges of the canvas, interlock like jigsaw puzzle pieces; the white form at times appears to recede into the wall. The shapes are reminiscent of Henri Matisse's cutouts or Alexander Calder's whimsical creations and attest to those artists' influence on him. *Red White* exemplifies the hard-edge style of abstraction that led to the precise forms of Minimalism during the 1960s. AC

George Segal

American, born 1924

Bus Riders, 1962

Plaster, cotton gauze, steel, wood, and vinyl

70 x 42³/₈ x 90³/₄ in. (177.8 x 107.6 x 230.4 cm)

Gift of Joseph H. Hirshhorn, 1966 (66.4506)

Although he has been linked with Pop Art, George Segal has remained thoroughly individualistic, developing his art independent of fashion. Segal's tableaux have included mundane domestic scenes, images of urban alienation, biblical themes, allusions to earlier artists, and political subjects. He has also produced plaster bas-reliefs, fragments, pastels, and public works in bronze. *Bus Riders* is one of Segal's early sculptures. The unpainted plaster figures are characteristically anonymous, representing ordinary people involved in everyday activities. Although they are physically close, the solemn riders seem psychologically isolated from one another. The empty seat allows the viewer to psychically enter and become part of the morose environment.

Segal has executed numerous sculptures related to the theme of buses, including a public commission installed at the Port Authority Bus Terminal in New York in 1982. His works have often been inspired by personal experiences, and Segal, a frequent commuter between New Jersey and New York, has commented on the importance of people in transition and the theme of travel. The theme of travel may also be seen as a metaphor for change or a metamorphosis from one condition to another. AC

Joan Brown

American, 1938–1990

Nun with Staffordshire Terrier, 1961

Oil on canvas, 60 x 60 in. (152 x 152.5 cm)

Gift of Joseph H. Hirshhorn, 1966 (66.685)

Nun with Staffordshire Terrier epitomizes the vibrant brand of figurative expressionism that flourished in the San Francisco Bay area from the early 1950s to the mid-1960s. The richly textured painting, which Joan Brown produced when she was a twenty-three-year-old student at the California School of Fine Arts in San Francisco, fuses genre subject matter with the gestural brushwork of Abstract Expressionism. Brown used a thick impasto of color planes to depict a nun rigidly seated in a tile-floored room. The eccentric silhouette of the nun's headdress, the intimacy evoked by the dog positioned at her feet, and the bold coloration of the canvas combine to provide an ironic counterpoint to the subject's stiff pose. Brown's choice of subject matter may reflect memories of her childhood experiences attending parochial school.

The bravura assurance of such paintings won Brown national recognition as a member of the "second generation" of the Bay Area Figurative movement. In her early work Brown extended the bounds of the expressionist style through her youthful mastery of translucent coloration, sensual impasto, and bold simplification of the human form. After the remarkable success of her student work, Brown went on to create paintings imbued with a mysticism that derived from her lifelong study of exotic cultures. JZ

David Smith

American, 1906–1965

Voltri XV, 1962

Steel, 89⁷⁄₈ × 77¹⁄₄ × 22⁵⁄₈ in. (228.1 × 196.1 × 57.4 cm)

Gift of Joseph H. Hirshhorn, 1966 (66.4643)

Inspired by the post-Cubist constructed metal sculptures of Pablo Picasso and Julio González, David Smith developed a geometric abstract style that retained oblique references to subjects. His work evolved from small-scale to outdoor compositions during the 1950s. Invited by Gian-Carlo Menotti to create sculptures for display at the 1962 music festival at Spoleto, Italy, Smith worked in Voltri, an industrial town near Genoa, in late May and June. Under the sponsorship of Italsider—the country's national steel company—the artist worked in a recently abandoned factory complex. He was inspired there by the leftover steel fragments, many hand forged, and needed only thirty days to fabricate twenty-seven sculptures. When Smith returned to New York, he brought back materials to incorporate into more "Voltri" compositions, which he created from December 1962 to March 1963.

The "Voltri" sculptures are characterized by boldly simplified abstract shapes, often planar and arranged in rhythmic patterns. Eight, including *Voltri XV*, incorporate curving forms described by the artist as pieces of clouds. Just as clouds constantly change, Smith wanted his sculpted variations to express the "great wonder and beauty of natural growth." Pictorial in conception, *Voltri XV* functions as a two-dimensional steel drawing that both depicts and enframes nature. Its imagery suggests the sun or moon with passing clouds, an impression enhanced by the sculpture's placement outdoors. Yet Smith also understood the circle as a primeval symbol with many implications, "from the first wheel of man, to wheels on Indian stone temples … to all the suns and poetic imagery of movement." VJF

James Rosenquist

American, born 1933

The Light That Won't Fail I, 1961

Oil on canvas, 71³⁄₄ × 96¹⁄₄ in. (182.1 × 244.3 cm)

Gift of the Joseph H. Hirshhorn Foundation, 1966 (66.4402)

One of two paintings by James Rosenquist titled *The Light That Won't Fail*, the Hirshhorn work is an early attempt by the artist to use commercial painting techniques and subjects in fine art. As a billboard painter, Rosenquist had learned to enlarge images from small photographs and to apply thick paint quickly and easily to broad areas. He also discovered that gigantic images seen at close range read as abstract, unidentifiable, meaningless forms.

The Light That Won't Fail I presents a scene of a woman smoking against fields of neutral colors. Over this primary image, which Rosenquist adapted from a Philip Morris magazine advertisement, he layered images of commonplace objects, such as stockings and a comb. By using different scales and drab colors, he disconnected the project from contemporaneous advertising and life, making the subject of the painting the uncertain relationships among its forms.

Originally Rosenquist included the ad's headline, "Believe in Yourself," but he later painted the comb over it. Shadows of the words are perceptible through this top layer of paint as it becomes more transparent with age. In a period when he was struggling to establish himself as a serious artist, Rosenquist may have found encouragement in the headline. Yet, when he rethought what he was trying to achieve, he eliminated the words. With the direct narrative removed, *The Light That Won't Fail I* became an ambiguous conjunction of painted objects. ALM

Andy Warhol

American, 1928–1987

Marilyn Monroe's Lips, 1962

Acrylic, enamel, and pencil on canvas

Two panels: left 82³/₄ × 80³/₄ in. (210.7 × 204.9 cm);
right 82³/₄ × 82³/₈ in. (210.7 × 209.7 cm)

Gift of Joseph H. Hirshhorn, 1972 (72.313)

Marilyn Monroe has been regarded as the ultimate American "sex goddess," a movie star whose public persona was a conflation of apparent sexual availability and compelling vulnerability. Perhaps more than any other modern media creation, she was a focus of erotic fascination and a blank screen for the projection of others' dreams and desires. Like many other women depicted by Andy Warhol, her life had tragic dimensions that were played out in public; like many of his subjects ("Liz," "Jackie," "Elvis"), Marilyn embodied the sense of false intimacy that Americans share with their celebrities.

Warhol began a series of portraits of Monroe in 1962, after her death by suicide in August of that year. The source of his images was a cropped publicity still made for her 1952 film *Niagara*. The most simplified of all Warhol's "Marilyn" pictures, *Marilyn Monroe's Lips* focuses on a single feature. The series coincides with Warhol's shift from painting to the use of photo silkscreen, a mechanical process identifiable with commercial production, and thus a seeming rejection of the personal expressive ethos that had heretofore given value to modern painting. Additionally, the two panels—one in black and white and the other in color—foreshadow the artist's own long-lasting involvement as a filmmaker beginning in the following year. While the marriage of commercial procedure and banal or popular subject matter branded Warhol as the quintessential Pop artist, works such as *Marilyn Monroe's Lips* hint at the dark side of America's culture. PR

Claes Oldenburg

American, born Sweden, 1929

7-Up, 1961

Enamel on plaster-soaked cloth on wire

55³/₈ × 39¹/₄ × 5¹/₂ in. (140.7 × 99.7 × 14 cm)

Joseph H. Hirshhorn Purchase Fund and Joseph H. Hirshhorn Bequest Fund, 1994 (94.13)

After immigrating to the United States as a child and growing up in Chicago, Claes Oldenburg in 1956 moved to New York, where he forged a humorous and provocative art form that is often considered archetypally American. A member of the generation of artists who inherited a painterly sensibility based on Abstract Expressionism, Oldenburg in the 1960s integrated an expressive handling of materials with representational themes. Culling his subjects from contemporary American advertising illustrations, manufactured objects, and fast foods, Oldenburg altered the typical appearance and size of such images while simultaneously highlighting their purely visual appeal. His soft vinyl and canvas sculptural representations of hard objects such as toilets or typewriters and his gigantic sculpted hamburgers, ice-cream cones, and french fries have become well known. In exaggerating the size, and thus the significance, of such items in modern consumer society, Oldenburg played an important role in developing the representational strategies of Pop Art.

7-Up was part of Oldenburg's notorious installation called *The Store*, 1961, which featured works derived from food, clothing, and other everyday commodities. The bright enamel paint on *7-Up* not only mimics the real product but also alludes to the brash colors of billboards and advertisements. Like his contemporary, Andy Warhol, famed for his images of soup cans, Oldenburg elevated the objects in his store to the status of art. His work deliberately confronts the issues of "high" versus "low" art, art as commodity, and art as a reflection of the commercialism dominating modern society. PR

Donald Judd

American, 1928–1994

Untitled, 1963

Painted plywood with iron pipe
22 x 45 1/8 x 30 1/2 in. (55.7 x 114.5 x 77.4 cm)
Joseph H. Hirshhorn Purchase Fund, 1991 (91.29)

An important art critic and sculptor, Donald Judd has come to personify Minimalism, the movement that developed during the mid-1960s in reaction to the organic and emotive qualities of Abstract Expressionism. Whether figurative, biomorphic, or geometric, sculpture before that time had traditionally been carved or modeled. Minimalist sculptures, however, were often machine crafted in precise or slightly varied rhythms. The resulting industrial look emphasized the sculptor's concern with mass, density, color, and form rather than gesture, narrative, or autobiog-raphy. Although made by hand of scrap wood, Judd's earliest sculptures, including this work, startled the art world with the bold simplicity of their reductive geometric shapes when first exhibited in 1963–64 at the now-defunct Green Gallery in New York.

Untitled encapsulates the tenets of Minimalist art: it is presented without a base, resting directly on the floor to create a sense of immediacy between object and viewer; and it is austere in form, color, and sur-face. To make *Untitled,* Judd used plywood as a shell that defined volume, and he employed the iron cylin-der as a counterpoint in weight and shape. To clarify and emphasize his forms, the artist painted the wood cadmium red, a color that distinguishes his early sculp-tures. The combination of *Untitled*'s two contrasting materials, wood and iron, with its intense hue yields a revolutionary sculpture of great simplicity and strength. ALM

Joan Mitchell

American, 1926–1992

Girolata, 1964

Oil on canvas
Each panel approx. 101 3/4 x 189 5/8 in. (258.4 x 481.7 cm)
Gift of Joseph H. Hirshhorn, 1966 (66.3581)

The Abstract Expressionist painter Joan Mitchell cre-ated colorful, gestural paintings inspired by memories of landscapes and her surroundings. Other themes that occupied her throughout her career included beloved dogs, bridges, bodies of water, and poetry. Rather than direct observations of nature, her paint-ings are syntheses of memories, sensations, and feel-ings registered by brushstrokes. During the 1950s, Mitchell's large works began with ambiguous Cubist structures and vaguely organic forms. She later loos-ened up their underlying organization and applied immediate strokes of color to create woven areas that hover against a predominantly white field.

In 1959, Mitchell moved to Paris. She often sailed to Corsica, Greece, and Italy; *Girolata* is named after a stream in Corsica. Some of Mitchell's polyptychs, such as the Hirshhorn piece, are quite large; later ones are composed of multiple vertical canvases. At the time she painted *Girolata,* Mitchell began intro-ducing darker masses of color and somber greens and blues into her works. Here, the dark areas float against fields of lighter washes of mauve, blue, and gray. Drips and calligraphic strokes enliven the sur-faces of the canvases, and light seems to emanate from the whole. AC

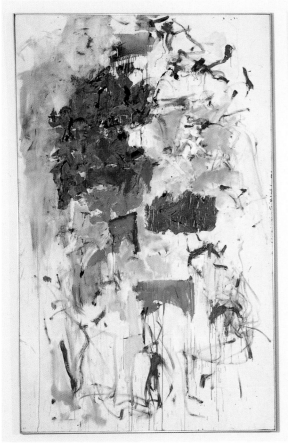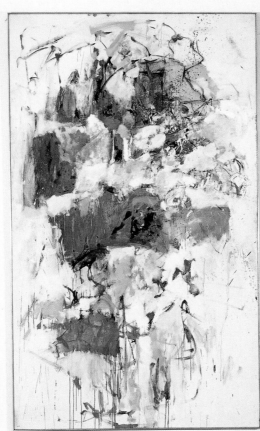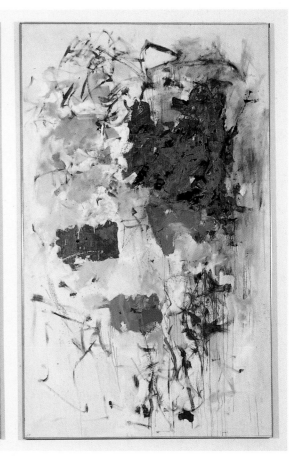

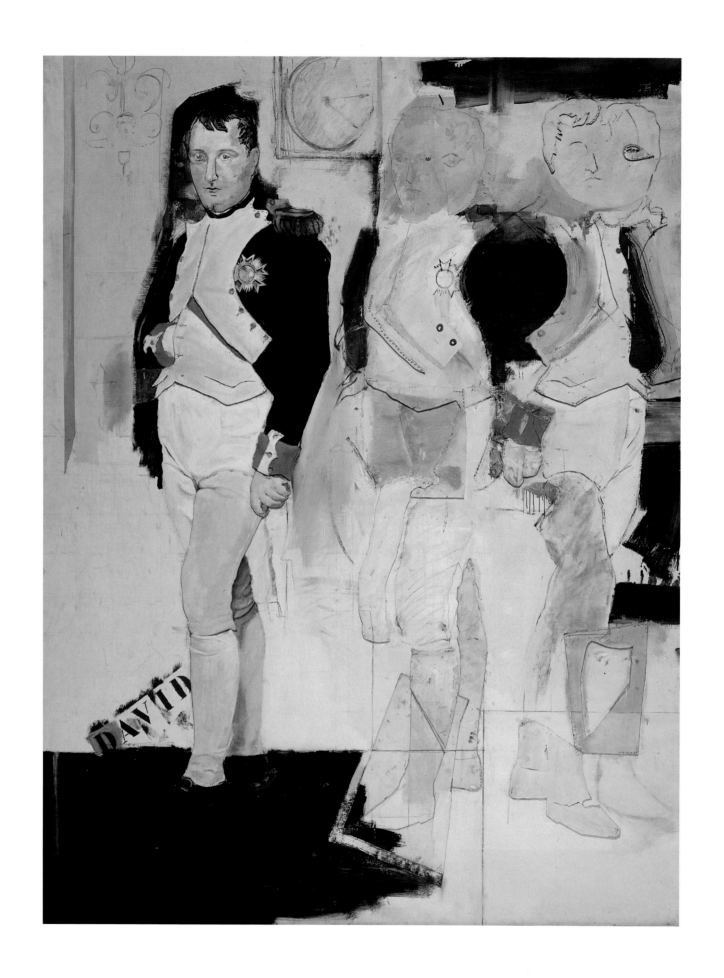

Larry Rivers

American, born 1925

The Greatest Homosexual, 1964

Oil, collage, pencil, and colored pencil on canvas

80 × 61 in. (203.1 × 155 cm)

Gift of Joseph H. Hirshhorn, 1966 (66.4295)

In the mid-1960s, Larry Rivers often used reproductions of works of art as themes for his own paintings: a work by Rembrandt as reproduced on a cigar box, or pictures by Paul Cézanne and Henri Matisse on French postage stamps. The subject of this work is Jacques-Louis David's 1812 portrait of Napoleon Bonaparte. The original painting hangs in Washington's National Gallery of Art, where Rivers presumably saw it, but his work is nonetheless based on a commercial reproduction.

The use of stenciled letters, a combination of painted and collage elements, and multiple images that create a casually drawn look are typical of Rivers's style of the mid-1960s. So, too, is his deliberately provocative linking of icons of high culture to an issue of sexual identification. Regarding the title, Rivers explained, somewhat tongue-in-cheek, that after many days of "repeated and detailed observations of the repro,"

I couldn't avoid some obvious non-technical conclusions. Given a right hand nestling in the split of the cream vest … the plump torso settled comfortably on the left hip, the careful curls and coif, the cliche of pursed lips, and what self-satisfaction I read into the rest of the face, I decided Napoleon was gay. Now if he wasn't history's "Greatest Homosexual," who was—Michelangelo?

PR

Richard Lindner

American, born Germany, 1901–1978

New York City IV, 1964

Oil on canvas, 70 × 60 in. (177.6 × 152.4 cm)

Gift of Joseph H. Hirshhorn, 1966 (66.308)

A self-proclaimed New Yorker, Richard Lindner considered himself a "tourist" in his adopted hometown, New York. *New York City IV* belongs to a group of canvases from the 1960s inspired by the constantly changing street life of Manhattan. Lindner constructed a pyramidal figure composition by superimposing fragmentary images over a background of geometric fields of saturated colors. The central image of a traffic light links the dominant female figure, seen in profile, with the red-uniformed boy in the lower left. To their right, the signlike letters "NY" provide a heraldic counterpoint to the lone figure of a dog. The flat application of paint and the precisely defined forms recall the hard-edge abstractions of such American contemporaries as Frank Stella. Lindner's deliberate evocation of advertising imagery in the clarity of his figures has been likened to the devices of Pop Art. Unlike American Pop artists, however, he transcended deadpan irony to imbue his work with harsh satire: the orbs of the traffic lamps, signals of potential danger, rhyme with the globes of the woman's breasts, while her ample thigh doubles as a corseted torso. Such disjunctive imagery, while derived from the "hip" Pop culture of 1960s Manhattan, also evokes the mystery and decadence of the Weimar Germany of Lindner's youth. In *New York City IV,* Lindner blended the abstract with the figurative and the past with the present to create a monumental emblem of modern alienation amid the spectacle of urban street life.

JZ

David Hockney

British, born 1937

Cubist (American) Boy with Colourful Tree, 1964

Acrylic with pencil underdrawing on canvas
65⁵/₈ x 65⁷/₈ in. (166.7 x 167.3 cm)
Gift of Joseph H. Hirshhorn, 1966 (66.2474)

David Hockney's paintings, with subjects ranging from children's tales to homoerotic themes, can be both whimsical and sensitive. While in art school in the mid-1950s and early 1960s, Hockney based his art on the descriptive tradition of British painting. He completed this work in 1964, while teaching a summer course at the University of Iowa. After moving to Los Angeles, he evolved a descriptive style focusing on the luxurious homes and lifestyles of Southern California.

In a letter of 1972, Hockney wrote that the imagery "is based on a number of earlier pictures using ideas of style in different ways." A gesturing figure assumes a dramatic pose in front of a stage curtain. On the left, a rectangle of grass defines the space as it recedes from the forefront of the picture, under the curtain, to the brightly colored tree. The figure's legs, vertical ribbons of gray tones painted in an intentionally clumsy fashion, allude to three-dimensional forms. Except for the legs and the accentuated, rounded buttocks, the "boy" is rendered generally, in a flat plane. Hockney has manipulated the planar element of Cubism to create a pastiche of striped planes that make gentle fun of the major art movement. In the same letter, Hockney wrote, "American athletes usually have nice, clear, rounded, and well-defined forms in their bodies … an appropriate subject to do in the Cubist's style. Therefore a certain amount of humour was intended." FG

Christo

American, born Bulgaria, 1935

Store Front, 1964

Painted wood, Plexiglas, cloth, metal, and mixed media
104¹/₂ x 105¹/₂ x 46 in. (265.3 x 268 x 116.8 cm)
Joseph H. Hirshhorn Purchase Fund, 1992 (92.13)

While an art student in Sofia, Christo Javacheff became interested in 1920s Soviet agitation-propaganda (agit-prop) projects. Originally they entailed painting slogans—collaboratively and in public view—on buildings and cliffs; in the 1950s they included beautification schemes to cover or disguise refuse with tarps and stacked hay bales. After fleeing Communist Bulgaria in 1958, Christo relocated to Paris, where he discovered New Realism, an art movement emphasizing commercial images, consumer goods, and found objects as material and subject matter. Christo began wrapping bottles and chairs in plastic and piling oil barrels at docksides or in streets, adroitly combining the techniques of agit-prop with those of New Realism. By the early 1970s he was working on large-scale collaborative projects: wrapped environments, from natural sites such as islands and rolling countryside to man-made structures.

Store Front is Christo's careful re-creation of the common urban building he saw upon immigrating to New York in 1964. Except for the box representing an air conditioner above the door, he wrapped only the inside of the sculpture, leaving unshrouded bands around the windows to reveal draped floors and an enigmatic swaddled object inside. A light from within invites questions about occupancy.

Encouraging yet denying access, the cloaked facade thwarts visual and physical entry. Christo explores hindered passages, boundaries, and the distinction between inside and out—metaphors, in part, of his escape from Eastern Europe. Coupling social collaboration with public architecture and sculpture, his work offers philosophical meditations on our relationship to our physical surroundings. ALM

Romare Bearden

American, 1914–1988

The Prevalence of Ritual: Baptism, 1964

Photomechanical reproductions, acrylic, and pencil
on paperboard, 9 1/8 × 12 in. (23.2 × 30.5 cm)
Gift of Joseph H. Hirshhorn, 1966 (66.410)

Born in Charlotte, North Carolina, Romare Bearden grew up in Harlem and Pittsburgh. He produced artwork with roots in Social Realism, medieval stained-glass windows, Cubism, and Abstract Expressionism before finding his strongest voice in collage. For inspiration he turned to childhood memories of his birthplace and the rituals he encountered there and to the urban milieu of the cities of his youth. A jazz enthusiast and songwriter as well as an artist, Bearden was associated throughout his life with the community of African American musicians and artists thriving in Harlem. Bearden's more intimate, figurative work shares qualities with that of Stuart Davis, a fellow painter and jazz devotee.

During his first year of producing collages, Bearden created The Prevalence of Ritual: Baptism, which depicts the sacrament as it was commonly practiced in the rural South. The initiate is in the center of the composition, surrounded by a tight jumble of fractured figures in a compressed Cubist space. The variety in the collage elements and in the scale of the figures establishes a sense of motion and shifting planes. A train, a frequent motif in Bearden's work, appears in the upper left corner, passing before a church. African masks connect the Christian ritual to ancient animistic ceremonies. Combining Bearden's many influences, the work reflects African American culture and myth informed by such varied traditions as European modernism, traditional African art, and the syncopated rhythms of jazz. AC

Bruce Conner

American, born 1933

Triptych, 1964

Linoleum, paper, photomechanical reproductions,
fabric, snakeskin, straw, leaves, adhesive bandage, and string
Three panels: left 45 × 31 1/2 in. (114.1 × 80 cm);
center 48 1/4 × 49 3/8 in. (122.4 × 125.3 cm);
right 44 1/4 × 31 in. (112.4 × 78.7 cm)
Museum Purchase, 1974 (74.26)

Triptych by Bruce Conner is a collage on three panels, each layered with torn sections of household linoleum. Arranged in overlapping shapes in a subtle, abstract design, the fragments suggest wear and the passage of time. In the center of the middle panel, fading artificial flowers and a red paper heart allude to unhappy love and sentimentality, while the adhesive bandage implies disrepair and impermanence. In the upper left corner, a collage of sensuous images of women partially concealed under the linoleum hint at an underlying eroticism. Attached to the bottom of the left panel is a page of sheet music for "My Country, 'Tis of Thee," a reference to patriotism.

Early religious paintings often used the triptych format to portray sacred scenes occasionally flanked by portraits of wealthy donors. In Triptych, spiritual connotations from the Old World merge with the formal language of the new. Commenting on the sociopolitical state of the world, Conner has linked the marks of hopeless poverty with signs and symbols of the ambiguous passions and beliefs that often coexist in human nature. This accumulation shows the artist's concerns about the dangers of modern society. By juxtaposing emotion-charged icons, he cast into ironic focus a society encompassing patriotism, poverty, and prurience in an atmosphere of moral indifference.
FG

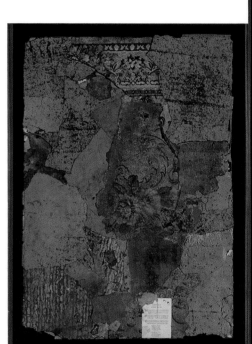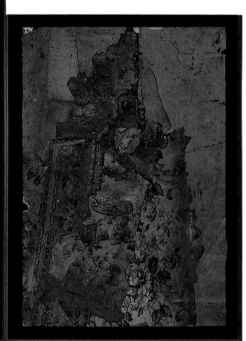

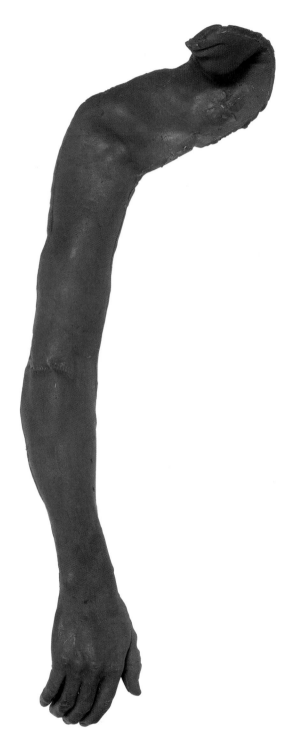

Bruce Nauman

American, born 1941

From Hand to Mouth, 1967

Wax over cloth, 28 × 10⅛ × 4 in. (71.1 × 25.7 × 10.2 cm)
Joseph H. Hirshhorn Purchase Fund, Holenia Purchase Fund in
memory of Joseph H. Hirshhorn, and Museum Purchase, 1993
(93.6)

Although informed by both Pop Art and Minimalism,
Bruce Nauman's work defies classification by media or
style. As a student at the University of California at
Davis, Nauman experimented with fiberglass, making
sculptures that revealed the casting process, and
explored the concept of interior and exterior spaces.
He also examined and recorded human activity in
performance pieces and films. In 1966 he began to
make sculptures using wax casts of parts of the body;
he also created his first neon works—private, poetic
messages or word games, presented in a medium
generally associated with public display. In the decade
that followed, Nauman constructed emotionally
charged, quasi-architectural, claustrophobic spaces in
which viewers often saw video images of themselves
from behind or upside down—unsettling meditations
on human behavior in manipulated spaces. Nauman
has continued to explore themes of cruelty and
stress. His more recent sculptures and videos contain
overt moral statements, political metaphors, and com-
mentaries on human brutality.

Nauman made From Hand to Mouth early in his
career, when his principal subject and image was the
body—not as a vehicle for self-expression but as a
medium for analyzing his ideas and the ways in which
images are linked to language. The sculpture is a cast
of his first wife. Meant to be hung at approximately
body height, this literal impression of a human body
makes a colloquial expression tangible. PR

Francis Bacon

British, born Ireland, 1909–1992

Triptych Inspired by T. S. Eliot's Poem "Sweeney Agonistes," 1967

Oil on canvas
Each panel approx. 78¼ × 58⅜ in. (198.8 × 148.3 cm)
Gift of the Joseph H. Hirshhorn Foundation, 1972 (72.16)

The paintings of Francis Bacon, who grew up in Dub-
lin and London amid the upheaval of World War I,
fuse horrific imagery with traditional literary or reli-
gious sources. Here, he accentuated the horror by
using the format traditionally associated with sacred
art—the three-panel altarpiece, or triptych. In the
central panel is the haunting image of the interior of a
railroad sleeping car filled with the gruesome evi-
dence of homicide. Yet the brushwork and colors,
particularly the deep violet carpet and window shade,
are imbued with a seductive beauty. The side panels
are mirror images of two bedroom interiors. In the
left panel, two figures, apparently women, lie exhaust-
ed on a dais or bed. In the right, a couple, most prob-
ably two men, engage in a primal struggle in the same
interior. Reflected in a mirror at the far right, an
anonymous figure on the telephone calmly witnesses
the violence. In each outer panel, Bacon used his
characteristic cagelike box to frame and thereby
focus the composition on the figures.

Although the panels resemble successive stills in a
movie, Bacon denied that such works have narrative
content. Originally titled Triptych, this mysterious
scene of struggle, grisly crime, and sexual violence is
now identified with the grim lines of T. S. Eliot's poem
"Sweeney Agonistes: Fragments of an Aristophanic
Melodrama":

> Birth, and copulation, and death.
> That's all the facts when you come to brass tacks:
> Birth, and copulation, and death.

JZ

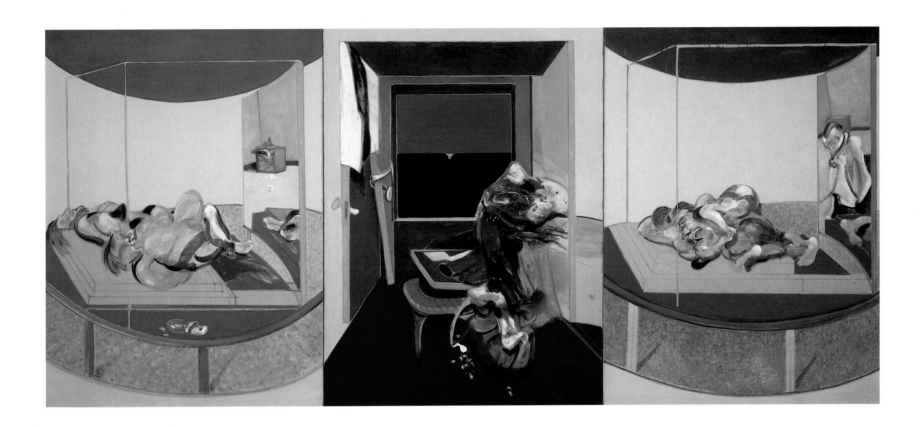

Sigmar Polke

German, born 1941

Bunnies, 1966

Acrylic on linen, 58³/₄ x 39¹/₈ in. (149.2 x 99.3 cm)

Joseph H. Hirshhorn Bequest and Purchase Funds, 1992 (92.7)

Sigmar Polke views the world as an unpredictable place full of intrigue and so creates paradoxical art permeated with irony. One of the leaders in the resurgence of postwar German painting, Polke grew up in East Germany and, in 1953, resettled in West Germany. While studying at the Kunstakademie in Düsseldorf, Polke and fellow students Konrad Fischer-Lueg and Gerhard Richter made work in a style called Capitalist Realism, a satirical response to American and British Pop Art. These artists took their imagery from mass-media sources but at the same time explored conceptual problems of painting, addressing matters of style, subject matter, and the power of images to convey meaning.

Bunnies is a significant early example of Polke's work and reveals his manipulation of popular imagery. Although related to American Pop Art, Polke's dense, paradoxical painting exhibits a far more acerbic and cynical tone. It is based on a photograph of four Playboy "bunnies," the suggestively attired hostesses at Hugh Hefner's Playboy clubs. Polke depicted these peculiarly American icons in Benday dots (a mechanical process used to construct images in commercial printing) in response to the American Pop artist Roy Lichtenstein, who favored that method. At the same time, Polke deliberately overpainted and altered the image. By combining a mass-reproduction technique with a popularly validated icon of women as commercial objects, Polke mocked the manufactured look of American Pop and a society that appraised sex appeal using the standard of women dressed as rabbits. ALM

Roy Lichtenstein

American, born 1923

Modern Painting with Clef, 1967

Oil, resin-based acrylic, and pencil on canvas

100¹/₈ x 180³/₈ in. (252.4 x 458.2 cm)

Gift of Joseph H. Hirshhorn, 1972 (72.176)

Roy Lichtenstein has explored the historical and mundane in several series addressing architecture, art styles of the nineteenth and twentieth centuries, and everyday objects. He created Modern Painting with Clef as one of several paintings that parodied the 1930s architectural and design style called art moderne in French and Art Deco in English. This style synthesized classical order and geometric motifs with machine production. Marked by elongated, flattened graphics and logical, repeated patterns such as zigzags and curving lines, Art Deco was an ode to the mechanized age. Also fashionable in the 1930s were formalized renderings of skyscrapers, steamships, and factories, as well as follies and musicals for stage and screen.

Lichtenstein incorporated motifs from all these sources—the classical column, zigzags, portholes, and the treble clef—into Modern Painting with Clef. The regulated and manufactured-looking forms of Art Deco assume unusual significance when used as subject matter. In addition, the ordinarily unremarkable Benday dots are hand painted and oversize, thus becoming ornamental elements. Modern Painting with Clef is an abstraction of a decorative style and a mechanical process. By treating the style seriously and the process playfully, Lichtenstein succeeds in capturing the look of the 1930s while making trite patterns fresh and unexpected. ALM

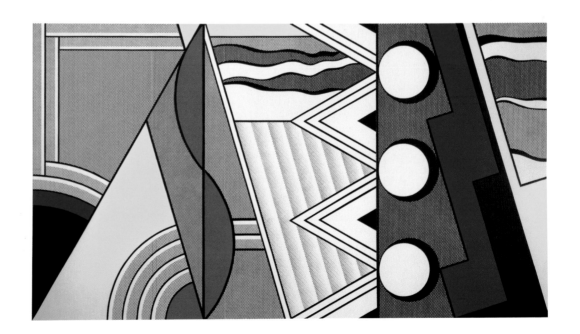

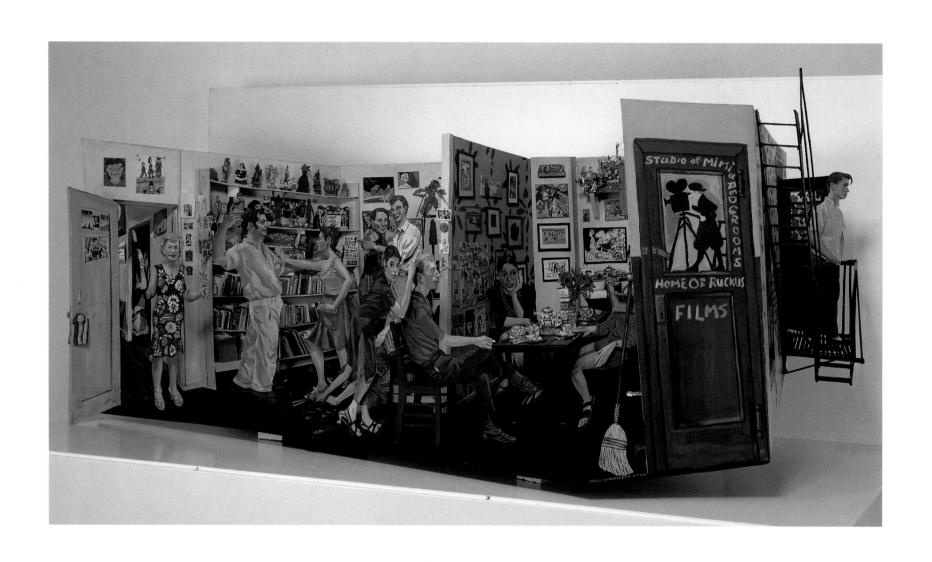

Red Grooms

American, born 1937

Loft on 26th Street, 1965–66

Painted plywood, cardboard, paper, and wire
28 1/4 × 65 1/4 × 28 1/2 in. (71.7 × 165.7 × 72.2 cm)
Gift of Joseph H. Hirshhorn, 1972 (72.143)

Red Grooms is best known for his exuberant and humorous life-size environments depicting city scenes and interiors. His body of work also includes prints, paintings, sculptures, films, puppetry, and performances. During the early 1960s, Grooms began to develop the sculptural cutouts and small tableaux that would lead to his later all-encompassing environments, or "sculpto-pictoramas." During that period he also produced *Shoot the Moon,* a filmed play with costumes and sets made by Grooms and his friends, who were also the actors.

Although he has been associated with the Pop Art movement, Grooms's work is idiosyncratic and personal. In 1965, after hearing that his apartment building was to be demolished, he created *Loft on 26th Street,* a miniature version of his home. Every detail, including paintings, books, and dishes, is carefully represented. Images of his friends, in cutout form, populate the cramped space; his wife at the time, the artist Mimi Gross, is in the center, leaning against the back of a chair. Since creating *Loft on 26th Street,* Grooms has gone on to create baroque extravaganzas like the immense installation piece *Ruckus Manhattan,* 1976, as well as witty homages to artists such as Pablo Picasso and Salvador Dalí. AC

Louise Nevelson

American, born Russia, 1899–1988

Dream House XXXII, 1972

Painted wood with metal hinges
75 1/8 × 24 5/8 × 16 7/8 in. (190.8 × 62.5 × 42.9 cm)
Joseph H. Hirshhorn Bequest, 1981 (86.3340)

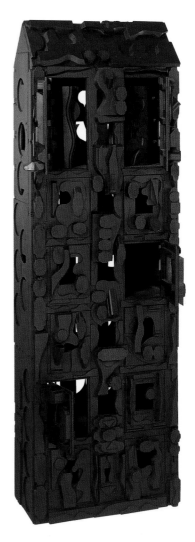

Louise Nevelson's studies under Hans Hofmann and Chaim Gross in the early 1930s led her gradually to abandon painting for sculpture. During the 1930s and 1940s she made clay and stone figural sculptures of simplified solid forms, echoing influences that ranged from Pre-Columbian pottery to Henry Moore's organic bronzes. Increasingly in the 1950s and 1960s, Nevelson gained recognition for her constructed and painted assemblage sculptures: wall reliefs made of wood boxes (often milk crates) filled with pieces of scrap lumber in abstract shapes. The artist painted these constructions a uniform black, white, or sometimes gold, colors that imbue the works with a dreamy quality and distance them from the mundane world. That otherworldly intention was emphasized in the titles of her series, such as "Sky Cathedral" and "Moon Garden."

In the late 1960s, Nevelson expanded her home and studio in Greenwich Village by connecting the adjoining properties into a warren of twenty rooms on various levels filled with her sculpture. Gratified with this architectural environment, she created a series of three dozen "Dream House" sculptures: modestly scaled, roofed constructions of abstract elements with opening doors that simultaneously suggest retreat to a safe place and escape to a different dimension. Their black monochrome evokes night, the time of dreams. These house sculptures also relate to Nevelson's larger environment *Mrs. N's Palace,* 1964–77, a sculpted black room that could be physically entered. VJF

Edward Ruscha

American, born 1937

The Los Angeles County Museum on Fire, 1965–68

Oil on canvas, 53½ x 133½ in. (135.9 x 339.1 cm)

Gift of Joseph H. Hirshhorn, 1972 (72.252)

The Los Angeles artist Edward Ruscha has produced paintings, drawings, prints, films, and books that merge remarkable graphic skill and interest in vernacular language with a witty Pop Art sensibility. In the early 1960s, impressed by the works of Jasper Johns and Robert Rauschenberg, he was producing word-based artworks, creating images out of words depicted as three-dimensional forms. Some of his best-known compositions portray icons of the Los Angeles landscape, such as the Twentieth Century Fox trademark or the famous Hollywood sign.

In *The Los Angeles County Museum on Fire*, Ruscha presents the building complex as it looked in the mid-1960s—except for the addition of the flames issuing from one of its wings. As in an idealized architectural model, the museum is removed from its neighborhood and set against an anonymous background. Similar in conception are a canvas of 1964 in which the word "damage" appears in flames, and paintings of a Standard Oil gas station that Ruscha rendered in flaming and nonflaming versions in 1965 and 1966.

Ruscha's painting coincided with the opening of the new museum in 1965. At the time of its unveiling, many in the Los Angeles art community were critical of the museum and its architecture. Ruscha's tongue-in-cheek comment on the institution is characteristic of the strong strain of irony that runs through his work. AC

Malcolm Morley

British, born 1931

Beach Scene, 1968

Oil on canvas, 110 x 89⅞ in. (279.4 x 228.2 cm)

Gift of Joseph H. Hirshhorn, 1972 (72.207)

Beach Scene is a prime example of Malcolm Morley's Super-Realist technique. Deriving the image from a 1959 advertisement for Daytona Beach, Florida, Morley transferred it to canvas by placing a grid over the advertisement and proportionately enlarging the shapes in each square onto the canvas. The grid is still barely visible in several areas, most noticeably in the towel by the man's foot. Painting each square individually, Morley created a relationship of abstract shapes, heightening the abstraction by working from an upside-down image. In common with all of Morley's Super-Realist paintings, *Beach Scene* from a distance looks like a gigantic photograph or postcard. The white border heightens the quality of photographic representation while it also concentrates the eye on the illusion of three-dimensionality. Viewed up close, the flattened surface of the painting dissolves into small, almost impressionistic, brushstrokes on the canvas. *Beach Scene* emphasizes the fable of the ideal family vacationing at a picturesque resort. Even without indicating that the "family" is a fake composed of an advertising agency director and unrelated models, Morley satirized the mock-perfection of the beaming group on the sand. He skillfully portrays paradoxes in the act of seeing and reveals our cultural fantasies as myths of impossible desires. ALM

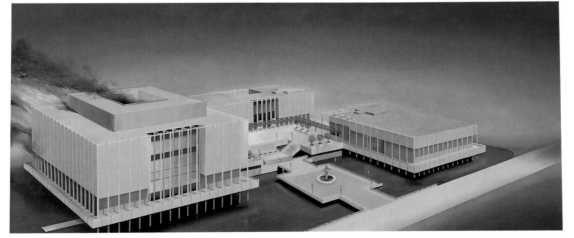

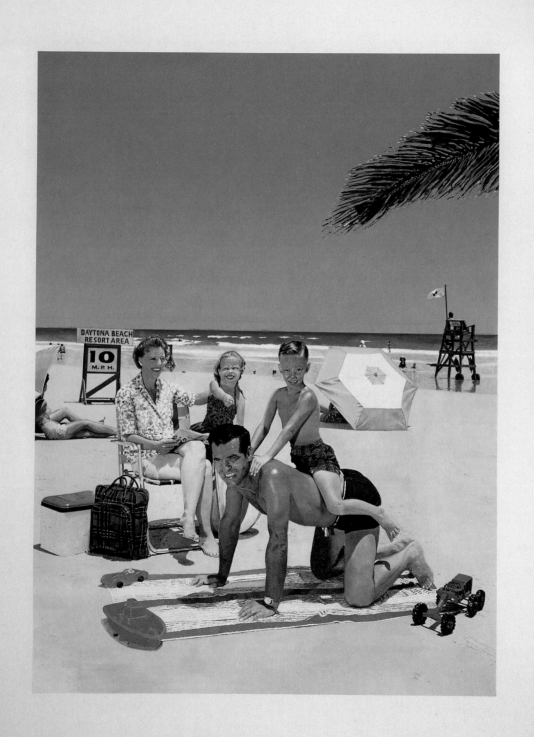

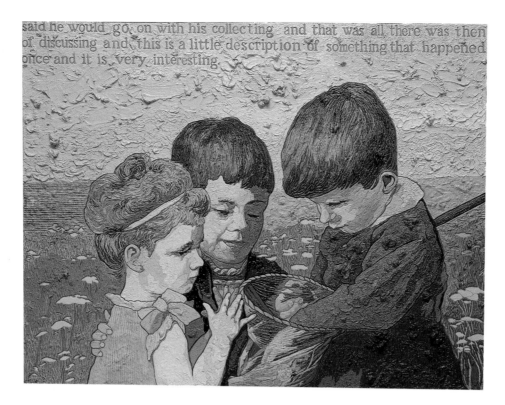

Jess

American, born 1923

Will Wonders Never Cease: Translation No. 21, 1969

Oil on canvas mounted on wood panel

21 × 28 1/8 in. (53.3 × 71.4 cm)

Joseph H. Hirshhorn Purchase Fund, 1986 (86.5885)

Works in the "Translations" series by Jess (born Burgess Franklin Collins) are based on images from newspapers, magazines, and books. Jess made his first "Translation" painting in 1959, when a friend gave him an 1885 issue of *Scientific American* illustrated with black-and-white engravings. He copied some of the engravings onto canvases, enlarging the scale and adding color in thick layers. He also lettered texts from disparate sources onto the front and back of his paintings. The resulting dialogue between images and texts lead the viewer to possible explanations of the subjects of the paintings.

Will Wonders Never Cease: Translation No. 21 was inspired by an engraved illustration in A. W. Gould's *Mother Nature's Children,* published about 1895. That illustration was based, in turn, on a painting by J. Dvorak, *The First Butterfly in the Net,* 1887. Starting on the back and continuing onto the front of *Will Wonders Never Cease,* Jess inscribed a few phrases of text from Gertrude Stein's *Making of Americans,* 1925. The text recounts a discussion between a little boy and his father: The boy wanted to have a collection of butterflies and beetles, but the father suggested that killing insects is cruel. Nevertheless, the next morning the man presented his son with a beautiful but lifeless butterfly he had just caught. Confused by the contradiction, the youth decided to resume his insect collecting. Jess's textured paint gives form to the faces of the children who observe a captured insect with wonderment, innocence, and concern. FG

Georg Baselitz

German, born 1938

Meissen Woodsmen, 1968–69

Oil on canvas, 94 3/4 × 75 in. (240.7 × 195 cm)

Holenia Purchase Fund in memory of Joseph H. Hirshhorn

1994 (94.12)

Dismissed from an East Berlin art school in 1956 for "social and political immaturity," Hans-Georg Kern transferred to a school in West Berlin. There he continued to dissent, renaming himself Georg Baselitz (an amalgam of his given name and that of his birthplace, Grossbaselitz, Saxony), painting figurative images when abstract art was current, and publishing manifestos on art. One of the most important German artists of his generation, Baselitz is renowned for brilliantly colored, lushly painted canvases in which monumental images are distorted, deformed, or inverted.

Meissen Woodsmen is from the artist's "Fracture" paintings of 1966 to 1969, a series he admits parallels "the European fascination with the ruins of past civilizations." Early works in the series were divided horizontally into sections, so that overall outlines, colors, and perspectives do not quite match. Later paintings are more complicated, with several fractures taking place concurrently within the picture plane. In *Meissen Woodsmen* the breaks appear as different perspectives and ambiguous images layered into one complex visual field.

Painted in woodsy hues, *Meissen Woodsmen* evokes the forest typical of the area around that city. The desecrated landscape and "woodsmen" carrying paintings summon images of ragged soldiers making off with spoils of war. The barely clad figure at right bears a vaguely Hitlerian visage, with his long, flopping forelock and hint of a mustache. The canine popping out of his chest suggests mankind at its most elemental, with the heart of a wolf. Despite these readings, meaning in *Meissen Woodsmen* remains as splintered as the image. ALM

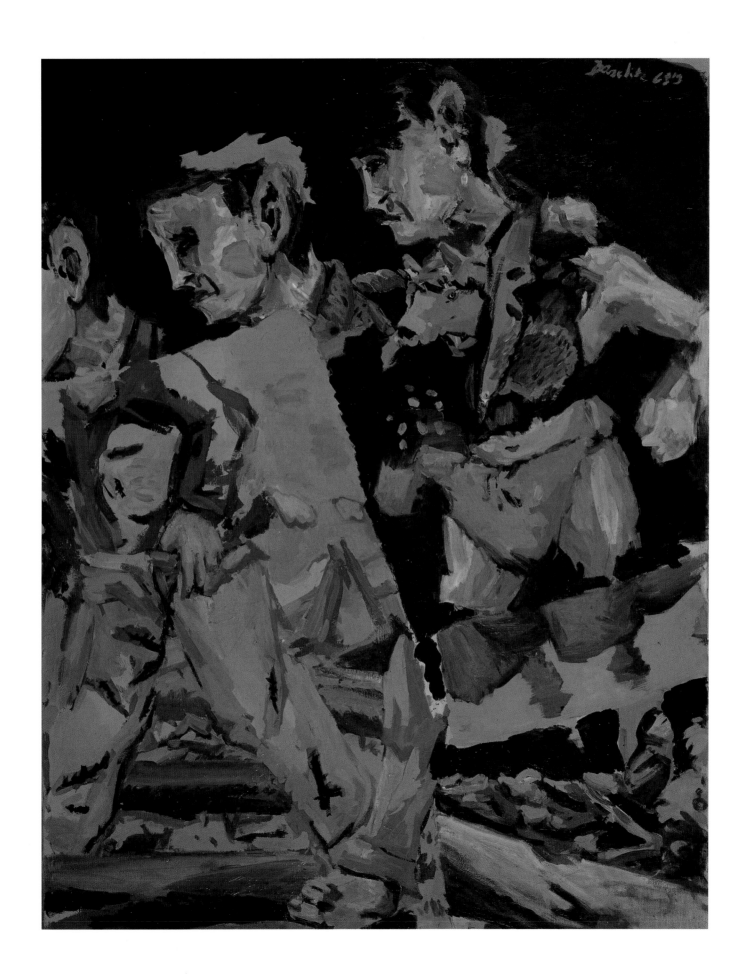

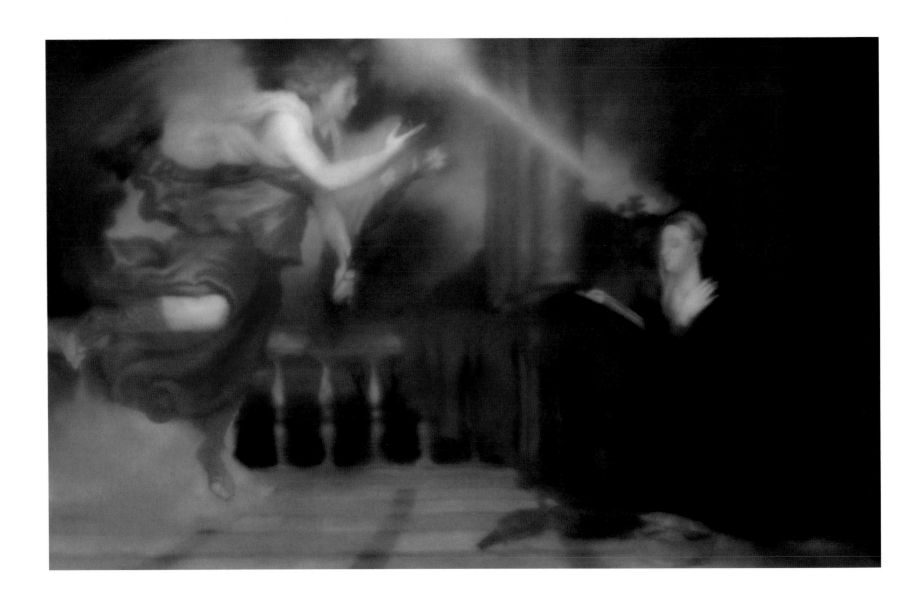

Gerhard Richter

German, born 1932

Annunciation after Titian, 1973

Oil on linen, 49³/₈ x 78⁷/₈ in. (125.5 x 200.2 cm)

Joseph H. Hirshhorn Purchase Fund, 1994 (94.16)

Gerhard Richter has produced stylistically varied paintings that range from Super-Realist landscapes to brilliantly colored abstract canvases. With fellow students Sigmar Polke and Konrad Fischer-Lueg, he instigated the satirical Capitalist Realist style in Düsseldorf in 1961. Richter produced realistic but blurred images based on reproductions from print media and other sources. Photographs and the combination of realism and abstraction continue to form the basis of Richter's strikingly diverse work.

In 1972, while in Venice for the Biennale, a biannual art exhibition, Richter visited the Scuola di San Rocco, where he saw Titian's famous *Annunciation,* c. 1540. Inspired to paint a copy, he developed a series of five canvases based on Titian's masterpiece. *Annunciation after Titian* is the first and most naturalistic version. It recalls the splendor of the older composition with the Virgin kneeling to receive the Holy Spirit, while the angel Gabriel brings word that God has chosen Mary to bear his son. Richter, however, has rendered his variant as if it were out of focus. All edges are blurred so that the rich tones seem to bleed together, creating a dreamlike ambiguity. In the other four paintings of this cycle, he obliterated the scene further with sweeping brushstrokes that create luminous, colorful abstractions. Richter's homage to the sixteenth-century virtuoso follows Titian's own practice, late in his career, of rendering form through color and increasingly abstract, feathery brushstrokes. ALM

Robert Irwin

American, born 1928

Untitled, 1969

Acrylic paint on cast acrylic disk, and light

Disk 54 in. (137.2 cm) in diameter

Joseph H. Hirshhorn Purchase Fund, 1986 (86.5887)

Robert Irwin is one of a group of Southern California artists who in the mid-1960s pioneered the use of light as a medium and the experience of perception itself as a subject for art. Irwin's development as an artist evolved from his production of gestural paintings in the late 1950s to nearly monochromatic paintings, to three-dimensional cast acrylic disks and columns that seemed to disappear into their environments. Later installations involved tape, scrim, and other semitransparent materials and placement outdoors. Irwin's mature work has consistently focused on the blurring of distinctions between objects and space and on a commitment to art based on the belief that the viewer's awareness of the process of perception takes precedence over the object per se.

Untitled is one of a number of pieces Irwin created in 1968 and 1969 in which lights from different directions cast shadows on a painted cast acrylic disk mounted to a wall. In this piece the single disk is cross-lit from four directions. The lighting creates four symmetrical, overlapping patterns of shadow on the wall in which the centered disk, the shadows, and the illuminated wall are perceived as an entity. The disk itself seems to disappear among the shadows, and the viewer's perception of the distinctions between light, shadow, and object is altered or obliterated. PR

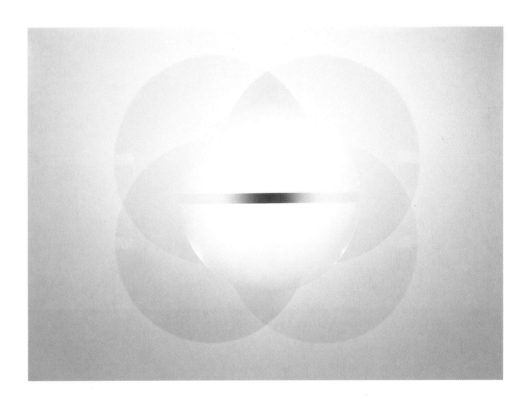

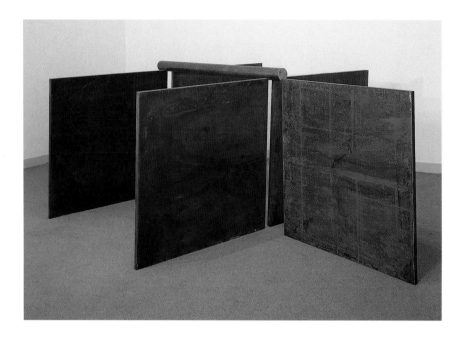

Richard Serra

American, born 1939

2-2-1: To Dickie and Tina, 1969

Steel, fabricated 1986
51³/₈ x 120¹/₄ x 99³/₈ in. (130.5 x 305.4 x 252.4 cm)
Joseph H. Hirshhorn Purchase Fund, 1986 (86.5898)

Throughout his career Richard Serra has investigated various physical properties of sculpture: its abstract shapes, the ways in which it can articulate or define a space, the weight and behavior of specific materials, and various principles of construction. The sculpture *2-2-1: To Dickie and Tina*—which Serra dedicated to the musician Richard (Dickie) Landry and his wife, artist Tina Girouard—belongs to a series originally executed in lead antimony and later refabricated in steel, a stronger material. In this work, square metal plates stand vertically and are held in position by the weight of a rolled rod of metal that crosses the top edges. The five plates and the rod appear to exist in poised but precarious balance. The title, *2-2-1*, is a deadpan description of the work's components: two pieces, two others parallel to the first two, and a plate perpendicular to the others. The construction of Serra's work recalls the simplicity and structural logic of Constantin Brancusi's cantilevered and stacked sculptures. Brancusi's straightforward building techniques and sensitivity to specific materials had a profound impact on other sculptors of Serra's generation, including Carl Andre and Donald Judd. Yet Serra's works introduced a new element created by the potential instability of the forms. PR

Eva Hesse

American, born Germany, 1936–1970

Vertiginous Detour, 1966

Painted rope, net, plaster, and papier-mâché
Ball approx. 16¹/₂ in. (41.9 cm) in diameter;
rope approx. 154 in. (391 cm)
Joseph H. Hirshhorn Purchase Fund, 1988 (88.24)

In her brief career, cut short by a fatal brain tumor, Eva Hesse produced an impressive body of work distinguished by eccentric forms, unusual and malleable materials, and a "hands-on" technique in which the process is revealed in the final product. Hesse was a significant figure in the movement away from the reductivist, pristine, geometric aesthetic of Minimalist sculpture.

Vertiginous Detour is one of several works Hesse made that hangs from the ceiling and thus challenges our expectations of sculpture. Hesse may have begun the work by wrapping string over an inflated beach ball or balloon. The rope, instead of being wound tightly, unravels through a net. The circular form of *Vertiginous Detour* is characteristic of the many drawings and sculptures Hesse produced in 1966–67. Its hanging weight, indefinite organic form, and strangely erotic and personal imagery are characteristic of the best of her oeuvre. As with many of her other works, the title is ambiguous but carries powerful connotations. It suggests an allusion to Hesse's frequent insecurity about her own accomplishments, the motion of a revolving ball, and the scary but often exciting sensations of deviating, erratically, from a direct route or course of action. PR

Paul Thek

American, 1933–1988

Fishman, 1968

Latex, 90$\frac{1}{2}$ × 25 × 8 in. (229.9 × 63.5 × 20.3 cm)

Joseph H. Hirshhorn Bequest Fund, 1990 (90.10)

Fishman, like much of Paul Thek's work, is a medita-
tion on temporality. It follows a series of encased
wax sculptures of rotting meat that Thek called
"Technological Reliquaries," and precedes the room-
size installations that preoccupied him for the remain-
der of his life. These installations were often filled
with newspapers, lighted candles, and other symbols
of transience, as well as stuffed animals like rabbits
and deer that traditionally represent rebirth and
spirituality. Elements of the installations were often
recycled; the installations themselves thus became
metaphors for death and resurrection.

 Fishman, which was cast from Thek's own body,
appeared in a number of installations during his life-
time. He first showed it in 1968 suspended from a
tree, on the outdoor patio of a New York art gallery.
It (or another version) reappeared tied under a table
in an installation at the Stedelijk Museum, Amsterdam,
in 1969 and in elaborated versions of that installation
in Minneapolis and Stockholm in 1970 and 1971,
respectively. Thek's suspended figure suggests depic-
tions of the Crucifixion, and the fish, in Western cul-
ture, is itself a symbol of Christ. But the figure can
also be read as swimming or flying, and the fish are
stuck absurdly on its body like oversize polka dots on
a clown's suit. Fishman is ambiguously funny and
poignant, suggesting an identification of the artist
both as clown and Christ figure, with its accompany-
ing hope of redemption through suffering. PR

Antoni Tàpies

Spanish, born 1923

Pants and Woven Wire, 1973

Cloth, wire, painted wood, and yarn

82 × 66$\frac{3}{8}$ in. (208.2 × 168.7 cm)

The Martha Jackson Memorial Collection: Gift of

Mr. and Mrs. David K. Anderson, 1980 (80.103)

In the late 1940s, Antoni Tàpies's work was associated
with several post–World War II European art move-
ments such as Art Informel and Surrealism, especially
with the latter movement's other Catalan protago-
nist, Joan Miró. During the 1950s and 1960s, Tàpies
painted expressionistically, in a thick impasto. By 1970
he had begun incorporating three-dimensional objects
in his work.

Pants and Woven Wire is related to a series of
assemblages from the early 1970s in which Tàpies
incorporated time-worn fabrics and clothing chosen
for their textural and associative qualities. The used,
threadbare materials evoke human action and the
passage of time, and they reflect the artist's belief
that the spiritual resides in everyday items and the
substance of daily life. Tàpies's work from the 1970s is
especially marked by his humanism and strong anti-
autocratic and antibureaucratic beliefs. In this compo-
sition, Tàpies presents a familiar object turned upside
down and suspended between strands of interweav-
ing wire. The paint-splattered, crudely mended, and
awkwardly short-legged pants hang in the form of a V.
Here, objects of mundane physical reality, a wire grid
and punctured and worn cloth, are raised to the level
of metaphor. PR

Alfred Jensen
American, born Guatemala, 1903–1981

The Sun Rises Twice: Per I, Per II, Per III, Per IV, 1973

Oil on linen, 96¹/₈ x 192³/₈ in. (244.1 x 488.5 cm)
Joseph H. Hirshhorn Purchase Fund, 1990 (90.16)

Relying on Pre-Columbian art, Chinese culture, and calendars and navigational symbols, Alfred Jensen combined the language and symbols from ancient and modern civilizations to illustrate universal truths. He also incorporated polarities into his paintings, using black to represent the female and white to signify the male, a square to symbolize day and a circle to indicate night.

The Sun Rises Twice catalogues such binaries: male/female, night/day, fall/spring, northeast/southwest. Also integrated is the I Ching, a method of divination using ideograms composed of groups of long and short lines. Each combination has a different meaning; several together determine a direction in life or an action to take. Navigational notations include, on the left panel, the inscription "Polar Pilot," probably referring to the North Star, and on the right, "Gnomon," the pointer on a sundial and a rule of conduct. The subtitle is derived from the notes Jensen inscribed on the back of the panels that make up this work.

In this and other paintings, Jensen gathered a wide variety of information into a personal map. Through his carefully composed images, he tried to make sense of the universe and provide guides to our physical direction, the understanding of time, and the correct path in life. FG

Philip Guston
American, born Canada, 1913–1980

Ancient Wall, 1976

Oil on linen, 80 x 93⁵/₈ in. (203.2 x 237.7 cm)
Smithsonian Collections Acquisition Program, 1987 (87.33)

In the last ten years of his life, Philip Guston produced an extraordinary body of work that combines a bold, visceral style of figure painting with apocalyptic imagery. Having abandoned the abstraction of the postwar New York School, Guston began in 1966 to create expressive figurative paintings with disturbingly violent allusions that anticipated the resurgence of "New Image" and Neo-Expressionist works in the 1970s and 1980s. Painted in a somber palette of blood red and black, *Ancient Wall* includes several images that recur with obsessive frequency in the artist's late canvases: dismembered limbs, a pile of shoes, and an omniscient, disembodied eye in the lower right corner of the composition. Guston rendered these stark images in a direct, somewhat cartoonlike style that recalls his introduction to art through a correspondence course. Yet the imposing pile of shoes and the bloody limbs disposed over the red brick wall form a classically stable composition. Perhaps unintentionally, Guston's nightmarish yet monumental painting evokes sinister visions of twentieth-century terror. While the shoes inevitably conjure visions of the Holocaust, Guston denied specific meaning in his choice of subject, citing instead his desire to deal merely with concrete objects. Nevertheless, the idea of evil fascinated him, and in the brutal simplicity of its imagery, *Ancient Wall* creates a haunting vision. JZ

Sam Gilliam

American, born 1933

Rail, 1977

Acrylic and canvas on canvas
90³/₄ x 181 ¹/₄ in. (230.5 x 460.4 cm)
Museum Purchase, 1978 (78.75)

In 1962, when Sam Gilliam moved to Washington, D.C., he came in contact with Kenneth Noland and Morris Louis, co-founders of the movement called the Washington Color School. Gilliam soon adopted the movement's abstract style and staining techniques. On frequent visits to New York, he studied the work of Abstract Expressionists, notably Jackson Pollock, Hans Hofmann, Mark Rothko, and Barnett Newman. By the late 1960s, Gilliam had begun to bend, fold, and manipulate stained canvases to produce chromatic effects similar to those obtained by the technique of African tie-dye. Working on a vast scale, he draped color-soaked canvases in room-size installations that won him national attention. In 1977 he began a series of black paintings in which collaged geometric shapes appear to float within heavily textured, dark fields of color. *Rail,* in that series, exemplifies the painter's mastery of emotive color, balanced composition, and expressive improvisation. Using rakes as well as conventional brushes, Gilliam spread thick layers of acrylic paint and gel across the full expanse of the painting. He also embedded patches of paint-soaked canvas into the heavily encrusted surface. Most notable is the narrow rectangular black band that seems to hover in the lower center of the painting. Bright red and green hues that glint from within the thick veils and skeins of black paint enhance the subtle interplay of geometry and expressive textures. Through his use of muted color and what has been called a "two-dimensional improvised architecture," Gilliam evoked a sober grandeur in this meditative painting. JZ

Eric Fischl

American, born 1948

The Funeral, 1980

Oil on canvas, 55¹/₂ x 103¹/₈ in. (139.8 x 261.8 cm)
Smithsonian Collections Acquisition Program with matching funds from the Jerome L. Greene, Sydney and Frances Lewis, Leonard C. Yaseen Purchase Fund, and Joseph H. Hirshhorn Purchase Fund, 1990 (90.5)

Eric Fischl paints disorienting images in which ordinary events and banal settings turn strange. His scenes of suburban backyards, interiors, and middle-class vacation sites have been termed Hopperesque in their depiction of the peculiar loneliness and alienation of American life. Characteristically for Fischl, *The Funeral,* a pivotal early painting, is populated by figures acting in an ambiguous drama. The painting's black-and-white coloring and stagelike, flattened space, however, are unusual in his work. While the funeral scene conveys a moment of overt pain and loss, we do not sense that the mourners are unified in their grief; instead, they seem lost and separated from one another. That some figures are almost entirely obscured behind others heightens the discordant psychological impact of the composition, suggesting a physical parallel to the psychological dislocation of the subjects.

Fischl painted *The Funeral* from photographs taken nine years earlier, after his mother's death. That same year, he had entered a conceptually oriented program with an emphasis on photography at the California Institute of Arts in Los Angeles. The influence of photography may offer a clue to *The Funeral's* unconventional composition and monochromatic coloring and to the disconnected, voyeuristic experience, such as provided by snapshots, that is reflected in the scene. Such psychological disorientation is central to nearly all of Fischl's subsequent work. PR

Tony Smith

American, 1912–1980

Throwback, 1976–79

Painted aluminum
81¼ x 155⅞ x 95⅝ in. (206.5 x 395.9 x 242.6 cm)
Museum Purchase, 1980 (80.3)

Formerly an architect, Tony Smith was initially inspired to sculpt by making architectural models. His art helped define Minimalism, a style characterized by simple geometric shapes, a neutral anonymous quality, industrially fabricated components of mechanical precision, and single-color schemes. Yet unlike other Minimalists, whose work appeared to be mathematically regulated, Smith often organized his geometric modules into irregular arrangements. His early sculptures were either compact or rambling forms that ranged from table- to room-size constructions. Beginning in the late 1960s he tended to create blocky compositions frequently more than ten feet tall or structures of connected chambers spread over a large area. *Throwback* is from the artist's late period, but its scale and forms recall his earliest sculptures—an apparent regression that Smith acknowledges in his title.

In *Throwback*, Smith organized tetrahedrons and octahedrons into an asymmetrical composition. The modules are arranged like waves across the sculpture, piling up and pouring back onto themselves at the high ends. When observed from different viewpoints, however, *Throwback* appears to change shape, evolving into a reclining figure with a bent leg or a lattice of angled forms. The artist achieved this organic quality through experimentation, a working method perhaps more allied to the accidental gesture used by his Abstract Expressionist friends than to the theory of his fellow Minimalists. *Throwback* exemplifies Smith's deft handling of the mutable geometry that is a hallmark of his work. ALM

Susan Rothenberg

American, born 1945

IXI, 1976–77

Vinyl emulsion and acrylic on canvas
78⅛ x 104 in. (198.2 x 264 cm)
Joseph H. Hirshhorn Purchase Fund, 1990 (90.19)

Susan Rothenberg's work of the 1970s reintroduced imagery to art in a period dominated by abstraction and forged an alliance between the painterly sensuality of Abstract Expressionism and the simplified reductive forms of Minimalism. In 1973, Rothenberg, who had been making abstract paintings, casually sketched a silhouette of a horse's profile divided by a vertical line. She was struck by the immediacy of the image and the tension created between its recognizable subject matter and abstract form. Between 1973 and 1979 she made a number of paintings, including *IXI*, based on the motif of the silhouetted horse. The title *IXI* is a visual pun, describing the cross made by the horse's awkward form framed by vertical stripes to its left and right. These bars at the edges weld the image to the surface of the painting, emphasizing the flat, painterly space and abstract composition. Like the work of many of the sculptors and performance artists with whom she was associated during that period, Rothenberg's image, although referential, divides and animates physical space. And like the abstract Minimalist sculpture of her contemporaries, Rothenberg's horse is pared down to its essential form. *IXI* combines forceful abstract design with an elemental image that projects the talismanic power of a Jungian archetype. PR

Richard Estes

American, born 1932

Waverly Place, 1980

Oil on canvas, 36¼ x 80⅜ in. (92.1 x 204.1 cm)

Museum Purchase, 1980 (80.154)

Richard Estes is one of America's leading Photo-Realists. The crisp clarity of his paintings is reminiscent of photography, yet upon closer inspection they reveal elements and perspectives that do not exist in reality. Most of Estes's canvases from the early 1960s are figurative, vigorously painted scenes of New Yorkers engaged in urban activities. Around 1967 his interest in city street scenes began to emerge in the form of paintings of glass storefronts reflecting the distorted images of buildings and cars. Basing his compositions on his own color photographs, he painted freehand, subtly altering the details for aesthetic balance but keeping the buildings and locations recognizable.

Waverly Place is one of Estes's "panoramas," or wide-angled views of buildings and streets. For this and other works made after 1974, he used panoramic cameras with special lenses to solve problems of perspective and distortion. By combining two or more such photographs, he created an image showing a juncture of streets from several viewpoints at once.

Waverly Place depicts an intersection of streets in Greenwich Village. A preternatural hush seems to fall over the scene. No people appear in the painting, and cars are parked sedately at the curbs. The perspective is defined by the streets as they angle away from the observer—a view that does not exist in reality. Yet the perspective, buildings, and cars are only slightly altered, and a part of urban New York is transformed into a carefully composed yet identifiable representation of a neighborhood. FG

Wayne Thiebaud

American, born 1920

Down Eighteenth Street, 1980

Oil and charcoal on canvas, 48 x 35⅞ in. (121.8 x 91.2 cm)

Museum purchase with funds donated by Edward R. Downe, Jr., 1980 (80.66)

One of the foremost American realist painters, Wayne Thiebaud joined the studio-art faculty at the University of California at Davis in 1960 and began a long and influential teaching career. Rejecting abstract painting in the late 1950s, he subsequently developed his celebrated paintings incorporating images of pies, cakes, candies, and other consumer items, such as ties and lipsticks. Thiebaud's subject matter has caused him to be grouped with the proponents of Pop Art, but, in contrast to that detached and slick style, Thiebaud's hand is always evident in his sensuous application of paint.

In 1973, Thiebaud indulged his fascination with San Francisco's hilly streets and began painting a series of works depicting the city. *Down Eighteenth Street* is typical of this group, its strong vertical composition giving a sense of the steepness of the street. People rarely appear in these works except as generic props. As with other works in the series, Thiebaud simultaneously presented different perspectives, arbitrarily changed the scale of objects, and retained a flat picture plane while suggesting space. AC

Edward and Nancy Reddin Kienholz

American, 1927–1994, and American, born 1943

In the Infield Was Patty Peccavi, 1981

Metal, resin, cloth, wood, glass, paper,
photomechanical reproductions, electric lights,
stuffed bird, and paint
$100^{1}/_{2} \times 88^{5}/_{8} \times 81^{1}/_{4}$ in. (255.3 × 225 × 206.2 cm)
Museum Purchase, 1985 (85.13)

In the mid-1960s, Edward Kienholz earned international renown for his assemblages of found objects and tableaux addressing uneasy situations of human pathos, usually laced with social and political commentary. Beginning in 1981 his wife, Nancy Reddin, became his collaborator. Their installation sculptures often involve the plight of the aged, the destitute, and the hopeless. *In the Infield Was Patty Peccavi* presents a pregnant woman seated on her bed, momentarily slumped in discouragement as she dresses to face the day. The artists have stated that this sculpture was intended as a commentary on birth control, but the imagery encompasses broader social and emotional issues than the self-evident religious ones. The stuffed bird symbolizes freedom or flight, while the "sunlight" shining through the window is supplied by a high-intensity headlamp, as if to imply that the woman is fatally caught, like a deer, in the blinding glare of an oncoming car or train. The sculpture's title conveys nuances about responsibility and guilt: the baseball allusion implies expectations to "play the game" properly (to avoid "errors"), and the name Peccavi means "I have sinned" in Latin (formerly the opening phrase in the confessional). Thus, the sculpture serves as a poignant evocation of women's uneasy awareness of complex and conflicting desires, expectations, pressures, options, and limitations in their personal lives. VJF

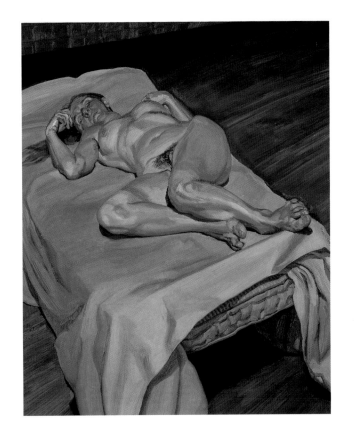

Lucian Freud

British, born Germany, 1922

Night Portrait, 1985–86

Oil on linen, $36^{1}/_{2} \times 30$ in. (92.7 × 76.2 cm)
Joseph H. Hirshhorn Purchase Fund, 1987 (87.11)

The grandson of Sigmund Freud, the founder of psychoanalysis, Lucian Freud was born in Berlin. After Hitler's rise to power, Freud's family left Germany and settled in London. By the mid-1940s, Freud had acquired a reputation as an individualistic artist of carefully observed detail. By the 1960s he had developed the overtly expressive painting style for which he is now known.

A recurrent subject in Freud's paintings, the reclining nude remains among the most provocative and disturbing of his motifs. Like Edgar Degas, whose unromanticized compositions of women shocked viewers in late nineteenth-century France, Freud challenges accepted notions of pictorial design and idealized human form. Working within the art historical convention of the nude as a subject, he allows his sitters—male and female—to choose their own poses; encouraged to be natural, they reveal themselves psychologically. In these paintings, which Freud calls "naked portraits," he combines the tradition of the studio nude with the disarming intimacy and frankness possible in a portrait.

The large shadows and intense color in *Night Portrait* identify it as having been painted at night under artificial light. The atmosphere in this work, as in many of Freud's naked portraits, is filled with contradictions. The expressive handling of paint incongruously records a supposedly objective image—a naked woman on a mattress viewed from above at a vulnerable angle. In *Night Portrait,* Freud has transformed the familiar motif of the reclining female nude into a highly charged image. PR

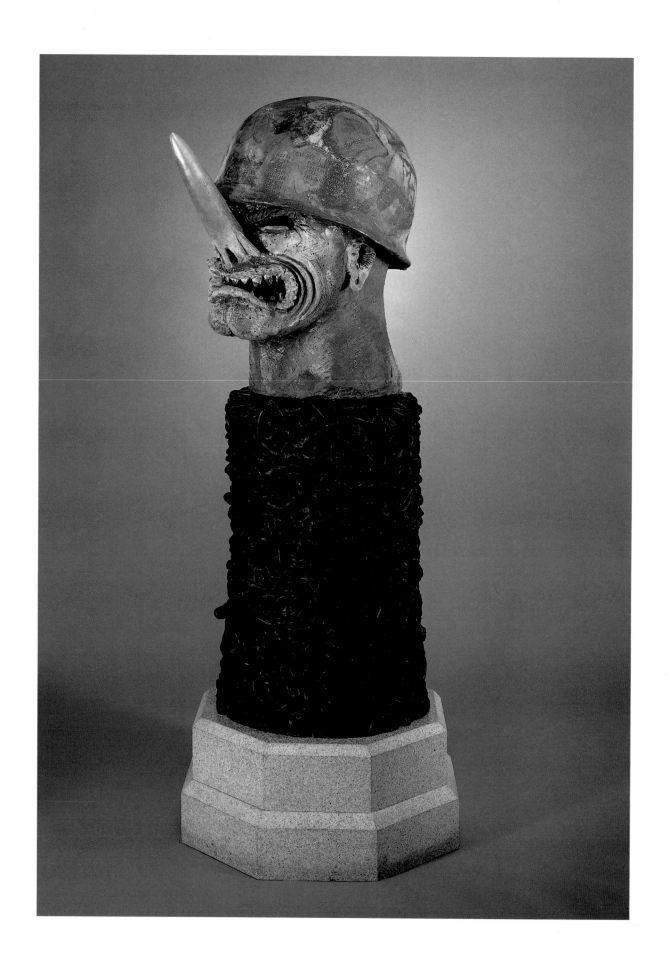

Robert Arneson

American, 1930–1992

General Nuke, 1984

Glazed ceramic and bronze on granite base
77³/₄ x 30 x 36³/₄ in. (197.5 x 76.2 x 93.3 cm)
Gift of Robert Arneson and Sandra Shannonhouse, 1990 (90.12)

Inspired by the ceramic sculptures of Joan Miró and Peter Voulkos, Robert Arneson turned to that medium in the late 1950s. He quickly developed a humorous style of portraiture, especially self-portraits, in punning, ironic, or mocking modes. Yet, after confronting a diagnosis of cancer, the artist redirected his art in the early 1980s to address nuclear holocaust at a time of escalating armament by the two superpowers. Conceived when the United States and the Soviet Union temporarily abandoned negotiations on arms control, *General Nuke* presents a caustic, denigrating stereotype of a military leader. With bloody fangs and a phallic MX "peacekeeper" missile for its nose, the snarling head wears the helmet of a three-star general, which is covered with a global military map incised with abbreviations for the available nuclear weapons: ICBM, IRBM, ACLM, SLBM. Some inscriptions ridicule those who, in Arneson's view, foster war, while other markings provide facts about the impact of a one-megaton bomb ("Fallout: lethal 600 sq. mi., death risk 2000 sq. mi."). Even the pedestal is part of the message, for the head stands on a bronze pedestal depicting hundreds of charred, stacked corpses, resting on a base of granite—a material traditionally used for memorials. VJF

Alison Saar

American, born 1956

Snake Charmer, 1985

Painted cottonwood, tin, and found objects
21 x 26 x 14 in. (53.3 x 66 x 35.6 cm)
Joseph H. Hirshhorn Purchase Fund and Partial Gift
of Merry Norris, 1993 (93.26)

Alison Saar's predilection for creating varied forms with unusual combinations of media may be partially owed to the influence of her mother, artist Betye Saar. Both make art based on found materials that addresses issues of African American culture. Alison's father, Richard Saar, a conservator, introduced his daughter to ancient cultures and an appreciation for traditional materials and techniques. In Saar's own study of art history, she focused on African, Afro-Cuban, Haitian, and other Black visual traditions. Her sculptures, reflecting this rich and varied background, often straddle many cultures and genres.

Saar made *Snake Charmer*, the subject of which is a man clenching a serpent in his mouth, when she was living in New Mexico. It is an elegant example of her ability to fuse diverse sources and traditions—in this instance Native American, African American, and ancient Mediterranean and Western European—in the creation of a compelling, singular image. The bust sculpture, a form more familiarly seen in classical or Renaissance marble or bronze portraits, is here assembled from two roughly cut logs. The subject's flattop haircut, emblematic of contemporary inner-city fashion, is suggested by a chopped log end. His eyes are made of turquoise and mother-of-pearl, and he wears Navajo potsherd earrings. Fusing a folk-art-like use of gathered materials, preclassical formal austerity, and felt rather than explicated spirituality, *Snake Charmer* is neither a portrait of a specific model nor a total fabrication but rather a powerful metaphoric image. PR

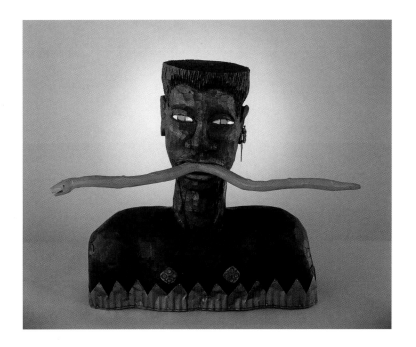

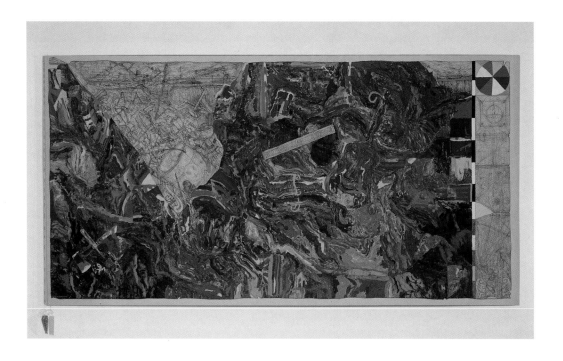

William T. Wiley

American, born 1937

Acceptablevels, 1985

Acrylic, felt-tip pen and ink, charcoal, and pencil
on canvas with screw, copper wire, painted string, wood,
plastic, and two framed drawings
Painting 78 × 153 in. (198.1 × 388.6 cm);
drawings, each 10¼ × 7 in. (26 × 17.8 cm)
Joseph H. Hirshhorn Purchase Fund, 1986 (86.5889)

William T. Wiley shares with Robert Arneson and
Roy De Forest, his one-time colleagues at the
University of California at Davis, an idiosyncratic,
irreverent sensibility and an interest in creating
humorous art from humble materials. A concern for
the environment is a common theme in Wiley's work.
The ominous title of this painting comes from the
jargon of the nuclear industry and refers to "accept-
able levels" of pollution, radiation, or other toxic sub-
stances that humans can withstand. A swirling mass
of acidic color engulfs a drawn industrial landscape of
garbage with a port in the background. Among the
jumbled, almost indecipherable, heap of trash are a
waste drum, an iron, a gun, and French curves. A sign
at the upper left corner states, "Everything Must Go!"
The lavalike flow of paint contains a guitar, toma-
hawks, and a carpenter's level that seems to float on
top. A vertical band at right includes a torn color
wheel, a gauge, and more French curves. Like a
plumb line, a string with two found objects hangs
down the painting's left edge.

Although Wiley's ecological message is clear, the
specific meaning of the various motifs is typically con-
cealed. Adding to the mystery are two framed draw-
ings that may be installed next to the painting; Wiley
created the piece to be shown with or without the
drawings. AC

Anselm Kiefer

German, born 1945

The Book, 1979–85

Oil, lead, photographic paper, straw, and fabric on canvas
130 × 217⁵/₈ in. (330 × 552.7 cm)
Thomas M. Evans, Jerome L. Greene, Joseph H. Hirshhorn, and
Sydney and Frances Lewis Purchase Fund, 1985 (85.27)

Although primarily a painter, Anselm Kiefer has also
created books throughout his career. While his early
books were based on photographic imagery, in 1976
he began producing large sculptural books made of
lead. Their numerous symbolic associations included
the great books of the world's religions, the
Argentine writer Jorge Luis Borges's view of the uni-
verse as an enormous, everlasting library, and the
infamous book burnings by the Nazis. Kiefer's use of
lead reveals his interest in alchemy, the medieval
science of transforming base metals into gold.
Alchemists believed lead to be the most resistant and
powerful metal and considered it a primary ingredient
in reaching their desired goals. Lead is also resistant
to radiation, and the lead book is thus a symbol of
strength. As a carrier of culture and the accomplish-
ments of humankind, it rises above the postapocalyp-
tic landscape depicted in the painting and suggests
such universal themes as regeneration, spirituality, the
role of art, and humankind's relationship to nature
and history.

In *The Book,* Kiefer incorporated the massive lead
book of the title into a painting of a devastated
anonymous landscape. The horizon is typically high for
Kiefer's work. The viewer, in effect, is directly con-
fronted with the barren field. AC

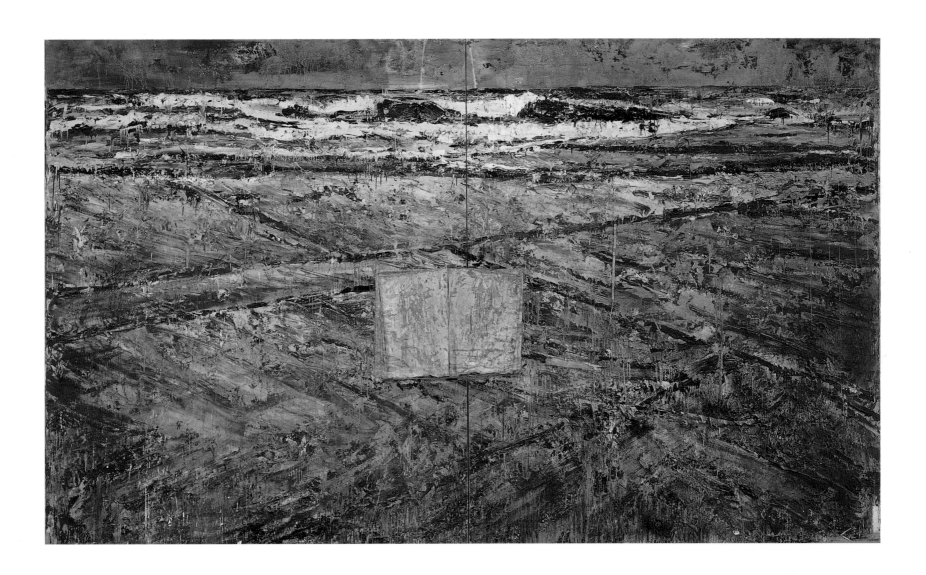

Leon Golub

American, born 1922

Four Black Men, 1985

Oil on linen, 121³/₈ x 190¹/₄ in. (308.2 x 483.2 cm)

Thomas M. Evans, Jerome L. Greene, Joseph H. Hirshhorn, and
Sydney and Frances Lewis Purchase Fund, 1985 (85.8)

Since the late 1950s, Chicago-born Leon Golub has
painted in a figurative expressionist style. In various
series of paintings of individual figures, faces, and bod-
ies in combat, he has addressed themes of violence
and relationships between power and vulnerability.
Four Black Men alludes to the abuse of power in a
specific aspect of contemporary society. It is one of
two large paintings from 1985 of Black South Africans
during the apartheid era. The figures are set in front
of a gridlike gray background that suggests a theatri-
cal backdrop but portrays the cement-block wall of a
township building. As in most of Golub's paintings, the
image comes from his collection of newspaper and
magazine clippings. The feet of the men are cut off by
the lower edge of the picture, which may reflect the
photographic source, but the cropping also enhances
the sense that the figures are being pressed forward,
uncomfortably, to the front of the scene. The rhyth-
mic arrangement of figures in the foreground plane
and the rich, flat colors suggest Golub's interest in
sources as incongruous with modern photojournalism
as ancient Greek vase painting and early Renaissance
frescoes. The smooth surface is a result of Golub's
characteristic method of applying, scraping off, and
then reapplying successive layers of paint. PR

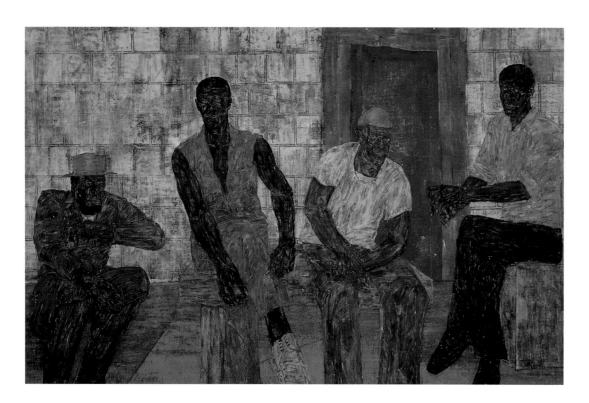

Julian Schnabel

American, born 1951

Portrait of Andy Warhol, 1982

Oil on velvet, 107³/₄ x 120¹/₈ in. (274 x 305 cm)

Joseph H. Hirshhorn Purchase Fund and Smithsonian
Collections Acquisition Program with matching funds from the
Jerome L. Greene, Sydney and Frances Lewis, and Leonard C.
Yaseen Purchase Fund, 1994 (94.11)

Julian Schnabel first painted on velvet in 1982 because
he liked the way images floated on the surface of the
pile. Such nontraditional material was not unusual for
the artist, who had already become known for his
paintings on broken crockery and who also painted
on truck tarpaulins during the 1980s. Velvet was espe-
cially appropriate for a portrait of the American Pop
artist Andy Warhol (1928–1987), who, famed for his
black velvet jackets, was sponsor of the 1960s rock
band called the Velvet Underground and of the
actress and model named International Velvet.
Schnabel's depiction of the bare-torsoed Warhol
alludes to the earlier but similar portraits of Warhol
made by painter Alice Neel and photographer Richard
Avedon soon after Warhol was shot and critically
wounded in his studio in 1968.

Warhol and Schnabel knew each other by the
early 1980s and painted each other's portraits in 1982.
This painting remained part of Warhol's collection
until his death in 1987. Schnabel proves himself an heir
to Warhol, taking a similar populist approach to cul-
ture and materials and mythologizing his persona as
an artist. Yet, though his eclectic and mannered paint-
ings recall the celebration of the banal in Pop Art,
they have none of the aloofness or smirking playful-
ness of the Pop era. Instead, Schnabel creates with an
operatic intensity, expressiveness, and drama that is
wholly his own. ALM

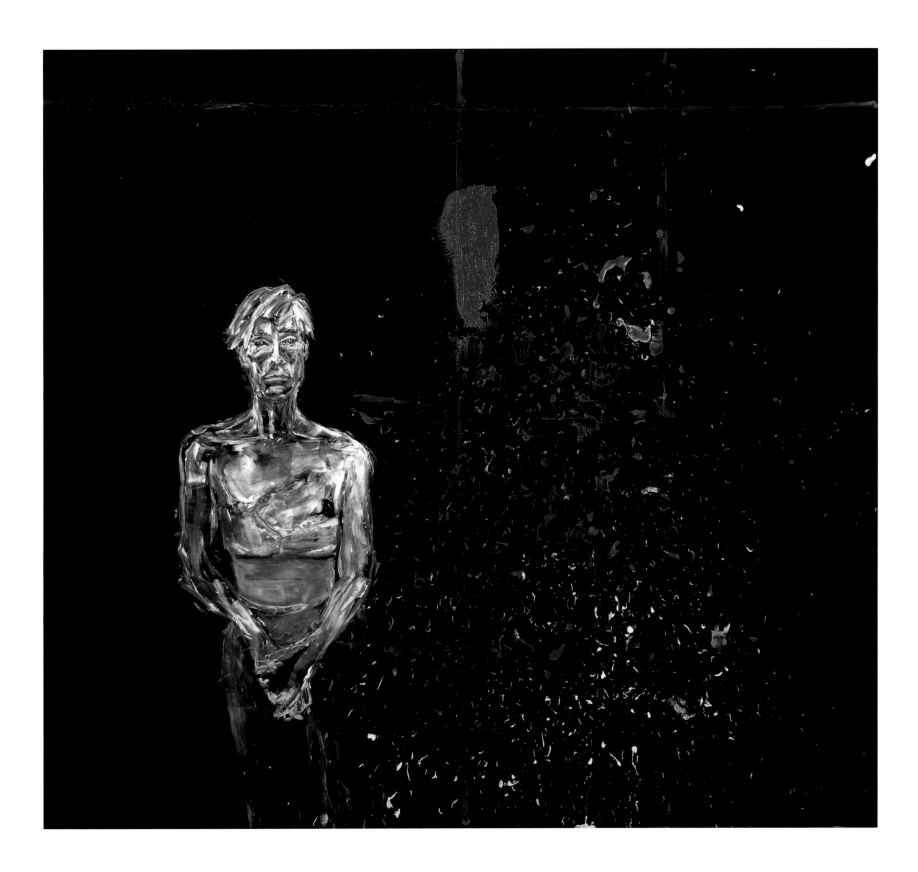

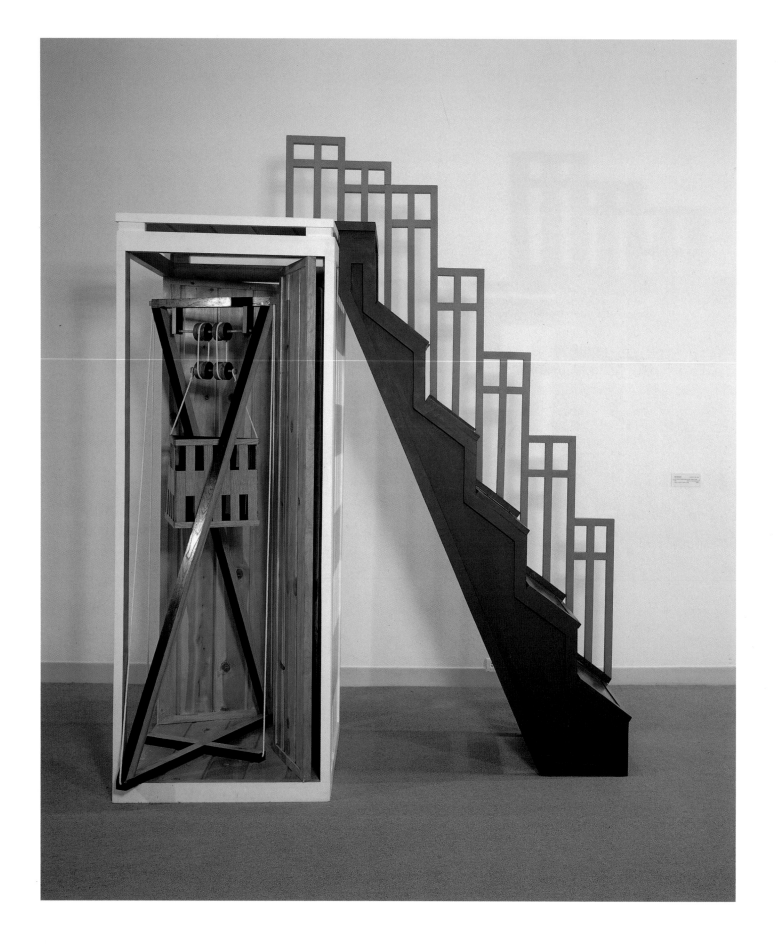

Siah Armajani

American, born Iran, 1939

Dictionary for Building: Closet under Stairs, 1985

Painted and stained wood and rope

110 1/2 x 86 3/8 x 44 1/8 in. (280.6 x 219.4 x 112 cm)

Joseph H. Hirshhorn Purchase Fund, 1986 (86.5884)

Born in Iran but a longtime resident of Minneapolis, Siah Armajani has been inspired by American vernacular architecture and the idealism of American democratic principles. His clarity of form and use of simple geometric shapes and diagonals reflect the idea that architecture and its components can serve political ends. Armajani is best known for his public projects—functional, communal environments such as reading rooms, gardens, lecture halls, and bridges. His earliest bridge forms, from the late 1960s, borrow from covered bridges of early America but reconfigure the elements in a surprising variety of ways: some contain apertures to record the sun's route at certain times of day; others have blocked or oddly placed entrances. Armajani's hybrid works break down architectural prototypes and reflect a populist attitude toward public art.

Armajani began the "Dictionary for Building" series in 1979. These conceptual, nonfunctional works depict isolated parts of domestic structures—windows, doors, and gates. The works analyze, alter, and present their several parts anew, fused into a unified structure. Inspired by earlier architectural forms and made of simple building materials, *Dictionary for Building: Closet under Stairs* combines a staircase of useless, slanted steps and its fanciful railing with an open closet. For this work, Armajani was inspired by the building theories of the Russian Constructivists: an interior sculptural element is directly related in concept and color to a 1922 design for a rostrum by the Russian Constructivist artist Gustav Klucis, who devised stands and kiosks for propaganda materials during the Russian Revolution. AC

Robert Mangold

American, born 1937

Four Color Frame Painting #9, 1984

Acrylic and graphite on canvas

115 5/8 x 80 1/4 in. (293.7 x 203.7 cm)

Gift of Paul W. Hoffmann and Camille Oliver-Hoffmann, 1994 (94.31)

In his paintings, Robert Mangold explores dynamic geometry and the shaped canvas. Inspired by Abstract Expressionist artists Barnett Newman and Mark Rothko, Mangold and fellow Minimalist painters Robert Ryman and Brice Marden are concerned with achieving an overall effect of individual parts perceived as a single, unified entity. Mangold's flat, meticulously organized compositions are formally distinct from the slashes, holes, and jutting forms found in works by other artists who have made shaped canvases, such as Elizabeth Murray and Frank Stella.

Four Color Frame Painting #9 belongs to a series of paintings in which the usual interdependence of frame and image is reversed. Deceptively simple, it is composed of four differently colored and sized canvas panels that fit together to form a rectangular frame. In traditional paintings on canvas, frames delineate the boundaries of an image and, when placed on a wall, establish a window into an illusionistic world. Here, the edges of the painting define the structure of the object, while the colors create the surface of the pictorial field. Within the "frame" is the white plane of the wall, which is simultaneously an image and a void. A freehand drawing of an ellipse inscribed on all four surfaces unifies the work and produces an intriguing tension between curved and straight lines. ALM

Martin Puryear

American, born 1941

Timber's Turn, 1987

Honduras mahogany, red cedar, and Douglas fir
86 1/2 x 46 3/8 x 34 1/2 in. (219.7 x 118.7 x 87.6 cm)
Museum Purchase, 1987 (87.34)

Born in Washington, D.C., Martin Puryear attended Catholic University of America. He served in the Peace Corps from 1964 to 1966 in Sierra Leone, West Africa, where he observed local artisans and worked with carpenters to learn woodworking techniques. Afterward, when he moved to Stockholm to study printmaking, he increasingly devoted himself to sculpture, independently investigating Scandinavian craft and furniture making. Back in the United States, he began graduate studies in sculpture at Yale University, where his instructors included Robert Morris and Richard Serra.

Puryear's earliest mature sculptures, from the late 1970s, are simple forms exquisitely crafted in wood. Fluctuating between the abstract and the representational, the natural and the man-made, his evocative works combine a devotion to craft with an adherence to abstract shapes. Puryear's sculptures elicit myriad associations, ranging from the organic world of birds, plants, and animals to the handworking techniques of the cultures of Africa and Scandinavia as well as Asia and the Arctic. Evidence of the working process and reference to human scale are important aspects of his work. Characteristically for Puryear, Timber's Turn is made of planks of wood that reveal the artist's labors. Its shape simultaneously refers to the organic—an elemental bird form—and the mechanical—a type of tool. Movement is suggested in the layering of planes of the surface as well as the uneven bottom, which makes the form appear to be able to rock back and forth. AC

Anish Kapoor

British, born India, 1954

At the Hub of Things, 1987

Fiberglass and pigment
64 1/8 x 55 1/2 x 59 in. (163.2 x 141 x 149.9 cm)
Gift of the Marion L. Ring Estate, by exchange, 1989 (89.12)

Anish Kapoor is associated with British sculptors of the early 1980s, including Tony Cragg and Richard Deacon. Kapoor's earliest efforts were drawings and sculptural compositions created from found objects and modest materials. In 1979, when he returned to India for the first time since his move to London in 1973, he became interested in Hindu religion. Impressed by the colored powders he saw on display in front of temples there, he began using powdered pigments in his sculptures. The white, yellow, red, and blue pigments, which spilled onto the floor, added an immaterial, glowing quality of light to the cones, crescents, pyramids, and mounds arranged in his early series of installations titled "One Thousand Names." After 1982 he began producing single works with pigment covering the entire form on a large scale.

At the Hub of Things, a hemisphere on its side, appears to hover over the floor at an angle. One looks into a deep blue, almost black, cavity that seems to recede into a limitless space. The blue pigment, which symbolizes Kali, the blue-skinned goddess of the cosmos in Hindu belief, dematerializes the object, adding an intangible dimension. Like much of Kapoor's art, the sculpture is an investigation of polarities. The material and immaterial, concave and convex, female and male exist simultaneously and reveal the artist's interest in exploring metaphysical states. Through the undeniable corporeality of his work, Kapoor suggests a transformation of the physical into the spiritual. AC

Christopher Wilmarth

American, 1943–1987

Do Not Go Gently, 1987

Bronze and steel, 55³/₄ × 17¹/₈ × 7¹/₈ in. (141.5 × 43.5 × 18 cm)
Gift of Robert Lehrman in honor of Agnes Gund, 1991 (91.26)

After working as studio assistant to Tony Smith and independently studying Constantin Brancusi's sculptures, Christopher Wilmarth developed his own style of abstract forms in delicate balance. He preferred to use industrial materials in sensuous combinations, subtly contrasting the weight of steel or the patina of bronze with the delicacy, luminosity, and translucence of glass. He favored wall-mounted constructions, which combine a pictorial approach to composition with an articulated space. His reliefs of the mid-1980s such as Do Not Go Gently are more complex than his earlier Minimalist pieces and usually include an ovoid element. The rounded abstract shape plays off against the more austere geometric components, while it also suggests a human presence, specifically the head as symbol of thought and imagination. Although Do Not Go Gently at first appears lyrically elegant, the blackened steel surfaces with a single ragged bronze edge create a somber, almost ominous effect. The title refers to Dylan Thomas's poem of 1946, which begins,

> Do not go gentle into that good night,
> Old age should burn and rave at close of day;
> Rage, rage against the dying of the light.

Wilmarth's sculpture eloquently reflects the artist's troubled, inward-searching consciousness in the months before his suicide in November 1987. VJF

Elizabeth Murray

American, born 1940

In the Dark, 1987

Oil on shaped canvas
115 × 142³/₈ × 24⁵/₈ in. (292.9 × 361.7 × 62.5 cm)
Museum Purchase, 1988 (88.3)

Elizabeth Murray makes shaped canvases in order to paint on their sliding, shifting surfaces. She constructs the huge three-dimensional forms from templates made from large drawings, or by working out the format in clay. She and her assistants laminate layers of plywood together, cut and smooth the edges, then stretch canvas around the resulting frames. Some frameworks create canvases layered over one another; others fit securely together with edges projecting from the wall.

In the Dark consists of three panels joined tightly, with irregular edges surging outward at the top and bottom. The canvas is covered with layer upon layer of paint, which the artist has scraped away or incised in some areas and built into clumps in others. The painting is further enlivened by the contrast between matte and shiny surfaces. Over this subtly textured canvas float three shapes with ragged edges. The forms at first appear completely abstract, but on closer inspection they seem to represent a fractured body: head with gesturing arms, torso with gushing hole where the heart should be, and hips with flailing legs. Red lines emanate from each segment in cartoonlike indicators of pain and movement. Murray's work is often autobiographical or broadly figurative, yet here her meaning remains mysterious. In the Dark combines the expectations of a narrative and an elegantly abstract study of forms in space. ALM

Robert Gober

American, born 1954

Untitled, 1990

Wax, cotton, wood, leather shoe, and human hair
10³/₄ × 20¹/₂ × 5⁵/₈ in. (27.2 × 52 × 14.2 cm)
Joseph H. Hirshhorn Purchase Fund, 1990 (90.15)

Robert Gober gained prominence in the 1980s with hand-fabricated sculptures based on plumbing fixtures and home furnishings. Taking a cue from the Minimalist insistence on primary forms and seriality, Gober reduced components to elemental shapes and produced variations on a theme, creating sinks and doors that multiply and mutate into eccentric configurations. His functionless sinks have exposed, vulnerable drains and deep receptacles for fluids; playpens, meant to protect, are distorted into dangerous or imprisoning forms; doors collapse in on themselves and are rendered useless.

Untitled is one of the first in a series of body-fragment sculptures that Gober has produced since 1990. A wax version of his left leg, it is complete with human hair and clothed in trousers, a sock, and a worn shoe. Meant to be placed on the floor and against the wall, it appears to be a leg emerging from the wall. As with much of Gober's anatomical forms, what is missing is as significant as what is visible; the absence of the rest of the body adds an eerie note. Although Gober's partial-figure sculptures are based on the work of Jasper Johns and Bruce Nauman, an equally important source exists in the artist's child-hood memories. Gober recalls:

> My mother … used to work as a nurse in an operating room, and she used to entertain us as kids by telling sto-ries about the hospital. One of the first operations was an amputation…. They cut off the leg and handed it to her. Stories like that had a big impact.

AC

Jasper Johns

American, born 1930

Untitled, 1987

Oil, encaustic, and charcoal on linen
50¹/₈ × 76¹/₈ in. (127.3 × 193.3 cm)
Joseph H. Hirshhorn Purchase Fund, 1988 (88.23)

This painting abounds with recurring motifs from Jasper Johns's past works, which often incorporate the use of optical illusions, trompe l'oeil, and references to art history. Here, three small paintings appear to be fixed with nails, painted in trompe l'oeil, to a mono-chrome background. Concealed in the background are two versions of a figure from *The Temptation of Saint Anthony,* a panel of the famous Isenheim Altarpiece by the German artist Matthias Grünewald (c. 1483–1528). A reclining figure with a cowled head appears at the left of Johns's painting; it emerges again, reversed and upside down, in the middle, where its head is partly obscured by Johns's interpre-tation of a 1936 painting of a woman's head by Pablo Picasso. The image on the far left seems to echo the eye and nostril motifs of the "Picasso" and allude to similar imagery in the late paintings of Philip Guston. The picture within the picture to the bottom right refers to a popular trick image by the cartoonist W. E. Hill; first published in *Puck* in 1915, titled *My Wife and My Mother-in-Law,* Hill's illusion represents, alter-nately, an old woman's face in profile or a young woman's face seen from behind and to the side. In this painting, themes of vision and perception, con-cealment and reversal, add an odd pathos to the wit and trickery of Johns's playful fantasy. PR

Magdalena Abakanowicz

Polish, born 1930

Four on a Bench, 1990

Burlap and resin on wood base
71 1/2 x 88 5/8 x 19 in. (181.5 x 225 x 48.2 cm)
Museum Purchase, 1992 (92.9)

Coming to maturity under the Communist regime
after World War II, Magdalena Abakanowicz turned
to art as a refuge. She resisted the official mode of
Socialist Realism by weaving large-scale, organic forms
that were suspended from walls and ceilings. When
Socialist Realism no longer dominated, she became
interested in the evocative power of human imagery
and soon created figures of minimal solidity. In the
"Garments" series, she suggested people by using
their empty clothes. In "Alterations" and subsequent
series during the 1970s and 1980s, she devised nudes
made of burlap sacking glued over metal frames and
plaster casts of bodies. She eliminated heads and
necks in the "Seated Figures" of 1974–77, then hands,
feet, and even the entire front or rear of the body, as
in the "Backs" of 1976–82. Abakanowicz's sculptures
usually consist of rigorously arranged groups of multi-
ple hollow identical bodies; their repetition in rows
evokes the dehumanization and anonymity of individ-
uals in regimented societies—the artist's meditations
on collective life and conformity in the modern era.

Four on a Bench belongs to Abakanowicz's
"Ragazzi" series, in which the figures were modeled
on her adolescent children rather than the mature
physiques typical of her other works. Even so, the
four teenagers resemble dried-up, hollowed-out,
headless husks—mere shells or remnants of flesh,
passively awaiting a change or completion. They perch
delicately on a wood bench, which rests atop two
logs that could roll away, causing their balanced world
to come crashing down. VJF

Tony Cragg

British, born 1949

Subcommittee, 1991

Steel, 100 1/2 x 74 1/4 x 64 1/2 in. (255.1 x 188.5 x 163.8 cm)
Gift of the Frederick R. Weisman Art Foundation and
Museum Purchase, 1992 (92.10)

Together with Richard Deacon and Anish Kapoor,
Tony Cragg was one of the key figures in the reinvigo-
ration of British sculpture in the early 1980s. Cragg
initially became known for his sculptures fashioned
from pieces of colored plastic or other inorganic rub-
bish, but he has explored many styles and a variety of
media. In collecting, isolating, and presenting mass-
produced objects as evidence of human existence, he
applies an archaeological interest to his work.

In the mid-1980s, Cragg began a group of monu-
mental sculptures that resemble scientific containers,
organic forms, and everyday objects. *Subcommittee*,
made in 1991, is a large-scale rusted-steel version of a
rack of rubber stamps, an item commonly found on
any bureaucrat's desk. By artistically manipulating a
mundane subject, Cragg makes a wry commentary on
human behavior. The analogy of the rubber stamps to
the subcommittee is represented in the ovoid handles
of the stamps, which tilt like human heads—with the
simplification and massing of elements reducing them
to a witless chorus. The medium and the monumental
proportion emphasize the artist's concerns.

Cragg has made rubber-stamp forms in various
materials. He often alters the shape, not only to cre-
ate a humorous effect in an almost scientific manner,
but also to expose a particular physical trait, or to
posit an alternative structural possibility. AC

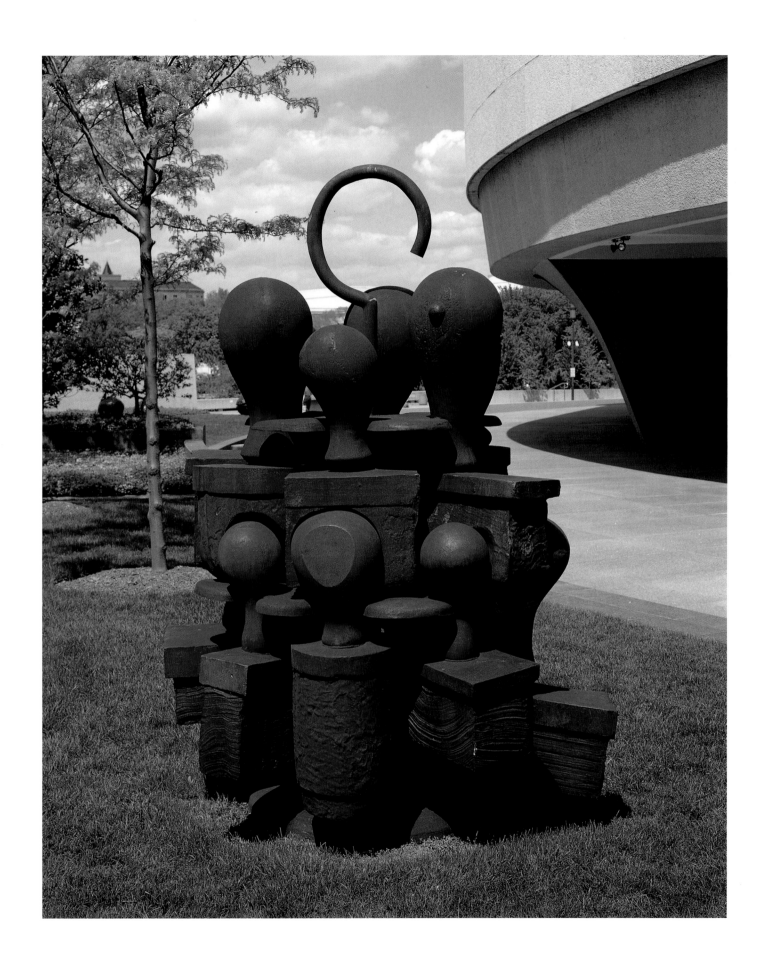

Rachel Whiteread

British, born 1963

Untitled (Yellow Bed, Two Parts), 1991

Dental plaster, 66³/₈ × 27¼ × 28 in. (168.5 × 69.2 × 71.1 cm)
Museum Purchase, 1993 (93.17)

Rachel Whiteread's themes are domestic objects and neglected spaces, from chairs to entire rooms. The subject of *Untitled (Yellow Bed, Two Parts)* is the space beneath a child's bed: it is a cast of the underside of a stained mattress, with indentations indicating where the legs of the bed frame would be. Casting is usually a two-step process in which the first cast, a negative space of the object, is used to make a second, final cast that replicates the original form. Like Bruce Nauman before her, Whiteread takes the unusual step of presenting the negative cast as the final object. Her sculptures impede perception, for it takes time to understand the outlines and configurations of the missing object that once "held" the shapes we see. Whiteread chooses common items that are worn through daily living—they are chipped, scratched, rubbed, stained, and otherwise battered. Although traces of use transfer to the casts, her sculptures are not replicas. Instead, they seem removed from any sense of human time and the cycle of use, disuse, and discarding. Their static quality prompts us to observe what we overlook in life through habitual utilization. Whiteread's sculptures, at once comfortably familiar and strangely remote, transform the transitory object of a single human life into an enduring symbol of human existence. ALM

Jan Vercruysse

Belgian, born 1948

Tombeaux, 1991

Glass and iron, 82 × 96¹/₂ × 15 in. (208 × 245 × 38 cm)
Joseph H. Hirshhorn Purchase Fund, 1993 (93.20)

Since 1979, Jan Vercruysse has worked in series of images that, while based on commonplace forms, ultimately obscure, fragment, or warp the familiar. Begun in 1988, the "Tombeaux" series explores furniture and architectural forms that are distorted by the addition of unnecessary legs, oddly placed shelves, or constricting metal braces.

Tombeaux is a French word with several meanings: tomb, death, memorial marker, or commemorative poem. This sculpture consists of three chairs made of Murano glass and hung from iron pegs. Murano, the Venetian center of glassmaking since the thirteenth century, is famed for its extravagant, colorful, and intricate glass creations. The irregular, handmade sheets of glass that form Vercruysse's chairs, though fantastic in concept, are monuments to Minimalist simplicity. Particularly for Americans, these wall-mounted chairs reverberate with the simple, pious asceticism of the Shakers, a formerly thriving utopian society now virtually memorialized by its songs and artifacts. In addition, empty chairs have repeatedly appeared in Western art as mementos of absent loved ones. The remote, translucent, and fragile chairs of *Tombeaux* become markers for the missing human figures that they literally cannot support. At once familiar and enigmatic, the sculpture tests our perceptions of form, substance, and poetic identity. By the metamorphosis of these objects, Vercruysse demonstrates that truth is multifaceted and exists as much through remembrance as through substance. ALM

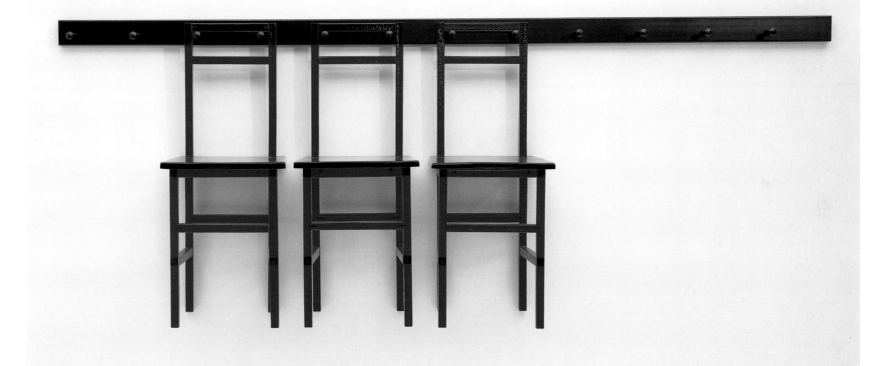

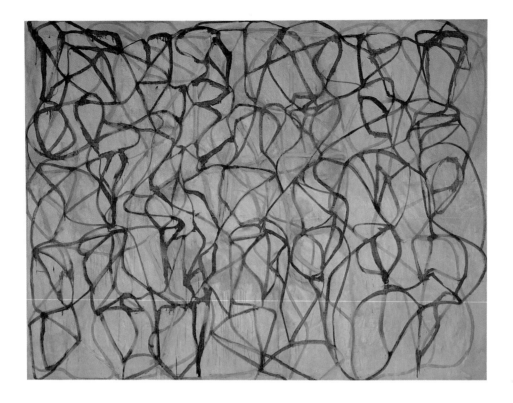

Brice Marden

American, born 1938

Cold Mountain 2, 1989–91

Oil on linen, 108 x 144 in. (274 x 366 cm)
Holenia Purchase Fund in memory of Joseph H. Hirshhorn,
1992 (92.22)

During the 1960s and 1970s, Brice Marden was
known for monochromatic canvases distinguished by
subtly textured encaustic surfaces, restrained brush-
work, and accidental drips. In the mid-1980s he began
exploring new materials and methods of painting.
Through an interest in Asian cultures, Marden discov-
ered a book of poetry in which Chinese calligraphy
and an English translation were printed together.
Written by the eighth-century hermit Han Shan
(Cold Mountain), who took his name from the moun-
tain in southern China on which he lived, the calligra-
phy appeared in stanzas or groupings of several char-
acters each. Marden adapted that form as a visual
principle for his "Cold Mountain" series.

Marden has worked in a variety of formats, from
canvases of standard easel size to those that are larg-
er than human scale. The "Cold Mountain" series
includes his largest works to date, measuring nine by
twelve feet each. With a brush attached to a stick, he
drew rows of abstract symbols over thin washes of
color reminiscent of the atmospheric landscapes in
Chinese paintings. In Cold Mountain 2 the characters
are arranged in eight vertical rows, each with five
symbols. Like Chinese calligraphy, the "writing" dis-
plays a controlled tension between careful planning
and spontaneous execution. While the "Cold
Mountain" series represents a new direction for
Marden through the use of lyrical lines, it also contin-
ues his long-standing preoccupation with color modu-
lation, light, and surface textures within a reductive
but expressive vocabulary. ALM

Chuck Close

American, born 1940

Roy II, 1994

Oil on canvas, 102 x 84 in. (259.1 x 213.4 cm)
Smithsonian Collections Acquisition Program and the
Joseph H. Hirshhorn Purchase Fund, 1995 (95.7)

A leading Photo-Realist of the 1960s, Chuck Close is
renowned for the colossal bust-length portraits he
has painted throughout his career. Initially influenced
by Abstract Expressionism and Surrealist biomorphic
imagery, Close was focusing by the mid-1960s on
hyper-realistic figures and had adopted the monumen-
tal scale of Pop Art. Painting in black and white, he
created portraits of friends and family using a tradi-
tional method of enlarging his images with a grid to
transfer shapes proportionally in each square. He
retained the grid in the final painting, however, thus
alluding to the geometry and precise execution of the
work of contemporary Minimalist artists. Since the
late 1960s, Close has experimented with a variety
of techniques, such as airbrushing to eliminate
signs of painterliness or using his fingers to smudge
painted lines.

Stricken with paralysis in 1988, Close has recov-
ered sufficiently to resume painting. His recent work,
in which he has enlarged the scale of his grids and
employed a broader brush and stronger color, shows
a new vitality and inventiveness. Roy II, in profile,
and its companion, frontal view, Roy I, 1994 (private
collection), are his first depictions of Pop artist Roy
Lichtenstein. Lichtenstein's characteristic use of
Benday dots and underlying geometrical structures
have long corresponded to Close's own dot and line
technique and use of strong vertical/horizontal and
diagonal grids. Highly unusual in Close's career, the
profile pose of the sitter suggests a mug shot and, by
extension, Andy Warhol's celebrated series of "Most
Wanted Men" paintings of 1964. ALM

Juan Muñoz

Spanish, born 1953

Conversation Piece, 1994–95

Bronze, unique

5 figures, variable dimensions, each approx.

64$\frac{1}{2}$ × 204 × 228 in. (163.8 × 518.2 × 579.1 cm)

Museum Purchase, 1995 (95.5)

Juan Muñoz came to prominence in the mid-1980s with his gallery installations, in which a single figure or architectural element was isolated spatially through perspectival techniques. Often the figure was a clown or dwarf, and the effect was one of alienation. In 1989,

Muñoz began his figurative "conversation pieces"—a Renaissance concept, revived by modern sculptors such as George Segal, in which one or more figures interact with their setting to generate a mood or narrative. Muñoz's works invite interpretation, but their meaning is never fully explained, as the artist strove to create an enduring sense of mystery.

The figures in *Conversation Piece* stand directly on the ground, inviting viewers to become part of the action. Initially inspired by a ventriloquist's dummy, these curious characters resemble stuffed toys, particularly the round-bottomed punching-bag clowns that bounce back up after being hit. They also refer

to the dwarves painted by Diego Velázquez in the seventeenth century and to the overlapping images of dancers by Edgar Degas in the nineteenth. The three central figures are enmeshed in an emotional confrontation with an unspecified narrative. One protagonist aggressively pushes the central personage, whose body curves back in spontaneous recoil; another leans in closely as if to murmur. Each posture and gesture suggests urgency and concern, tension and empathy. Nearby, two ancillary figures lean forward, as if moving into the drama, but their inability to move quickly frustrates their desire to intervene. VJF

Index of Illustrations

Hirshhorn Museum and Sculpture Garden